FRAGONARD'S ALLEGORIES OF LOVE

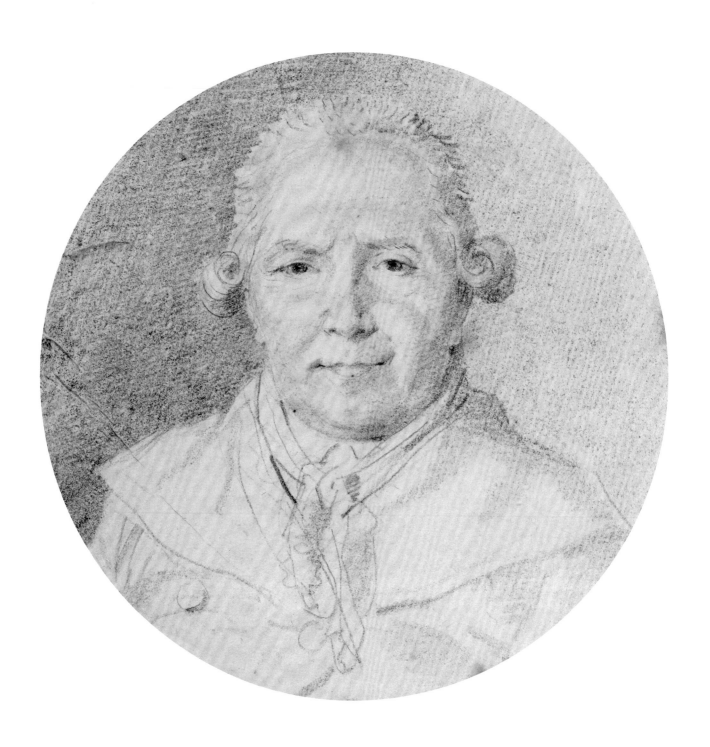

Jean-Honoré Fragonard
(French, 1732–1806), *Self-Portrait*, circa 1785. Black
pencil on paper, diameter:
12.9 cm (5 in.). Paris, Musée
du Louvre, R.F. 41192.
Photo: Gérard Blot, Réunion
des Musées Nationaux/
Art Resource, New York.

FRAGONARD'S ALLEGORIES OF LOVE

ANDREI MOLOTIU

THE J. PAUL GETTY MUSEUM LOS ANGELES

For Donald Posner

Fragonard's Allegories of Love accompanies the exhibition *Consuming Passion: Fragonard's Allegories of Love*, held at the Sterling and Francine Clark Art Institute in Williamstown, Massachusetts, from October 28, 2007, to January 21, 2008, and at the J. Paul Getty Museum, Los Angeles, from February 12 to May 4, 2008. The exhibition was organized by the J. Paul Getty Museum, Los Angeles.

© 2007 J. Paul Getty Trust

Published by the J. Paul Getty Museum, Los Angeles

Getty Publications
1200 Getty Center Drive, Suite 500
Los Angeles, California 90049-1682
www.getty.edu

Mark Greenberg, *Editor in Chief*

Jon L. Seydl, *Curatorial Consultant*
Mollie Holtman, *Series Editor*
Cynthia Newman Bohn, *Copy Editor*
Catherine Lorenz, *Series Designer*
ReBecca Bogner and Stacy Miyagawa,
 Production Coordinators
Stacey Rain Strickler, *Photographer*

Typography by Diane Franco
Printed and bound in China through Asia Pacific Offset, Inc.

Library of Congress Cataloging-in-Publication Data

Molotiu, Andrei.
 Fragonard's Allegories of love / Andrei Molotiu.
 p. cm. – (Getty Museum studies on art)
 Issued in connection with the exhibition Consuming passion : Fragonard's Allegories of love, an exhibition of the artist's work at the Getty Museum that opens in February 2008.
 Includes bibliographical references and index.
 ISBN 978-0-89236-897-6 (hardcover)
 1. Fragonard, Jean-Honoré, 1732–1806—Exhibitions. 2. Fragonard, Jean-Honoré, 1732–1806—Criticism and interpretation. 3. Love in art—Exhibitions. 4. Allegories—Exhibitions. I. J. Paul Getty Museum. II. Title.
 ND553.F7A4 2007
 759.4–dc22
 2007004526

Cover: Jean-Honoré Fragonard (French, 1732–1806), *The Fountain of Love*, circa 1785 (detail on front cover, full painting on back cover). Oil on canvas, 62.2 × 51.4 cm (25 3/16 × 20 5/8 in.). Los Angeles, J. Paul Getty Museum, 99.PA.30.

CONTENTS

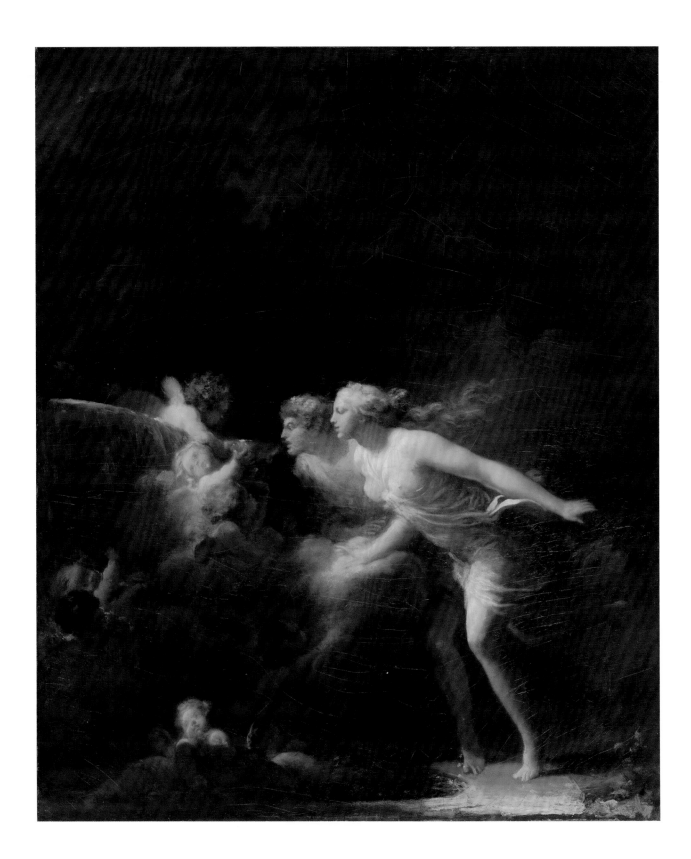

When we first step into the gallery, the can-
vas is just a blonde blur in the darkness, caught within a golden frame. As we approach, it
resolves into shades of brown, ivory, and gold, and we can make out a couple, a man and a
woman in diaphanous classical dress, running in unison toward a fountain surrounded by
mist. Darkness fills the top of the canvas, but shapes can be discerned there, too. Are those
branches? Foliage? We must be in a forest, then, or perhaps a garden grove. Children seem
to be playing in the fountain and in the vaporous clouds around it. No, not children exactly.
They have wings; they must be cupids. Three of the cupids hold up a golden cup, toward
which the lips of the man and the woman are being drawn; he is just about to drink from
it, and she will follow suit a split second later. Or maybe she'll catch up with him at the last
moment, and they will drink from it as one.

The painting is entitled *The Fountain of Love* [Figure 1], but we need not have read
the label to tell what is going on. Even without the frolicking cupids, how could the image
be about anything else? What other meaning but love could be attributed to this scene of
a couple running together at night, to share the same elixir?

As opposed to many other pictures from the period—whether defined as the
1780s or the entire eighteenth century in France—in order to understand what this one is
about it is not necessary to consult learned tomes, recondite books of emblems, or treatises
on iconography, or to know the minutest incidents in Greek mythology or Roman history.
The same is true of a number of other images created around the same time by the painter
of *The Fountain of Love*—Jean-Honoré Fragonard—and which recall it in form and spirit.
Even if we could not read the inscription on the stone tablet in *The Oath of Love* [*see*
Figure 12], we would be able to tell that the embracing couple are swearing to love each
other forever. And what other emotion could possibly be moving the lone woman in *The
Invocation to Love* [*see* Figure 18] to precipitate herself toward a statue of the god Eros?
This group of compositions has come to be known as the "Allegories of Love," but perhaps
that designation is overdrawn. The *Invocation,* for example, is barely allegorical at all: It
conveys its meaning primarily through the protagonist's ecstatic rush of movement, the
tautness of her body, which is straight as an arrow, and the play of light and darkness
across her figure. While the last composition in the series, *The Sacrifice of the Rose* [*see*
Figure 32], makes use of allegory, its meaning is hardly difficult to discover. Although two
and a quarter centuries have passed since the image was made, it takes very little effort to

FIGURE 1
Jean-Honoré Fragonard
(French, 1732–1806),
The Fountain of Love,
circa 1785. Oil on canvas,
62.2 × 51.4 cm (25³/₁₆ ×
20⁵/₈ in.). Los Angeles,
J. Paul Getty Museum, 99.PA.30.

decipher the meaning of a picture that shows a young woman sacrificing a rose on an altar, while the god of love himself swoops down to burn her flower with his torch.

The term "compositions" rather than "paintings" is used intentionally because for each of these subjects more than one treatment by Fragonard is known. There are two or possibly even three finished versions of the *Sacrifice,* not to mention numerous drawings and oil sketches, and two finished versions of *The Oath of Love.* It is true that only one finished version of the *Invocation* exists, but there is a stunning oil sketch for it, in the Louvre, as well as two drawings that are probably not preliminary studies but records of the completed painting. Furthermore, the *Oath,* the *Sacrifice,* and the *Fountain* were published by Fragonard as prints and in that medium were some of the most successful of his works, both during his lifetime and beyond. To this day, photoengraved versions of all three can be bought at the bouquinistes on the banks of the Seine, and chromolithographs of the paintings are regularly sold on eBay.

Until recently, *The Fountain of Love* was thought to have only one finished version—in the Wallace Collection in London. However, in 1999 another version of the composition appeared on the market. Passed down through the same American family since the 1920s, it had long been out of the public eye. Its existence had barely been suspected, based on brief mentions in nineteenth- and early-twentieth-century sales catalogues, and most scholars imagined that those mentions related to the London picture, despite a few minor discrepancies.

The new version of the *Fountain* was acquired by the J. Paul Getty Museum in Los Angeles. Soon X-rays revealed pentimenti (reworked passages covered over by the picture's final paint surface) which demonstrated that the Getty painting must be the first version of this composition, and the work in the Wallace Collection an autograph replica. Some evidence of this is visible even to the naked eye: As visually stunning as the Wallace picture is, the Getty Museum's version is even more alive, in the energy of its brushwork and in the interplay of its light and shadows, fully demonstrating the magic of painting for which Fragonard was justly famous.

The discovery of this new *Fountain* is a propitious occasion to take another look at the entire Allegories of Love series, which constitutes the primary innovation of Fragonard's late period and has no parallels anywhere in his earlier production. The work Fragonard produced during the 1780s, the last decade of his creative life, has received much less attention than the rest of his oeuvre, probably due to the common perception of him as a high-Rococo painter rendered obsolete by the rise of Neoclassicism. However, Fragonard's late period contains significantly more than simple rehashings of his earlier style. The Allegories, in particular, combine Neoclassical stances with a liberal use of chiaroscuro and of Correggesque sfumato to create scenes that anticipate (or even initiate) the earliest strain of French Romantic painting, the so-called Anacreontic painting of the Directory, Consulate, and Empire, exemplified by works such as Baron Antoine-Jean Gros's *Sappho Leaping from the Rock of Leucatus* of 1801 [*see* Figure 73] or Pierre-Paul Prud'hon's 1808 *Abduction of Psyche* [Figure 2]. Thematically, they can be shown to relate closely to the writings of an entire generation of French writers of the 1770s and 1780s who, in the wake and under the strong influence of Jean-Jacques Rousseau, elaborated the concept of "Romantic love," a concept that was to have a powerful transformational effect upon late-eighteenth- and early-nineteenth-century society as a whole. Indeed, it can be argued that

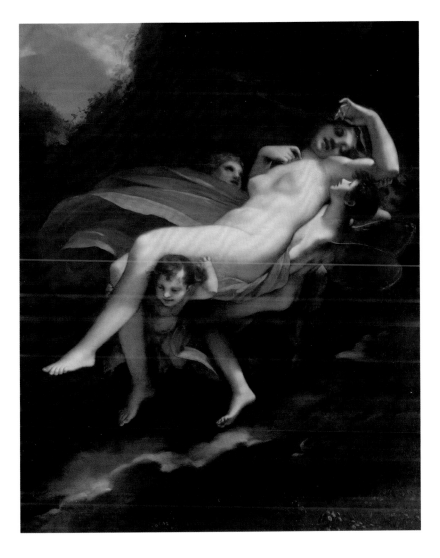

FIGURE 2
Pierre-Paul Prud'hon (French,
1758–1823), *The Abduction
of Psyche,* 1808. Oil on canvas,
195 × 157 cm (76¾ × 61¾ in.).
Paris, Musée du Louvre,
R.F. 512. Photo: Erich Lessing/
Art Resource, New York.

it is because we continue to experience the effects of that transformation that we can still relate to the subject matter and the emotional charge of the Allegories, centuries after the date of their creation.

Explaining the Allegories' specificity within Fragonard's oeuvre, as well as their meaning within their larger cultural context, will be the task of this book. After a brief survey of the painter's career and an elucidation of several important terms, including "Romanticism" itself, each painting's stylistic and iconographic sources will be analyzed and the iconographic and structural parallels between the Allegories and the writings of Rousseau and his followers identified. These parallels are crucial as they help place the Allegories among the earliest manifestations of Romanticism in France in any medium. Next it will be argued that the Allegories' primary contribution to the new conception of love can be read in terms of temporality. As works of art that illustrate a single moment rather than the development of a series of actions over time, Fragonard's pictures both bring to the foreground and attempt to solve a paradox about the temporal nature of love inherent in the work of the period's early Romantic writers. Finally, the question will be posed as to whether any significant connection can be drawn between the private world of the Allegories and that very public upheaval that followed them by only a few years, the French Revolution.

BETWEEN PUBLIC AND PRIVATE: THE ALLEGORIES OF LOVE IN THE CONTEXT OF FRAGONARD'S CAREER

How did Fragonard get from the high-Rococo style of his most famous paintings, *The Swing* [Figure 3] and *The Bathers* [Figure 4]—characterized by their luxuriant brushwork, bright colors, and unabashed celebration of erotic pleasure[1]—to the mysterious shadows and deeper emotions of *The Fountain of Love?* A brief survey of the artist's life will help elucidate the peculiar trajectory of his career, the conflicting demands put on his production by various groups, including the Salon critics and the private patrons who accounted for most of his livelihood, the way the painter navigated the changing social and cultural landscape of the ancien régime and the French Revolution, and the stylistic transformations in his work that resulted from the combination of all these factors.

FIGURE 3
Jean-Honoré Fragonard, *The Swing,* 1767. Oil on canvas, 81 × 64.2 cm (31⅞ × 25¼ in.). London, Wallace Collection, P430.

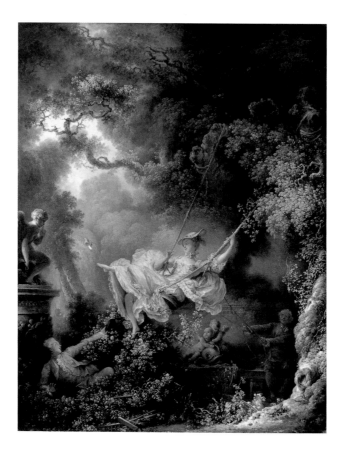

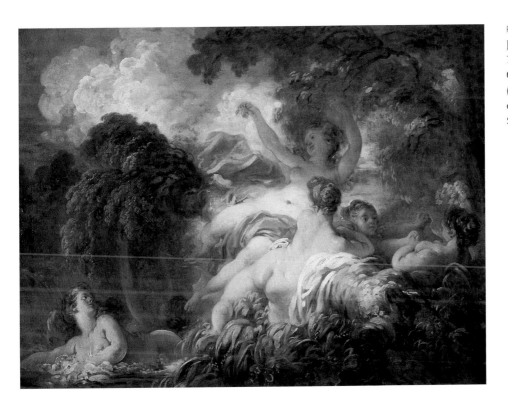

5

FRAGONARD'S CAREER

Jean-Honoré Fragonard (1732–1806) began as a student of François Boucher, and his very early pictures [Figure 5] evince a complete appropriation of the older painter's style, particularly his decorative pastorals with scenes of gallantry.[2] However, the young artist was groomed by the French Royal Academy of Painting and Sculpture for a much higher destiny: a career as history painter—that is to say, a painter of scenes taken primarily from Greek and Roman history and mythology and from the Bible, the kind of painting which constituted the highest genre in the Academy's hierarchy. After winning the prestigious Prix de Rome for painting in 1752, at the young age of twenty, Fragonard studied until 1756 at the newly established École royale des élèves protégés. This institution had been founded, as part of the Academy's reforms of 1747, in order to supply the state with more history painters, who were seen as critical to the healthy survival of the arts in France.[3] The École gave students a thorough training not only in practical art making but also in the history of art as well as in other humanistic fields, such as history and the classics. Thus prepared, Fragonard was ready to complete his artistic education at the French school in Rome, where he was a *pensionnaire* from 1756 to 1761.

Upon returning from Rome, the next step for any young and ambitious painter was to gain acceptance into the Academy. This process occurred in two stages: a candidate first became *agrée*

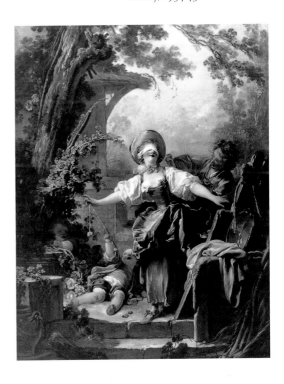

(associate member), then *reçu* (full member). At each of these stages the candidate had to present to the Academy an important piece in order to demonstrate his artistic mastery—a *morceau d'agrément* and a *morceau de réception,* respectively. Fragonard diligently entered upon this path; however, at the same time as he was working on his suitably grand *morceau d'agrément,* he began dabbling in the creation of risqué erotic pictures, such as *The Bathers* [*see* Figure 4], and in other lower genres not befitting one of the Academy's most promising prospects. This situation was noted with dismay by Charles-Nicolas Cochin, the secretary of the Academy, in a letter of August 5, 1765, to the Marquis de Marigny, the *directeur des batiments*—effectively, the king's minister of arts. Cochin wrote that the young artist, finding himself in dire financial straits, was thereby "forced by this need to take on works that are little suited to his genius, and that will delay the successes that we have the right to expect of him."[4]

Despite such distractions, at his debut at the Paris Salon, which took place only weeks after the date of Cochin's letter, Fragonard was seen by many critics and government officials as the best hope for the reform of French painting. This impression was particularly based on his *morceau d'agrément, The Grand Priest Coresus Sacrificing Himself to Save Callirhoë* [Figure 6], a large, dramatic tour de force that in its lighting, poses, and overall composition turned away from Boucher's example and toward the grand

FIGURE 6
Jean-Honoré Fragonard,
The Grand Priest Coresus Sacrificing Himself to Save Callirhoë, 1765. Oil on canvas, 309 × 400 cm (121²⁄₃ × 157¹⁄₂ in.). Paris, Musée du Louvre, 4541. Photo: Erich Lessing/Art Resource, New York.

6

ambitions of seventeenth-century Italian Baroque painting, particularly the works of Pietro da Cortona. The need to find a new figurehead for reform was that much greater since Jean-Baptiste Deshays—generally accepted as the leader of French progressive painting (the *encyclopédiste* Denis Diderot had called him "the first painter of the nation" in 1761)—had just died, at the untimely age of forty-four. Deshays's work from the late 1750s had mined the same neo-Baroque tendencies that informed the *Coresus,* and it is very possible that Fragonard had chosen to go in that stylistic direction (perhaps under Cochin's and Marigny's coaching) so as to ally himself with the latest and most promising developments in French painting.

However, this critical consensus was not to last. Fragonard's submissions to the next Salon, of 1767, were largely seen as frivolous and as showing a great decline in quality from his earlier work. They consisted of a small oval composition—possibly a sketch for a ceiling—of naked cherubs frolicking among clouds [Figure 7], a head study of an old man,

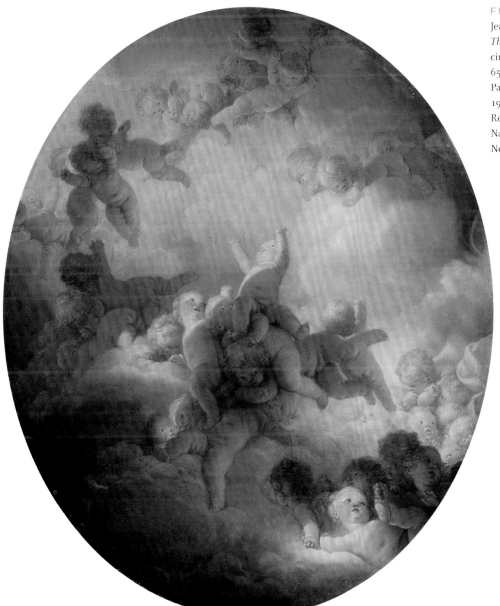

FIGURE 7
Jean-Honoré Fragonard,
The Swarm of Cupids,
circa 1767. Oil on canvas,
65 × 56 cm (25⅝ × 22 in.).
Paris, Musée du Louvre, R.F.
1949.2. Photo: Jean Schormans,
Réunion des Musées
Nationaux/Art Resource,
New York.

and several drawings. For Diderot, this hodge-podge of minor works was a serious letdown from an artist who had shown so much promise two years before. As he wrote in his book-length review of the Salon: "Mr. Fragonard, when one has made a name for oneself, one must have a little more self-regard. When after an immense composition that elicited the greatest acclaim one shows only a head, I ask you, how great that head must be."[5]

From that point on, Fragonard abandoned the career path that had been traced out for him; he never exhibited at the Salon again and never attained full membership in the Academy. His decision may have had to do with the meager rewards of government commissions (though the crown bought the *Coresus* in 1765, Fragonard did not receive the full payment until 1773),[6] but it also reflects his discomfiture with the requirements of academic painting. Despite Cochin's belief, as stated in his letter to Marigny, it is clear that the demands of official history painting were exactly what was *not* "suited to his genius." Giving up the academic search for the ideal of history painting, Fragonard retreated into creating pictures that can be associated with the then already waning *style moderne,* or what is now called the Rococo, the favorite target of all the progressive Salon critics. This choice was clearly marked in 1767, the year of his last submissions to the Salon, when Fragonard executed his famous *Swing* [*see* Figure 3], following the specifications of the aristocrat who commissioned it, and who wanted to be shown looking straight up the skirts of his swinging mistress. The Academy's former great hope was now devoting his considerable talent to pictures that were the exact opposite of what he had been trained to paint: erotic rather than morally edifying, frivolous rather than highly serious, and intended for an *amateur's* private *cabinet* rather than for public exhibition at the Salon.

A brief comparison to Boucher reveals the singularity of Fragonard's artistic practice. Despite the frequent association, in most art-historical surveys, of Fragonard and Boucher as the practitioners par excellence of the Rococo style, the relationships of their respective manners to the artistic mainstream of their time were of essentially different natures. Boucher, born in 1703, formed his style in a period whose comfortable ideals of sociability and Epicureanism were essentially consonant with the hedonistic connotations of his work; consequently, he was able to attain a prominent position in the highest circles of the official art world of his time. In contrast, Fragonard attained a style that could still be dubbed Rococo at a time when most progressive critics saw such a manner as a sign of the decadence that had characterized the arts in the early part of the century, and which now had to be overcome in a search for a more moral, less frivolous painting—a tendency that culminated in the cool austerity of Jacques-Louis David's Neoclassicism, as exemplified by his 1784 painting *The Oath of the Horatii.* Fragonard's embrace of the Rococo after 1765, thus, was nowhere near as unproblematic as Boucher's had been but rather, almost perversely, went against the flow of the period's artistic mainstream; such a manner could only flourish away from the public scrutiny of the Salons, where it would have been sure to come under strong attack.

Fragonard's failure to fulfill his putative destiny was noticed by Salon critics and by other writers. Louis Petit de Bachaumont, in his *Memoires secrètes,* perceived Fragonard's 1767 showing as the abrupt end of a formerly fast-moving career: "Why has M. Fragonard, on whom we had set such great hopes at the last Salon, whose talent announced itself with a clamor that could only flatter his vanity, all of a sudden stopped?"[7] Such disappointment prepared the ground for Fragonard's failure to exhibit at all in 1769; the

critics felt confirmed in the judgment they had made of him two years previously. As Bachaumont dryly noted:

> M. Fragonard, that young artist who gave us, four years ago, the greatest hopes
> for the genre of history painting, but whose talents developed little at the last
> Salon, does not figure in any fashion in this one. It is said that the desire for
> making money has turned him away from the beautiful career on which he
> had engaged, and that, as far as posterity is concerned, he is content to sparkle
> in boudoirs and dressing rooms.[8]

Thus was Fragonard seen as having failed to fulfill the mission for which he had been primed by Cochin and the rest of the arts administration: to lead in the vanguard of the new French painting that would distance itself from the decadence of the Rococo. Fragonard's continuing absence from the Salons was noted by others who advanced the same notion. In 1771, the pamphleteer Raphael le Jeune (Daudet de Jossan) wrote: "M. Fragonard! He will not exhibit…it's because he has given up the grand genre."[9] The financial explanation which Bachaumont had offered for Fragonard's inactivity would be echoed over and over again, yet rarely as caustically as in a letter of October 5, 1771, from Mme d'Epinay to abbé Galliani: "M. Fragonard? He's wasting his time and his talent; he's making money."[10] In all of these commentaries an opposition is set up between the public, historical mission imputed to the painter (phrases such as "la posterité" and "le grand genre" are employed along with the idea that the true mission of painting is to benefit the nation) and the inconsequential act of simply selling one's work to private individuals, whether wealthy nobles or *fermiers généraux*. (The latter—financiers who rented from the state the right to collect taxes and often grew exceedingly rich as a result—were perceived as using their immense fortunes for purely private, hedonistic ends, rather than for the good of the nation and had therefore become the favorite bêtes noires of progressive critics.)

The argument that there was an irreconcilable conflict between the interests of the state and those of private collectors had already been advanced by Diderot in 1767, when he offered an extended, withering critique of the negative effect money from financial speculation had on the progress of the arts. According to him, any painting which went directly into a financier's private cabinet took something away from the wealth of the nation itself:

> The talented man from whom the rich man demands a work that he can leave
> to his child…no longer works for the nation, but for a private person, and you
> will only obtain from him a mediocre and worthless piece. One cannot set
> enough obstacles to laziness, cupidity and unfaithfulness; and public censure
> is one of the most powerful such obstacles there is.[11]

Public exhibition at the Salon and subjection to the comments of the Salon critics were seen by Diderot as essential to maintaining the quality of the arts. Artists who removed themselves from that exchange erred in two ways: by not producing art for the public, and thus for the nation, and by compromising for posterity the value of the art they did produce. Fragonard, in the eyes of Diderot, would have been guilty on both counts.

While privately commissioned easel paintings remained his bread and butter for the rest of his life, Fragonard did not immediately choose to abandon wholesale the ideals for which he had been trained. However, rather than focusing on *grandes machines*—elaborate history paintings with complex compositions and iconographies and a large cast of characters, such as his own *Coresus Sacrificing Himself to Save Callirhoë* had been—after the middle of the 1760s he seems to have envisioned a career as a painter of large-scale decorative works. In this format he could better indulge his love of bright colors and lush brushwork and needed to be less concerned with the historically and archaeologically correct narratives demanded in history painting in the grand manner.

In the beginning, the officials of the Academy seem to have encouraged him in this new path. With their help, in 1766 he secured commissions for two overdoors for the Château de Bellevue, on the subjects of "Day" and "Night"[12] and in 1770 for two paintings (on subjects of his own choosing) for the king's dining rooms at Versailles. Even more revealing is the fact that on May 31, 1766, Fragonard was offered the opportunity to paint a section of the ceiling in the Louvre's Galerie d'Apollon for his *morceau de réception*. Located in one of the most important rooms in the most important public building in Paris, this commission was a sign of the Academy's continuing confidence in the promising artist, who was thus given a chance to create a piece that might approach the level of the much-admired Italian Baroque ceilings of Annibale Carracci or Pietro da Cortona, or of Jean-Baptiste Lemoyne's work in the Salon d'Hercule at Versailles.

The kind of decorative painting that, on the other hand, represented a certain downgrading in status consisted of more frivolous subjects intended for private residences, and it is exactly this kind of work that Fragonard sought in the following few years (prob-

10

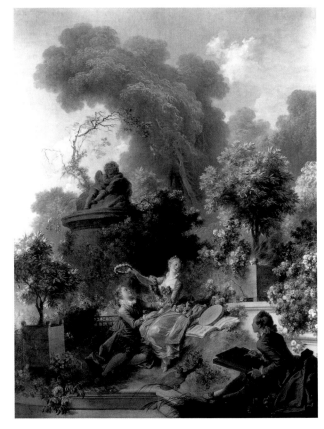

ably as he was faced with the growing realization that working for private patrons was significantly more lucrative, and the payments much more likely to come on time, than working for the crown). Between 1767 and 1771 he secured commissions from Marquis Voyer d'Argenson for a ceiling; from Mademoiselle Guimard, the famous actress, for decorative panels for her new house in Paris; and from Madame du Barry, Louis XV's latest mistress, for a decorative cycle for her pavilion at Louveciennes.[13]

One last commission is relevant here. Sometime around 1770 Fragonard participated in the decoration of the salon of engraver Gilles Demarteau, for which he painted one of four door panels with scenes of trellises and statues of Cupid [Figure 8]. That project had been started by Boucher and his studio and had most likely been left unfinished at the time of Boucher's death on May 30, 1770; we can hypothesize that Fragonard stepped in, perhaps at the client's request, to complete the project.[14] The artist may have seen this moment as an opportunity to present himself as his teacher's successor, since in the panel he painted he molded his manner as closely as possible to that of the older painter.

Fragonard's intent to fill the void left by Boucher is especially clear in the Louveciennes panels made for Mme du Barry [Figure 9]. These paintings mark the only moment in his oeuvre when he fully reverted to the *pastorale-galante* idiom that he had perfected in the early and middle 1750s under Boucher's influence. The characters, settings, and particularly the hidden symbolism of the Louveciennes pictures find their closest parallels in works such as *The Musical Contest* [Figure 10] of about 1754–55. There can be no better proof of Fragonard's distancing himself from the reformed manner of the Salon than this conscious reversion, around 1770, to a style that had already been falling out of fashion even at the time he first encountered it.

FIGURE 10
Jean-Honoré Fragonard,
The Musical Contest,
circa 1754–55. Oil on canvas,
62 × 74 cm (24³⁄₈ × 29¹⁄₈ in.).
London, Wallace Collection,
P471.

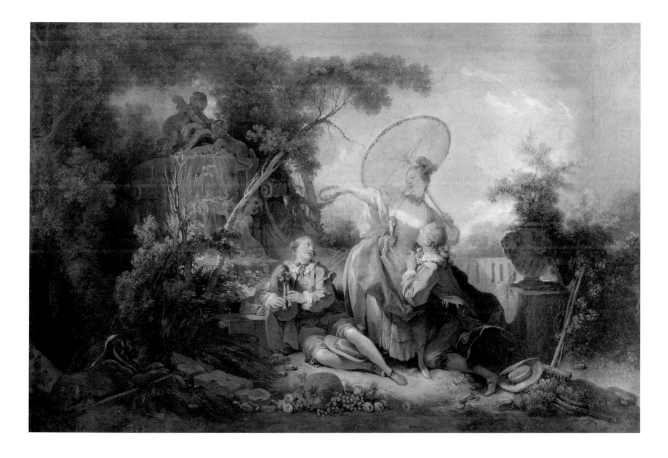

Unfortunately, despite Fragonard's ability to garner commissions, he had a much harder time completing them. In the end, all of the decorative projects chronicled here—both public and private—came to little. The story of the artist's *morceau de réception* makes instructive reading in this regard. The painter Louis-Jean-Jacques Durameau, who had been commissioned by the Academy at the same time as Fragonard to paint a section of the Galerie d'Apollon ceiling, completed his task by 1774; on September 20, 1776, on the other hand, Fragonard was relieved by the Academy, at his written request, from his obligation to fulfill his commission as prescribed, due, in his reported words, to his fear of "not being able to complete it promptly enough to satisfy" that august body.[15] He was nevertheless still expected to provide a *morceau de réception* in the form of an easel painting on a subject of his choosing.[16] Over twelve years later, on December 17, 1788, Fragonard was again summoned by the Academy on account of his reception piece. The result of this summons, as recorded in the Academy's minutes, reveals Fragonard's cavalier attitude toward that institution: "The painter Fragonard presented himself but left saying he would come back, and did not come back."[17] Six days later, the minutes recorded the Academicians' lack of illusions about the possibility that Fragonard would ever fulfill this obligation. Four painters were listed "who will not satisfy the request for and are even unable to provide their *morceaux de réception*":[18] one on account of his old age (seventy-two); another who had gone blind; a third due to his "usual absence from France"; and Fragonard himself, "through fickleness and insouciance."[19]

This insouciance had been made clear to the Academy long before. A report of March 29, 1773, records that the painter, having been called to account for the missing Bellevue paintings (almost seven years after the commission), had invoked the Louveciennes panels as an excuse: "up to now he hasn't been able to work on them, having been busy with the pictures commissioned from him by Madame du Barry. Now he assures us that he will work at them with all zealousness and assiduity."[20] Despite Fragonard's reassurances, those paintings never seem to have been executed; no trace exists of the Versailles pictures either, and it is doubtful they were ever completed, or even undertaken.

Factors beyond that of his fickleness led to the failure of his other decorative projects. The Voyer d'Argenson ceiling seems to have been completed; but in June 1769, Charles de Wailly, the hôtel's architect, expressed dissatisfaction with the work, which may have been soon after replaced with a painting by Louis-Jean-François Lagrenée. Fragonard seems to have fallen out with Mlle Guimard over prices, first having asked for only 6,000 livres, then raising his demand to 20,000 after producing the initial sketches. As a result, he was replaced on the project by the young David, whom he himself recommended.

Fragonard also completed the commission for Louveciennes, but Mme du Barry promptly rejected his panels. By August of 1773 two classicizing paintings by Joseph-Marie Vien that were meant to replace Fragonard's were already on display at the Salon. The Louveciennes commission needs to be seen in the context of Fragonard's other unfinished, rejected or never even started decorative projects. Of all of them, its failure constituted perhaps the artist's greatest disappointment and the final indication that, in deciding to present himself as a decorative painter, he had chosen the wrong career path. It is easy to imagine that these compounded fiascos weighed heavily on Fragonard's shoulders when, that October, he decided to leave France and accompany his friend and patron, the *fermier-général* Pierre-Jacques-Onésyme Bergeret, on his trip to Italy. They only returned to Paris

in September of the following year. After this break, Fragonard had to decide again among his professional options. Practically, decorative painting seemed no longer to be a choice—there is no evidence that he either sought or was offered any further commissions for large decorative schemes (at least until his 1791 reinstallation of the Louveciennes panels in Grasse, which constitutes a special case). He could have attempted to return to the fold of the Salon, where much of his work would still have been completely acceptable, but he chose not to go in this direction either and never again exhibited at the Academy's biennial exhibition.

Thus, in midcareer, the painter closed off the primary opportunity available to him for making contact with the wider Parisian public, as well as any chance of becoming established as an important artist in any vein of artistic production still rated highly by the Academy. Financially, his main source of income after 1774, as before, was patronage of his easel pictures by *amateurs* among the nobles and the financiers. In opting to work for private patrons, Fragonard seems to have chosen the path of least resistance. Private commissions of easel paintings had most likely provided the greater part of his livelihood between 1761 and 1773, and, indeed, it was probably such commissions that accounted for the interminable delays in his decorative work. No longer ambitious for public recognition or for the high visibility of major decorative schemes, Fragonard now produced exclusively for the cabinets of rich collectors. He emphasized diversity, focusing not only on gallant and erotic scenes but also on religious subjects, genre scenes that celebrated the joys of bourgeois family life, and landscapes. It is among these varied subjects that, in the 1780s, the Allegories of Love appeared.

Fragonard did take measures to have his compositions available beyond the confines of private cabinets, boudoirs, and *garde-robes*. He made concerted efforts to have prints published after many of his works (a decision probably based on the considerable additional income such a move brought), particularly his genre scenes, as well as the Allegories of Love—topics specifically designed to court the period's rising bourgeois sensibility.[21] Although he no longer exhibited at the official Salon, Fragonard did show at some of the period's newly established alternative spaces; particularly, between 1778 and 1785, at the Salon de la Correspondance, a fledgling exhibition space which featured rotating weekly art shows.[22]

In 1790, Fragonard briefly moved back to his native town of Grasse, where he reinstalled, in his cousin's house, the paintings that Mme du Barry had rejected eighteen years before; he added to them ten new paintings that are his last documented works. (The entire ensemble is now in the Frick Collection, New York). He returned to Paris in 1792 and apparently abandoned painting altogether, accepting a position as a curator at the newly founded Louvre museum. He died in 1806, at which time most obituaries described him as a painter of the "ancienne école," an anachronistic relic of the Rococo in the modern age of Napoleon. Along with his *morceau d'agrément, Coresus Sacrificing Himself to Save Callirhoë* [Figure 6], two of the Allegories, *The Fountain of Love* and *The Sacrifice of the Rose,* were the only paintings of his that any of the obituary writers mentioned by title.[23]

THE CONCEPTS OF "PUBLIC" AND "PRIVATE" IN THE INTERPRETATION OF FRAGONARD'S CAREER

Throughout the above discussion Fragonard's career has been plotted as moving between the opposite poles of "public" and "private," as the painter abandoned *public* exhibition at the Salon in favor of working for *private* patrons, only to turn back to the *public* through the publication of prints after his compositions. Discussing his efforts in these terms might suggest that the two notions are easily defined and uncontroversial, but the very opposite is true: in the eighteenth century, these were ideologically freighted concepts, and the baggage they carried has survived undiminished into recent art-historical debates. Before moving further with the interpretation of the Allegories of Love, it is necessary to analyze these two concepts more closely, as they will inform the rest of our discussion.

Of the two concepts, it is the notion of "public" that has taken on a surprising variety of meanings in the literature on the period. For example, in his book *Painters and Public Life in Eighteenth-Century Paris,* Thomas Crow finds Fragonard's work after he stopped exhibiting at the Salon irrelevant to his topic. Crow sees the change in Fragonard's art as being marked by the commission of *The Swing:* "With that, this pupil of Boucher abandons history painting and the *public* sphere to pursue the personal, sensual, and erotic possibilities of paint like no other artist of the century."[24] Conversely, Christian Michel, discussing the same event in his monograph on Charles-Nicolas Cochin, employs the word "public" in a way that is utterly opposed to Crow's usage: "Fragonard took advantage of the recognition of his talent by the official powers to turn toward the *public* and to practice a more lucrative genre."[25]

Can Fragonard, in one and the same gesture, have both "abandon[ed]…the public sphere" and "turned toward the public"? The contradiction cannot be solved by arguing that the commentators are writing in different languages; it is rather that their uses of the term "public" seem to be grounded in utterly different social philosophies. Crow's "public sphere" denotes a space of ideological contention, symbolized by the biennial Salon, in which the dialectical interplay of the activities of the Academy, the crown, and the Salon pamphleteers ultimately resulted in a specific vision of what painting had to become— namely, the Neoclassical style of painting in the grand manner, best exemplified by Jacques-Louis David's work of the 1780s. Crow borrows his particular use of the term "public" from a highly ideologically minded group of eighteenth-century writers—the Salon pamphleteers themselves. The anonymous author of the 1773 critical pamphlet *Dialogues sur la peinture,* for instance, allowed only a very limited portion of the Salon audience to be identified as the true "public." One of the dialogue's characters, espousing progressive, anti-Rococo views, says to a like-minded interlocutor: "You know that there are different kinds of public: the one you are a part of clamors its disapproval; another is indifferent; a third kind praises due to its bad taste, or by hearsay."[26] As the *Dialogues* make clear, only the first group has the competence to make judgments. One must "draw a distinction between the public that repeats what it has been told and the public that sees. It is the latter that has a say at the theater or at the Salon."[27]

What Michel seems to mean by his use of "public" is the loose assemblage of nobles and *fermiers-généraux* whose patronage proved quite remunerative for Fragonard after he stopped exhibiting at the Salon. To this group should be added the much wider but

even more amorphous portion of the populace who bought prints after Fragonard's works. From this perspective, it is somewhat ironic that *The Swing*—the very symbol, in Crow's opinion, of Fragonard's retreat from the public—was made into one of the artist's most successful engravings. In turning to these groups Fragonard reached at least as large an audience as he would have at the Salon, but neither print buyers nor the owners of private cabinets had as concrete an existence in the art-critical discourse of the period as the Salon pamphleteers' ultimately fictional construct of "the public."

Michel's definition of the word "public" then, can be seen as more empirical than Crow's; it relates not so much to the launching of images onto the Salon's stage of public discussion and controversy, as to the more discreet dissemination of paintings, by way of private commissions and prints, to a large section of the population.[28] This sense of the word is closer to the usage of its derivative "publication," as applied to works of literature (significantly, it was probably the same section of the middle class who both consumed the latest novels and bought Fragonard's prints); it denotes a more dispersed audience, one that did not congregate around any single institutional space and that did not—as opposed to the Salon's "public"—end up producing a single, normative, aesthetic discourse. Despite the implied claims of anti-Rococo critics, Fragonard's choice of one public over the other had little to do with the painter's own political opinions (indeed, insofar as he had any political commitment, Fragonard seems to have been progressive, ultimately supporting the 1789 revolution). Rather, this choice should be seen more as a matter of Fragonard's passive resistance to the increasingly hegemonic discourse that was forming around the Salon (as well as, of course, a financial decision based on the much higher possibilities of remuneration when working not for the state but for the private market).

Given this situation—both the empirical facts of Fragonard's career during the 1780s and the various critical claims made of terms such as "public" and "private"—a question arises in connection with the Allegories of Love, a question to which only a speculative answer can be provided. Namely, could these paintings have been produced in the context of the Salon? Is there a direct connection between Fragonard's retreat from public exhibition and his elaboration, in the Allegories of Love, of perhaps the earliest specimens of Romantic sensibility in French visual culture—or would the Allegories' early-Romantic vocabulary of dark shadows and intense passion have been seen as perfectly acceptable by the critics and the biennial exhibition's audience?

An argument could be made that it was only when not subjected to the requirements of the Academic style and the demands of the Salon critics, when allowed to indulge his private leanings, that Fragonard was able to fashion the imaginary world of the Allegories of Love. This hypothesis is supported by the fact that the Allegories are utterly dissimilar from any other works of the period, particularly anything that was exhibited at the Salon. Their closest equivalents—albeit not very close—can be found in the prints and book illustrations of the period, works meant to be consumed in the privacy of one's own home, in a one-to-one act of communication between artist and viewer that was completely unlike the experience of viewing large history paintings like the *Coresus* in the Salon Carré. The further observation that the Allegories appear to originate some of the formal qualities later taken up by the earliest widely acknowledged "Romantic" style of French painting—the so-called Anacreontic manner of Pierre-Paul Prud'hon, Anne-Louis Girodet, and Baron François Gérard—would support an explanatory schema whereby the private

aspects of art production in the late ancien régime are opposed to its public aspects just as Romanticism is opposed to Neoclassicism. The birth of Romanticism would then be associated with the private sphere, a position easily integrated with the common view of Romanticism as an exacerbation of subjectivism and psychological interiority.

Such a schema, however, runs the considerable risk of fixing the notions of the private and the public into a stable dichotomy. To begin with, the iconography of Fragonard's Allegories belongs to the widening discourse of sentimentalism and incipient Romanticism which can be found in many of the novels and poems of the period. The messages conveyed by the Allegories correspond to new attitudes about love that were being elaborated, during the first flourishing of French Romanticism, by an entire generation of writers raised on Jean-Jacques Rousseau, then pushed aside by the French Revolution. These writers could fairly be called the children of Rousseau's epistolary 1761 novel, *Julie, ou la Nouvelle Héloïse* (*Julie, or the New Héloïse*), with the important qualification that they responded not so much to the novel's ultimately moralizing message, as to the vision of all-encompassing, irrational love put forward in its early books. There is little need to claim Fragonard's direct familiarity with either Rousseau's text or with that of any of his followers; *La Nouvelle Héloïse* was the century's biggest best-seller, touching almost every stratum of the population, and in the process uniting them in a new community of sentimentalism and deep feeling. The novel's theme, echoed in the works of Rousseau's epigones, resonated throughout the culture, and Fragonard responded to it either consciously or unconsciously. Having abandoned the restrictive cultural environment of the official Salon, and having chosen instead to address the public in the medium of print, Fragonard was in a better position to respond to these new ideas than any other important artist of the period.

Yet this "public" discourse placed a strong emphasis on private experience and solipsistic subjectivity. Examination of another art, namely music, can elucidate this issue. The clearest instances of early Romantic music, from the so-called *Sturm und Drang* movement of around 1770, are symphonies, a form of public music par excellence.[29] The combinations of driving rhythms and surging, tormented melodies in minor keys with wide interval leaps in the first movements of these works sound to the modern listener — and most probably did to their contemporary audiences, too — as representative of tragic feelings and intense emotions. However, the brief period of these symphonies' popularity indicates that such subjective effects constituted a *fashion* — which by definition is a particularly *public* phenomenon. A similar phenomenon can be found in the reaction of the audiences at the Paris Opera in the 1770s and 1780s, as detailed in James H. Johnson's *Listening in Paris*.[30] Johnson shows that in those decades audiences gradually stopped conceiving of the Opera primarily as a setting for socializing; rather, a new need began to be felt for a higher attentiveness on the part of the listener to the music itself. This new attentiveness broke down what had been a communal activity into one of individual subjectivity, as each audience member endeavored to listen to and be absorbed by the music, while attempting to forget the existence of his or her peers undergoing similar experiences in the neighboring seats. The experience was then exteriorized through exaggerated — and ostensibly visible — shows of emotion, tears, and so on; displays that made public these "private" emotions.

Such an overlaying of private experience onto a public setting had no direct parallels in the official displays at the Salon, where history paintings such as David's *Horatii*, aimed at the "public" constructed by the critics, were intended to arouse a communal moral response. It could be argued that the *Horatii*, in the distinction it draws between the men's and the women's attitudes, as well as David's later *Lictors Returning to Brutus the Bodies of His Sons*, specifically depicts the conflict between the private and public spheres, and that these works contain at least certain elements (the women's grief in the *Horatii*, Brutus's conflicted sentiments) which were meant to be experienced empathetically by each member of the public individually. While this is an important qualification, in both of these images it is ultimately the public duty that triumphs, and it is the very necessity of that triumph that is thematized. While David sublimates a private feeling into a public duty, the Opera performances worked the other way around, providing the public setting for the experience of a private sentiment, a sentiment that was not then resolved into any kind of communitarian duty.[31]

Despite the change of venue from a public hall to a private residence, early Romantic novels such as *La Nouvelle Héloïse* and prints such as the Allegories of Love were like music in incorporating the new dichotomy between the public and the private. The occasional quoting, in mixed company, of a line from Rousseau or the hanging of a framed engraving of *The Fountain of Love* on one's dining room wall came closer to the public displays of emotion at the Opera than anything that was possible in the festival atmosphere of the Salon. Even in the privacy of his or her room, a reader of Rousseau could be expected to react to moving passages with emotional displays that were no less deeply felt for being already codified as part of the early Romantic sensibility. Such an appropriate "private" response to the representation of love is depicted in Bernard d'Agesci's painting *Lady Reading the Letters of Héloïse and Abelard* of around 1780 [Figure 11]. The painting's protagonist is clearly led to swoon by the amorous passion she finds in her reading, and doubtlessly the painting is also meant to recall Rousseau's book, which not only

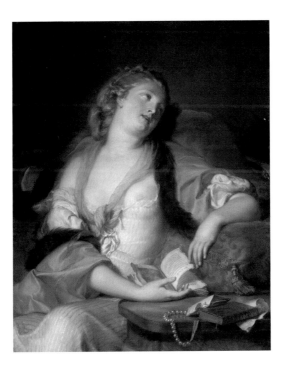

FIGURE 11
Bernard d'Agesci (Auguste Bernard) (French, 1756–1829), *Lady Reading the Letters of Héloïse and Abelard,* circa 1780. Oil on canvas, 81.3 × 64.8 cm (32 × 25½ in.). Art Institute of Chicago, Mrs. Harold T. Martin Fund; Lacy Armour Endowment; Charles H. and Mary F. S. Worcester Collection, 1994.430.

in its title but also in its epistolary form and theme was intended to recall the star-crossed medieval lovers.

Focused on their own concept of what constituted "the public," the Salon critics simply could not (or refused to) grasp the existence of a complex audience that paradoxically intertwined the notions of public and private, and therefore they dismissed it, as do contemporary art historians with the same ideological views. However, an understanding of this audience is crucial if we are to interpret Fragonard's Allegories of Love correctly in their social and cultural context.

THE ALLEGORIES, ROMANTICISM, AND "PREROMANTICISM"

As a major theme of this book is the relationship of the Allegories of Love to Romanticism, it would seem imperative to define Romanticism itself before going further. Unfortunately, the concept is notoriously slippery. In 1965 in his Mellon lectures on the roots of Romanticism, Isaiah Berlin quoted Northrop Frye to the effect that "whenever anyone embarks on a generalisation on the subject of romanticism…somebody will always be found who will produce countervailing evidence" from different sources.[32] Berlin himself gives a two-page list of (often mutually contradictory) examples of what Romanticism is or can be said to be. While some of the notions on the list clearly fit Fragonard's Allegories—"desire to live in the moment, a sense of timelessness, intoxicating dreams"—clearly many others, such as "Satanic revels, cynical irony, diabolical laughter," do not.[33] Berlin points out that many previous writers, such as A. O. Lovejoy and George Boas, gave up in despair at the possibility of ever defining the movement; nevertheless he argues that "[t]o say of someone that he is a romantic thinker or a romantic hero is not to say nothing." That is to say, an intuitive knowledge of what does or does not belong under the concept remains and, though it might not fit into a two-line definition, what constitutes Romanticism can ultimately be unraveled "by slow and patient historical method."[34]

That the adjective "Romantic" does indeed apply to the Allegories has been suggested by art historians before now; however, since these observations were often made in passing, none of the writers felt the need further to define the term as it applies to Fragonard's paintings. But while they lack definitions, these testimonies are highly instructive. For example, in an article dedicated primarily to The Sacrifice of the Rose, Richard J. Campbell argues that the Allegories "occupy a higher plane of conception and emotion than the work of his contemporaries…Fragonard's special talent was the ability to transform sensuality into raw passion. In this respect, his oeuvre anticipated the concerns of the great Romantic artists of the nineteenth century."[35] Eunice Williams, discussing the drawing of The Invocation of Love in her 1978 exhibition catalogue, found that Fragonard combines in it "forceful neoclassical form with a theme which anticipates nineteenth-century romanticism's preoccupation with intense feeling."[36] Finally, Jean-Pierre Cuzin, in his monograph of 1987, was led by Fragonard's new emphasis on the "nocturnal" to categorize the Allegories of Love as belonging to "a new register, that of romanticism."[37]

Even based on this short list it is possible to gather from the Allegories some concrete qualities that might warrant the application of the term. Specifically, a preoccupation with "raw passion" or "intense feeling" has always been seen as defining the Romantic move-

ment: An anonymous reviewer of the Salon of 1827 wrote of "that new school which aims at the faithful representation of strong and affecting emotions which is rightly or wrongly called the Romantic School."[38] As for the focus on the nocturnal elements of life, that, too, has often been cited as an element of Romanticism.[39] This emphasis places Fragonard not only in the company of a number of French writers of the period, such as Claude-Joseph Dorat and Joseph-Marie Loaisel de Tréogate, in whose works the preoccupation with night scenes, as well as the relationship between darkness and heightened passion, comes to the fore, but also in the company of the German author Novalis, whose *Hymns to the Night* constitutes perhaps the ultimate expression of this Romantic obsession. To acknowledge the nocturnal nature of Allegories is to notice the difference between their chiaroscuro and the bright, even light of the Rococo, thereby placing the late work of Fragonard not in the company of Boucher but in that of Prud'hon [*see* Figure 2], Gros [*see* Figure 73], Ary Scheffer [*see* Figure 74]—and even Henry Fuseli. The change from day to night in Fragonard's work can also be seen in metaphorical terms: day standing for the reason and clarity of the Enlightenment and night for Romanticism's irrationality (which relates to the higher stress on passion).

The stress on passion was also the key argument in the commentary of the first art historian to apply the sobriquet "Romantic" to the Allegories of Love—Louis Hautecoeur—who did so in an article of 1928 devoted to the "origins of Romanticism." In surveying the representation of "the fortunes of love" in eighteenth-century painting, Hautecoeur saw Fragonard as the first artist to have transcended the formulas of the Rococo to move in the direction of a more direct representation of erotic passion: "A few painters, at least, were not satisfied with libertine symbols à la Boucher: when Fragonard depicts the *Fountain of Love,* he animates his protagonists with a kind of ardor, he casts them forth with a kind of transport that is already Romantic."[40] Hautecoeur's meaning is clear: Fragonard abandons the conventionalized, coy double entendres of Boucher's paintings, replacing them with a new kind of passionate intensity, and thereby transcends the Rococo style with which he is usually identified. Indeed, Hautecoeur believes he can already find in the Allegories of Love the exalted gestures and intense emotionalism commonly thought to be typical of later Romantic painting: "All those exaggerated gestures that are imputed to the Romantics were already executed by the artists of 1775 or 1780…The *Oath of Love* by Fragonard is accompanied by convulsive tremors."[41] According to Hautecoeur, Romanticism proper will do no more than continue the achievements of Fragonard and Watteau, although it will do so on the other side of the (temporary) abyss—or aberration—that was Neoclassicism.[42]

Hautecoeurs's article evinces the direct influence of the then-recent concern among French literary historians for the new category of "Preromanticism." This term seems to have arisen in Daniel Mornet's 1907 *Le Sentiment de la nature en France de Rousseau à Bernardin de St. Pierre* and found its most systematic expression in André Monglond's work in the 1920s.[43] Rather than using the term to mean simply the period preceding Romanticism (in which sense it has sometimes been applied to almost the entire second half of the eighteenth century, including such un-Romantic authors as Laurence Sterne and Diderot), scholars such as Mornet and Monglond employed it to name those various elements of French culture, particularly literature, between the time of Rousseau and the French Revolution which could already be seen to incorporate the characteristics that would later

define Romanticism proper, which, in France, had traditionally been understood to start only in the 1820s. Preromanticism, then, rather than being opposed to Romanticism, was seen as an early variant that corresponded closely with the onset of the movement in other countries: for example, Johann Wolfgang von Goethe's "Romantic" novel of 1774, *The Sorrows of Young Werther,* is virtually indistinguishable in its emotional emphases from much of the literature produced in France in the 1770s and 1780s by Rousseau's followers.

Monglond's historical schema is identical to Hautecoeur's: Flourishing in the wake of Rousseau, the new emphasis on emotion and on the irrational begins to recede with the approach of the Revolution and the rise of Neoclassical poets such as Lebrun-Pindare and André Chenier.[44] At the beginning of the next century, Romanticism proper is seen not so much as having restarted as having continued the impulse of the Preromantics: "From Preromanticism to Romanticism, the continuity is obvious."[45] Monglond is also important because he was primarily responsible for the critical rehabilitation of most of the writers in whose works are found the closest parallels to the iconography and atmosphere of Fragonard's Allegories. Principal among these are the novelists Claude-Joseph Dorat (1734–1780), Joseph-Marie Loaisel de Tréogate (1752–1812), and Nicolas-Germain Léonard (1744–1793) and the poets Evariste de Parny (1753–1814), Antoine de Bertin (1752–1790), and Philippe-François-Nazaire Fabre d'Eglantine (1755–1794).

Several criticisms have been raised against the use of the term "Preromanticism." Since the 1930s, the term has fallen out of fashion, at least in French literary history, most often victim to an ideological critique that sees in the establishment of a cultural continuity between the late ancien régime and the early nineteenth century a political maneuver intended to obscure the achievements of the French Revolution. As Jean Deprun remarked at a 1972 colloquium devoted to the issue: "the notion of Preromanticism is not innocent, because it establishes a continuity there where there is a rupture…this rupture which the notion of Preromanticism tends to camouflage, to make occult, to atomize, depending on what theoretical vocabulary one chooses to adopt, is the Revolution of 1789."[46] Bronislaw Baczko provided an important rejoinder, pointing out that the rise of a new cultural paradigm in the second half of the eighteenth century is an incontrovertible fact: "It happens to be the case that at a certain moment, probably toward the middle of the eighteenth century, one can observe at the level of texts, but also at that of collective manners of thinking, believing and feeling…diverse phenomena which enter into opposition with dominant culture and which—and this is an important aspect—do not seem intelligible. It is then a matter of understanding them starting from such an opposition."[47] It is the notion of an opposition to dominant culture that is important for our present purposes. After 1767 Fragonard espoused at the very least a policy of quiet resistance to the official institution of the Salon, which for all intents and purposes was organized to exhibit the dominant culture when it came to the visual arts. Whether such a resistance carried any further ideological meaning, or is simply attributable to professional motives, and the relationship between such a resistance and the specific pictorial idiom of the Allegories of Love, are two of the principal questions of this study.

Art history, at least when concerned with French art, has had little use for a historical rubric equivalent to literary history's Preromanticism, and perhaps appropriately so: In late-eighteenth-century France there is very little visual evidence that could be placed in such a category (the designation when used here refers strictly to the writers identified

by Monglond and others).[48] The difference between the situations in literature and art history can be perhaps explained by the utter domination, in the visual arts, of the Royal Academy and its Salon. Given the prestige of the institution and of the biennial exhibition, there were few artists of any talent who refused to participate in the Academy's activities, and those who did participate generally followed the paradigms of the dominant visual language, as imposed on the one hand by the Academy and on the other by the (increasingly vociferous) Salon critics. This official language was above all a public language and allowed no space for the intimate exploration of private feelings that was the stock in trade of the Preromantics. The situation in literature was of course more fluid, with no central authority successfully controlling the circulation of works between authors and their public. If even a small fraction of Fragonard's work can be said to have belonged to a primarily literary category, this may be explained by his peculiar position in the art world during the late 1780s. Since he withdrew his participation from the Salon in favor of working directly for private patrons and for the print trade, his situation was closer to that of an author than to that of most painters at the time. This situation also helps explain why Fragonard's Allegories have parallels in the book illustration of the period, while, in painting their style would first find analogues in the post-revolutionary style of Prud'hon and of some of David's students.

THE ALLEGORIES OF LOVE:
FORM, ICONOGRAPHY, AND SOURCES

Before considering the Allegories in their wider social context, let us examine more closely each composition from the point of view of its formal characteristics, its art-historical sources, and its iconography. Such close analysis will show not only Fragonard's dependence on earlier traditions but, more importantly, identify the novel elements the Allegories introduced into his oeuvre and, more generally, into eighteenth-century French painting. It is these new elements that locate this series of compositions squarely within its specific cultural moment and enable us to see them as a coherent series, formally and iconographically distinct from the rest of Fragonard's output.

THE OATH OF LOVE

The Oath of Love (*Le Serment d'amour*) has survived in two versions, an oval painting in an English private collection [Figure 12][49] and a poorly preserved rectangular work in the Fragonard Museum in Grasse [Figure 13].[50] The Buckinghamshire picture is probably the one that was engraved by Jean Mathieu in 1786 [Figure 14], thus providing the earliest date we have for any of the versions.[51] There is also an exquisite preliminary drawing for the composition in pen and wash [Figure 15].[52]

The composition depicts a shadowy garden grove in the center of which a couple in contemporary dress embraces passionately. Both the man and the woman are golden-haired and clothed in ivory and gold fabrics, contrasting with the darkness around them. The man's right arm, extended behind him, touches a large stone tablet on which are inscribed the words: Serment d'aime[r] toute sa vie—"Oath to love for one's entire life." The tablet is held up by three cupids above a fountain's small waterfall; the cupids themselves float on clouds of steam rising from the fountain. Given the almost monochromatic tones in which they are painted, as well as the condition of the Grasse version, it is hard to tell whether the cupids were meant to be flesh- or stone-colored; that is to say, whether they are allegorical apparitions or simply emblematic statues similar to the ones in the Louveciennes cycle [*see* Figure 9]. Behind the fountain a seated statue of an adolescent Eros, leaning on his quiver, looks down benevolently on the couple. On the other side of the picture, the torso of a sculptured nymph, atop another fountain waterfall, also gazes

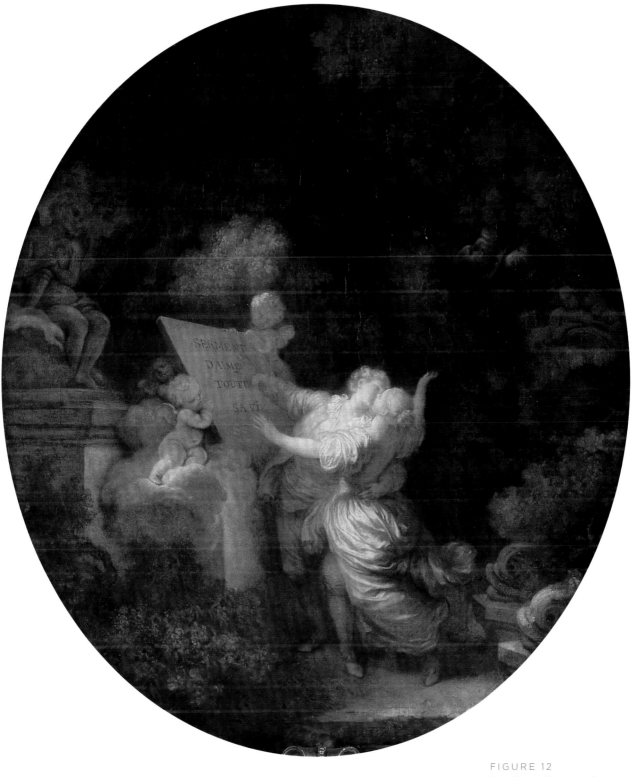

23

FIGURE 12
Jean-Honoré Fragonard,
The Oath of Love, circa 1780.
Oil on oval canvas, 62 x 54 cm
(24 ³/₈ × 21 ¹/₄ in.). Bucking-
hamshire, Rothschild
collection, 287.1997. Photo:
Mike Fear/ © The National
Trust, Waddesdon Manor.

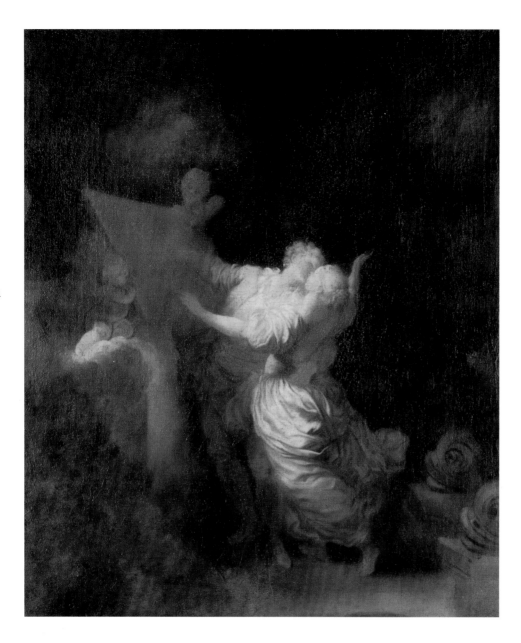

24

at the lovers.[53] The flat ground on which the protagonists stand is defined at the bottom of the picture by a step or ledge, which identifies the grove as a man-made garden terrace. The heads of two stone dolphins, protruding from the picture's right edge, indicate the entrance to the terrace. The background of the picture is filled by wild, rich forest foliage, here and there broken up by bare branches and two massive, leaning tree trunks.

Strong highlights—what at the time were called *effets de lumière*—pick out of the grove's darkness the heads of the two protagonists, the man's upper torso, the woman's left shoulder, most of her arm, her dress from the waist down almost to her ankle, the legs of one of the cupids, together with a patch of the steam cloud he is leaning on, and (in the English picture only) the top of another cupid's head—not to mention the ground between the lovers' feet and the ledge at the bottom of the picture. Such highlights, along with a few other scattered ones in the trees in the picture's background, are what Diderot referred to as *réveillons:* willful sprinklings of brightness whose distribution has more to do with the pleasing patterns they form across the picture plane than with any laws of optics.[54]

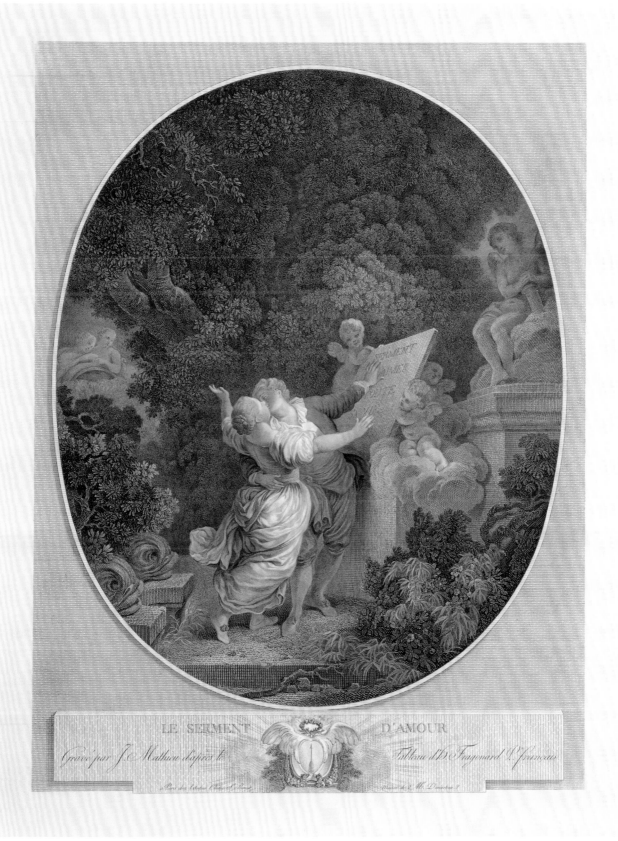

LE SERMENT D'AMOUR

Gravé par J.C. Mathieu d'après le Tableau M.D. Fragonard Pr. français

à Paris chez les Associés Chalco. St. Morel Membre de S. M. Directeur?

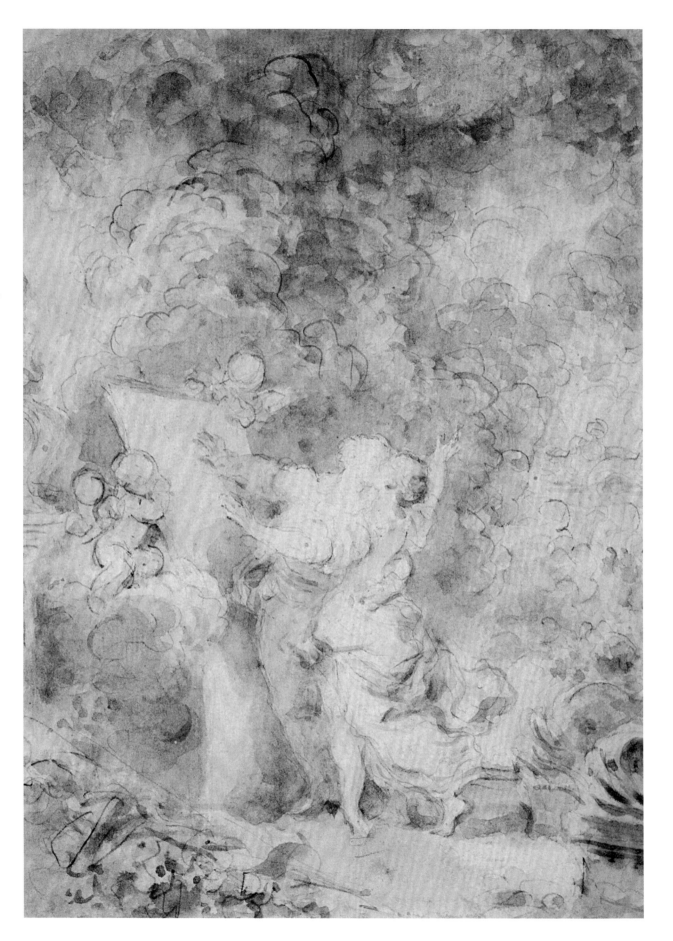

Refusing to unify themselves into a solid mass of light, they contribute to the picture's *papillotage* (confetti-like aspect), [55] which was seen at the time as an attribute of the *style moderne,* or Rococo, paintings, as opposed to the *style ancien,* the Neoclassicism that was coming into vogue. What distinguishes the painting from Fragonard's high Rococo style, as exemplified in the Louveciennes panels, is the depth of the background shadows, which lend the scene an early Romantic sensibility, together with the more muted, earth-toned palette (as opposed to the earlier images' emphasis on brighter, primary colors), as well as the generous use of sfumato, which helps soften the sharpness of the light-dark contrasts. (Fragonard's sfumato, by the way, seems particularly influenced here by Correggio—an influence that will become even clearer in the later Allegories, and which can also be seen in the works of such Napoleonic-era painters as Pierre-Paul Prud'hon and Anne-Louis Girodet, which derive, at least partly, from the Allegories.) In its formal aspects, then, *The Oath of Love* already effects a transition from Rococo to Romanticism, seeming to skip the Neoclassical style that is supposed to come in between the two (at least in the conventional narrative of the period's stylistic changes).

If not actually the earliest of the Allegories of Love (it is impossible at this point to determine the exact order in which the compositions were invented), *The Oath of Love* is nevertheless conceptually the least advanced of the four. The couple's modern dress is dissimilar from the classicizing draperies and diaphanous veils of the protagonists in the other pictures. Furthermore, the *Oath*'s depiction of a gallant couple in an overgrown garden grove surrounded by fountains and emblematic statuary places it in the direct lineage of the Louveciennes pictures. As such, it marks the transition between Fragonard's earlier representations of the play of love and the more intense elaborations of the later Allegories.

The novel elements that *The Oath of Love* introduces into the pictorial vocabulary of the earlier gallant depictions will largely come to define the entire series of Allegories. A certain sense of chiaroscuro had always been a characteristic of Fragonard's painting, from the early *Cephalus and Procris* of 1755 on, reaching an apogee in the *Coresus* of 1765 [*see* Figure 6]; yet the depth of the shadows here, as well as the diaphanous treatment of the *effets de lumière* is closest in character to the smoky, mysterious character of the lighting developed in Fragonard's religious pictures of the second half of the 1770s, such as *The Visitation* [Figure 16] or *The Adoration of the Shepherds* [Figure 17], where a similar employment of hazy sfumato to give coherence to a picture plane otherwise strongly divided by shadows and lights can be found. Along with this purely pictorial technique, the mystical sense of religious awe in those pictures is transferred, in *The Oath of Love,* to a much earthier passion—a passion which is thereby raised to a degree of intensity never before seen in Fragonard's depictions of love or lovemaking. Such an intensity of feeling is strengthened by the stance of the lovers; united in a single, twirling movement of limbs and draperies, they form what Diderot might have called a hieroglyph for the emotion the picture is meant to depict.[56] In this way the figures transcend the anecdotal arrangements of those in the Louveciennes pictures. Such an evolution from the anecdotal representation of amorous feeling to an intensification of each pictorial element (brushstroke, chiaroscuro, composition, and body stance) in order to express directly the depicted passion is continued and elaborated in the other Allegories. From a narrative point of view, the protagonists in the *Oath* seem much more generic than those in the Louveciennes pictures;

FIGURE 15 27
Jean-Honoré Fragonard, *The Oath of Love,* 1780–85. Brown ink and brush with brown wash over black chalk on paper, 22.5 × 17 cm (8⁷⁄₈ × 6³⁄₄ in.). Private collection.

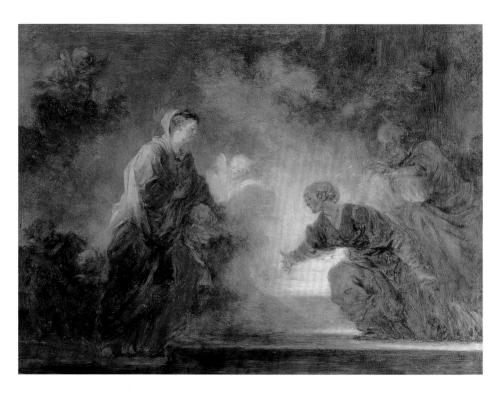

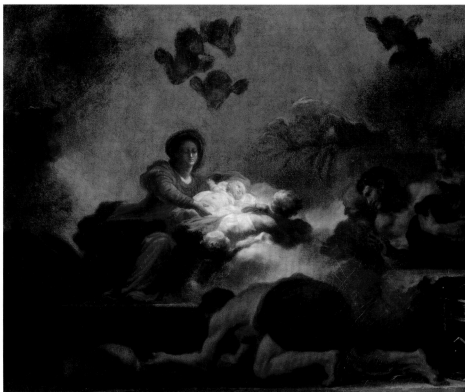

FIGURE 16
Jean-Honoré Fragonard,
The Visitation, circa 1775.
Oil on canvas, 24.1 × 32.4 cm
(9½ × 12¾ in.) Private collec-
tion, France. Photo courtesy
Doyle New York.

FIGURE 17
Jean-Honoré Fragonard,
The Adoration of the Shep-
herds, circa 1775. Oil on
canvas, 73 × 93 cm (28¾ ×
36⅝ in.). Paris, Musée du
Louvre, R.F. 1988–11. Photo:
Erich Lessing/Art Resource,
New York.

they are no longer characters in a narrative genre painting, but, as befits an allegorical subject, they are ideal types, embodiments of all lovers at all times who have vowed that their love would last forever.

THE INVOCATION TO LOVE

The only finished version of *Voeu à l'amour,* or *The Invocation to Love,* is in a New York private collection [Figure 18].[57] A small oil sketch for the composition, stunning in the boldness of its brushwork, is in the Louvre [Figure 19], and two drawings (which are probably not preparatory sketches but records of the composition) are in Cleveland [Figure 20] and Princeton, New Jersey [Figure 21], respectively. Neither the oil sketch nor the drawings record significant variations from the finished composition.

The *Invocation* is the earliest of the Allegories to be documented. A drawing sold on December 3, 1781, was described in the sales catalogue as "a young girl invoking love, at the foot of its statue; the background presents an attempt at a landscape."[58] This description certainly fits the composition under discussion here, as does the description of another, or perhaps the same, drawing, sold in 1783: "a young girl throwing herself at the foot of the statue of love, in a garden grove."[59] The *Invocation* differs from the other Allegories in several aspects. It is the only one that was not commercially engraved (only an extremely rare, undated and unsigned stipple engraving has been found, which does not seem to have been advertised in the press).[60] It is also the only one to have been painted on a horizontally oriented canvas. From the point of view of subject matter as well as of pictorial treatment, however, the *Invocation* clearly belongs in the company of the other Allegories.

Of the four, the *Invocation* has the simplest as well as perhaps the most effective composition. It focuses on a young girl, her flowing robes in a state of disarray, rushing toward a statue of a seated adolescent Eros placed atop a high round pedestal. The girl's body, seen from her right, runs perfectly parallel to the picture plane, thus lending the image the strong planarity associated with the Neoclassical movement. This classicizing flavor is also emphasized by her dramatic stance, derived from ancient sources. Her head is thrown back, one arm is bent back to hold a fold of drapery close to her face and the other arm stretched ahead of her. Her bent left leg seems nearly, but not quite, to rest on a flower- and grass-covered ridge of earth around the pedestal's base. Otherwise, her body is almost arrow-straight, from the toes of her right foot to her outstretched right palm, making about a forty-five-degree angle with the ground. The line of this angle continues along the statue's principal axis, ending with its raised arm. A strong diagonal, cutting across the picture from the lower left to the upper right, is thus established as the defining element of the painting's composition.

Golden-haired, the girl is clothed in a white, high-waisted, flowing dress, distancing the scene from the modern world and placing it in the ancient past. Working toward the same effect, the Cleveland drawing also provides the protagonist with laced Roman sandals, traces of which are visible only faintly in the finished painting. The figure is further wrapped—very loosely—in a heavier, golden cloth or mantle, which cushions her contact with the statue's pedestal while also swirling behind her, accentuating the energy

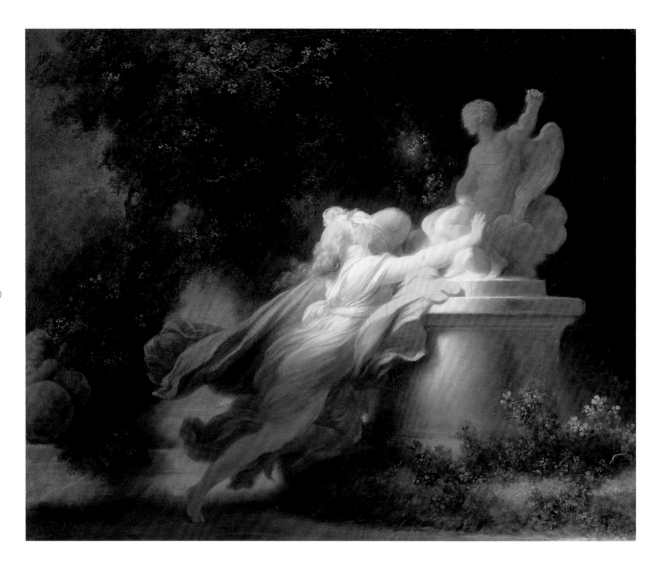

FIGURE 18
Jean-Honoré Fragonard,
The Invocation to Love,
1780–85. Oil on canvas,
52 × 63 cm (20$^1/_2$ × 24$^3/_4$ in.).
Private collection, New York.

FIGURE 19
Jean-Honoré Fragonard,
The Invocation to Love,
1780–85. Oil on panel,
24 × 33 cm (9½ × 13 in.).
Paris, Musée du Louvre,
R.F. 1722. Photo: Erich Lessing/
Art Resource, New York.

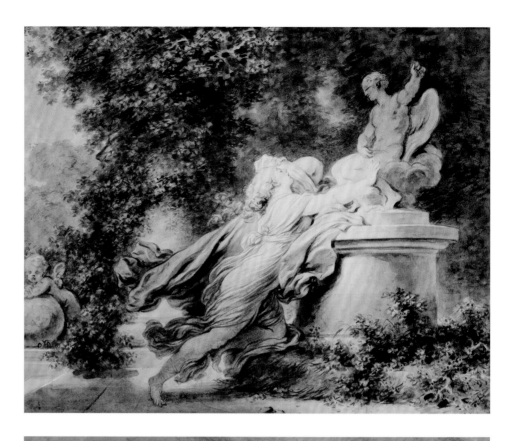

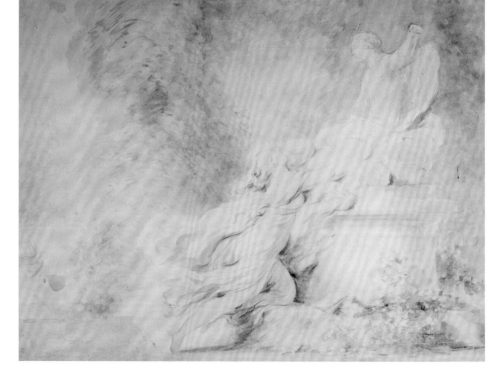

FIGURE 20
Jean-Honoré Fragonard,
The Invocation to Love,
1780–81. Brush and brown
wash over graphite on paper,
33.5 × 41.6 cm (13⅛ ×
16⅜ in.). Cleveland Museum
of Art, Grace Rainey Rogers
Fund, 1943.657.

FIGURE 21
Jean-Honoré Fragonard,
The Invocation to Love,
1780–85. Pen and sepia ink
and wash over black chalk on
paper, 35.4 × 46.3 cm (13¹⁵⁄₁₆ ×
18¼ in.). Princeton University
Art Museum. Gift of Miss
Margaret Mower for the Elsa
Durand Mower Collection,
x1965-37.

of her movement. The color scheme of her robes and hair echoes that of the embracing couple in *The Oath to Love.*

The *"intention de paysage"* (attempt at a landscape) in the picture's background suggests an overgrown garden grove similar to the one in *The Oath to Love.* Square paving stones cover the ground, while behind the girl's flowing robes can be seen the base of a stone column, the thick shaft of which disappears into the dark foliage. Next to the column, cut off by the picture's left edge, is a statue of Cupid lying atop a sphere or globe, perhaps symbolizing Love's all-powerful rule over the world. Above this statue, along the picture's edge, a break in the trees shows only a dark, amorphous sky.

The picture's overall darkness is broken up by the use of *effets de lumière* analogous to the ones in *The Oath to Love;* as opposed to that picture, however, practically no highlights appear in the background foliage. The brightest areas are concentrated in the center of the composition, creating a unified pool of light which encompasses the upper half of the girl's body, the knees of Eros, and a part of the statue's pedestal. The effect is highly artificial—reminiscent of nothing so much as a theatrical spotlight. Yet in its very artificiality it helps make explicit one of the principal uses to which Fragonard puts his overemphatic chiaroscuro: He employs it not so much to stress the physical reality of the depicted bodies, as to pick out the principal elements of the picture's narrative.

Studying the chiaroscuro's distribution across the picture plane reveals that it has another use as well. The other parts of the composition that capture the light—although they cannot compete with the utter brightness at the picture's center—are close to the bottom edge; they include part of the paved terrace and the column's base and lower shaft, as well as a patch of the grassy ridge on which the statue's pedestal rests. Together with the spot-lit center, they form a pyramid across the picture plane. However, this stable form is thrown off balance by the brightness of the statue of Cupid, which, despite its placement in the shadows, still seems to glow by virtue of the marble's whiteness. This formal tension echoes the protagonist's rushed movement, thereby emphasizing her unbridled passion and adding to the melodramatic feel of her gesture.

Many sources have been proposed for the picture's iconography. The likeliest influence comes from Louis-Jean-François Lagrenée the Elder who, as Pierre Rosenberg points out, painted an *Invocation to Love* in 1775 for the duc de la Rochefoucauld-Liancourt [Figure 22].[61] Fragonard's own *Invocation* first appears in the same duke's 1827 estate sale; the duke himself may have commissioned Fragonard's version, taking Lagrenée's work as a model. Lagrenée's daytime scene presents a young woman, also in a high-waisted classical dress and a mantle, kneeling before a statue of Cupid. The statue,

33

FIGURE 22
Louis-Jean Lagrenée (French, 1725–1805), *The Invocation to Love,* 1775. Oil on canvas, 44.5 × 36 cm (17½ × 14⅛ in.). Private collection, Paris.

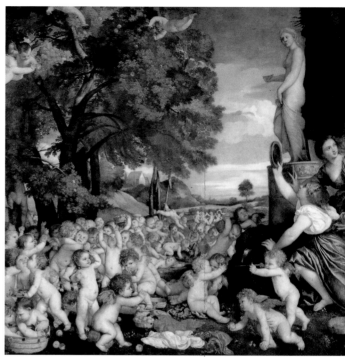

as in the *Invocation,* stands on a high, cylindrical pedestal, behind which, in this case, the real Cupid hides and listens to the young girl's prayer. Formal connections between the two compositions can be found in the stances of the two girls as well as in the relationship between their heavy mantles, which barely envelop their bodies, and their lighter dresses. Comparison to the Lagrenée also allows us to interpret the overgrown ledge around the pedestal in Fragonard's picture as the lowermost level of the base; the knee of Fragonard's maiden, resting on the ledge, as well as her raised arm, may be reminiscences of the praying pose of Lagrenée's figure. In all other ways, however, the girl's stance has been dramatically changed, from the languid slackness in the earlier painting to the tension in Fragonard's figure, taut as a stretched bow.

Lagrenée's picture in turn may have a source in a work by Jean-Baptiste Greuze, *Votive Offering to Cupid* [Figure 23], exhibited at the Salon of 1769. Greuze's painting also features a dark grove and a young girl kneeling before a statue of Cupid; it is easy to trace the continuity of the iconography from 1769 to 1775 to 1781. However, Fragonard's treatment of the theme differs significantly from those by his predecessors in reducing the amount of anecdotal or allegorical detail and allowing pictorial elements to carry a much larger portion of the picture's theme. Lagrenée's real-life Cupid and the crown held over the girl's head by Greuze's statue are eliminated, and Fragonard's protagonist expresses the intensity of her passion primarily through her violent movement, the tension of her body, her ecstatic facial expression, and the disorder of her clothes.

Where did Fragonard find the corporeal vocabulary he employs here? For one, the figure of the rushing girl is quite close to that of the bacchante at right lifting up a mirror to the goddess's statue in Titian's *Worship of Venus* [Figure 24], seen in the similarly raised arms, thrown-back heads, and diagonal axes of the bodies. While Fragonard did not have access to Titian's painting, Peter Paul Rubens's famous copy of it was at the time in Paris, where Fragonard could have studied it at leisure. Cornelius Vermeule has proposed

FIGURE 25
Roman Sarcophagus with
the Story of Medea, mid-
second century A.D. Marble,
65 × 22.7 cm (25⅝ × 8⅞ in.).
Berlin, Staatliche Museen,
Preussischer Kulturbesitz
Antikensammlung, ZV 1941.

FIGURE 26
Torso of a Dancing Maenad,
reduced Roman copy from
the first century A.D. after a
Greek model by Skopas,
circa 350 B.C. From Marino
(lago di Albano). Marble,
height: 45 cm (17¾ in.).
Staatliche Kunstsammlungen
Dresden, Skulpturensamm-
lung, Hm 133 (ZV 1941).

another source in a female figure found on several Roman sarcophagi depicting the story
of Medea, which may also have provided a source for Titian [Figure 25].[62] This figure itself
derives from even earlier images of bacchantes by Skopas and his many Greco-Roman
imitators [Figure 26].[63] Thus, we can posit an ultimate source for the stance of the *Invo-
cation*'s protagonist in images of religious, and primarily Dionysiac, ecstasy. Fragonard
improves on Greuze's and Lagrenée's timorous praying figures by adding to them the
drunken ecstasy and the energetic forward rush of the bacchante. The irrationality and

36

Le cruel poifon Ne glace plus mon ame,
De la raifon Je l'abandonne à toi.

S.t Quentin inv. D. Née Sc.

orgiastic uncontrollability of love are expressed in Fragonard's figure in ways at which his immediate predecessors did not even hint. The changing of the setting from day to night, and the recourse to atmospheric chiaroscuro, also significantly assist this transformation.

Another source for Fragonard's picture lies in a less lofty image, which emphasizes the irrationality of love even more clearly: an illustration to Jean-Benjamin Delaborde's *Choix de chansons mises en musique* (*Selection of Songs Set to Music*), of 1773 [Figure 27]. Fragonard surely knew this image since Delaborde, who was *premier valet de chambre* to Louis XV, as well as a *fermier-général,* was his close acquaintance and patron.[64] The *Choix de chansons* was a lavishly produced and illustrated collection of Delaborde's musical settings of poems by Voltaire, Claude-Joseph Dorat, Jean-Baptiste Rousseau, and others. The composition illustrates a song entitled "L'Amour Vainqueur de la Raison" (Love, Conqueror of Reason). The four lines from the song that serve as a caption succinctly summarize the picture's meaning: "The cruel poison / of reason / no longer freezes my soul / I surrender it to you."[65] While the scene is set inside a temple rather than in a forest grove, the print's depiction of a young woman throwing her entire body toward a statue of Cupid atop a high pedestal otherwise closely parallels the iconography of the *Invocation.* (The "you" in the verse can equally denote Cupid, or more generally Love itself, and a specific lover.) The inclusion of a fallen and broken statue of the goddess of wisdom further emphasizes the poem's theme. Love's triumph over reason is also inscribed in the woman's passionate posture; the *Choix de chansons* illustration, indeed, is the only one of the possible sources for the *Invocation*'s iconography that contains a sense of movement and imbalance similar to that of Fragonard's protagonist. No clearly emblematic detail such as the broken statue appears in Fragonard's picture (a further indication of the artist's tendency to de-emphasize the anecdotal or allegorical dimensions of his sources), yet it is easy to see that the figure of Fragonard's maiden carries the same meaning as the Delaborde song and its illustration: the irrationality of amorous passion, and its triumph over any impediments that might hinder its progress.

THE FOUNTAIN OF LOVE

The earliest documentation we have for the *Fontaine d'amour* is a December 1785 announcement in the *Mercure de France* for Nicolas François Regnault's print after it [Figure 28]. A sales catalogue of ten years later provides a good outline of the painting's iconography: "A grove in which is placed a fountain, surrounded by little Cupids holding out a cup to two young persons, who rush to drink from it so as to increase their amorous frenzy."[66] There are two finished versions of the composition: the one that the Getty Museum acquired in 1999 [*see* Figure 1] and another in the Wallace Collection in London [Figure 29].[67] A preparatory oil sketch for the composition is in an American private collection [Figure 30].

In *The Fountain of Love,* as in the other Allegories, the garden grove is darkened; the fountain in its center is circular and blanketed in clouds of steam. The man and the woman rushing toward it wear classical dress and crowns of roses in their hair. Their heads, torsos, and legs are almost parallel, making the man and the woman near doubles of one another.[68] The only differences between their stances are in the positions of their upper limbs. The woman has both her arms free, the left one stretched behind her and almost

FIGURE 27 37
François Denis Née (French, 1732–1817) after Jacques Philippe Joseph de Saint-Quentin (French, 1738–after 1780), *Love, Conqueror of Reason.* Illustration for Jean-Benjamin Delaborde, *Choix de Chansons mises en musique* (Paris, 1773). Engraving in bound volume. Williamstown, Massachusetts, Sterling and Francine Clark Art Institute. Robert Sterling Clark Collection of Rare Books.

OVERLEAF

FIGURE 28
Nicolas François Regnault (French, 1746–circa 1810) after Jean-Honoré Fragonard, *The Fountain of Love,* 1785. Engraving. Los Angeles, Special Collections, Getty Research Institute.

FIGURE 29
Jean-Honoré Fragonard, *The Fountain of Love,* circa 1785–88. Oil on canvas, 63.5 × 50.7 cm (25 × 120 in.). London, Wallace Collection, P394.

38

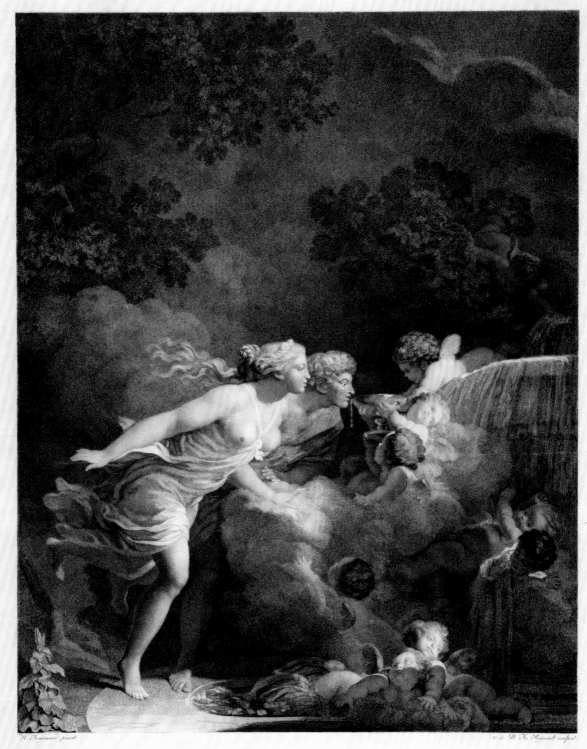

H. Fragonard pinxit. 2.e st. N. Fr. Regnault sculpsit.

LA FONTAINE D'AMOUR.

parallel to her leaning body, the right one bent, its forearm jutting forward, perpendicular to her torso. The man, however, has an arm around his companion's waist, while the other, bent across his chest, leans on a pillow of clouds before him, as on a table's edge.

The couple's left feet pound the circular stone border of a small water basin. In the basin's center is a fountain whose overall design, due to the clouds of steam that surround it, is impossible to discern; it seems to consist of a large round bowl, over the highlighted rim of which sheets of water fall. This rim, seen from slightly below, is at the same level as the runners' heads. The fountain and the basin are cut off by the picture's bottom and left edges. Of the great number of putti frolicking around the fountain, three—one leaning over the bowl's rim and the other two lying on the surrounding clouds—proffer a large cup to the running couple. The man, who is slightly ahead of the woman in the race, seems about to drink from the cup: his lips are only inches away from it. A moment later, undoubtedly, his companion will follow suit.

The upper two fifths of the composition are primarily occupied by foliage, unaccented by any *effets de lumière,* which opens at the upper left corner to let a dark, cloudy sky show through. The only highlight in this entire area is caught by the hair of the lone shadowy putto playing among the tree branches above the fountain's bowl. The rest of the painting's surface is characterized by the same kind of fractured chiaroscuro that appears in the other Allegories. A light shines from the upper left, illuminating the young woman's face, shoulders, and bare breasts, as well as her right forearm (together with the cloudy pillow on which her hand is lying), and the knee and foot of her left leg. The same beam also lays down highlights on some of the putti playing in the fountain, as well as on the faces of two of the putti playing in the basin below the fountain. While still well-lit, the male lover is darker-skinned than his companion, his darker tone helping to set off the brightness of her face and chest.

The cup from which the lovers drink is an ambiguous symbol in the metaphorical lexicon of the period: its meaning wavers between (spiritual) love and (physical) sex. For example, when the narrator of Loaisel de Tréogate's 1779 novel, *Dolbreuse,* tells us, "For the first time we drank deep from the elixir of love,"[69] that elixir is, as the context makes clear, metaphorical only of their innocent infatuation. Fifty pages later, however, the narrator uses the same metaphor on his wedding night, as he prepares to make love to his wife for the first time, or, as he puts it, "to empty through all my senses the cup of voluptuousness."[70] Similarly ambiguous are the rose crowns, which could symbolize either marriage or sexual consummation.[71] *The Fountain of Love* presents no obvious clues that could help us choose one of these meanings over the other. It is probably more useful to see this picture as symbolizing the more general category of passionate love (or, more specifically, Romantic love), of which infatuation, physical love, and marriage are all manifestations.

The fountain itself, as opposed to the cup of love, has fewer immediate precedents in eighteenth-century art or literature. A fountain of love figures, of course, in the medieval romance known as the *Roman de la rose,* but Fragonard's painting is free of the elaborate emblematizing that characterizes this thirteenth-century allegory. At most, one can suggest that the generalized symbol of such a fountain, having seeped from courtly literature into popular culture, found its way into Fragonard's scenario. More pertinently, a fountain, or spring, was an important plot device in Matteo Maria Boiardo's late-fifteenth-

century verse epic *Orlando Innamorato* and therefore was mentioned in its sequel, Ludovico Ariosto's *Orlando Furioso,* as an explanation for Rinaldo's love for Angelica.[72] As the over one hundred and sixty illustrations to Ariosto's epic that Fragonard drew sometime in the 1780s or 1790s testify, the painter was extremely well acquainted with this text, which may very well have suggested the subject to him (though the passage concerning the springs is not among the ones that Fragonard illustrates). Ariosto's mention is very brief ("two springs in the Ardennes, not far apart, whose waters produce diverging effects: the one inclines the heart to love, whereas love loses place in the heart of whomever drinks from the other"[73]) and thus cannot have furnished any of the iconographic detail that appears in Fragonard's painting.

Ariosto's two fountains—and especially the fountain of love—were featured prominently in a context chronologically and geographically closer to Fragonard, Jean-Baptiste Lully's 1685 opera *Roland,* with a libretto by Philippe Quinault drawn (rather loosely) from *Orlando Furioso.* Lully's operas continued to be performed in Paris throughout the eighteenth century, so Fragonard would have had many opportunities to see *Roland*—and indeed, given his interest in Ariosto, is very likely to have done so.[74] The opera's entire second act is set around the fountain of love, which here is used to explain Angelica and Medoro's love for each other (rather than Rinaldo's one-sided yearning, as in Ariosto). In the act's grand finale, cupids ("*amours*") appear, as well as other pairs of lovers who sing the praises of the amorous sentiment. The cupids sing, "Love calls you. / How beautiful is his flame! / Love calls all of you. / Love, love each other," and the lovers reply, "Who tastes of these waters can no longer keep himself / from following the laws of Love: / Let us taste it, thousands of times. / When one drinks of Love, one cannot drink enough."[75] While such sentiments may seem too operatic and artificial for Fragonard's protagonists, cupids uttering the call of love, as well as love's flame or passion (what the sales catalogue described as their "amorous frenzy"), can be readily identified in the composition.

Even more significant for our reading of the Allegories are three verses that appear later in the same scene: "Tender loves [or cupids], / enchant us forever. / Dreary reason, we shun your assistance."[76] Here is the same thematization of the conflict between love and reason identified in the illustration to Delaborde's song *L'Amour vainqueur de la raison,* and, by extension, in *The Invocation to Love.* As in that painting, the passionate stances of the *Fountain*'s protagonists encode the fiery intensity, and therefore the irrationality, of love.

Now, of course, the Lully opera predates the *Fountain* by exactly a century, and there is no empirical evidence, as exists in the case of Ariosto's epic, that Fragonard was aware of it. At most, the opera indicates that an iconographical symbol (the fountain) and a characteristic of the concept it symbolizes—the irrationality of love—had been associated long before Fragonard. Furthermore, any discussion of amorous "irrationality" needs to be placed in the cultural context, or contexts, of the specific works. When Lully and Quinault refer to the irrationality of love, they are connoting the more courtly, and less socially significant, *amour-passion* of the seventeenth century—a notion that certainly influenced the cultural paradigm of Romantic love that arose in the latter part of the eighteenth century but which cannot be equated with it. Nevertheless, an examination of these iconographic sources for Fragonard's painting makes clear both the Allegories' continuing dependence on Baroque and Rococo emblematic language and their transcendence of such simple

allegorical language in favor of connoting erotic passion more directly through pictorial elements such as bodily stances, lighting, and even brushwork.[77]

One last source for the *Fountain* can be found very close to Fragonard—indeed, in the same place where we found a source for the previous Allegory, Delaborde's *Choix de chansons.* There, another song tells the story of Iris who, in a fashion akin to Ovid's Pomona, has locked herself away from all possible suitors, refusing to love anyone; however, her resistance is defeated when she steps into "a garden made for the sweet mystery / of the play of cupids."[78] The plate accompanying the song sets the action in a formal French

98

Il vole avec empreſſement,
Lui jurer
Un amour qui ne peut changer ;

Le Bouteux pin. D. Neé Sculp.

FIGURE 31

François Denis Née (French, 1732–1817) after Joseph-Barthélémy Le Bouteux (French, born 1744), *Le premier souper de l'amour.* Illustration for Jean-Benjamin Delaborde, *Choix de Chansons mises en musique* (Paris, 1773). Engraving in bound volume. Williamstown, Massachusetts, Sterling and Francine Clark Art Institute. Robert Sterling Clark Collection of Rare Books.

43

garden with a Versailles-like palace in the background [Figure 31], although Iris is shown sitting under a clump of freer, more unkempt trees. Her future lover, dressed as she is *à la grecque,* comes running toward her in an attitude very close to that of the couple in *The Fountain of Love:* his drapery swirling behind him, he is preceded by three flying cupids carrying torches, enveloped by a cloud of vapors. The cloud obscures half of a classical fountain, the garden's centerpiece. The overall relationship of running lover, fountain, clouds, and putti closely parallels Fragonard's composition, and we may suspect that, once again, he found inspiration for it in the *Choix de chansons.*

THE SACRIFICE OF THE ROSE

The last and perhaps the best known (at the time it was created) of the Allegories is *The Sacrifice of the Rose.* At least two autograph versions of the finished composition exist, one in a private collection in Los Angeles [Figure 32], the other in a private collection in Paris [Figure 33].[79] (A third version, in the Museo Nacional de Arte Decorativo in Buenos Aires, has also been claimed as autograph [see Figure 34].)[80] Fragonard's brother-in-law, Henri Gérard, engraved the composition for the Société des Amis des Arts in 1790 [Figure 35]. Two oil sketches exist that include significant variations from the finished composition, as do several surviving drawings. The discussion that follows will focus first on the composition as engraved, then move on to the more relevant of these variations.

 The Sacrifice of the Rose is the only one of the Allegories not set in a tree-covered grove. In this case, shadows and clouds form the picture's entire background. A young woman, in a vaporous dress, is seated on a cloud close to a small cylindrical altar on which a rose has been placed. Supported by a small winged putto, she appears to be fainting. Upon deciphering the picture's allegorical elements, however, we can easily read her stance as orgasmic. An adolescent Eros, sweeping down into the scene, holds the young woman's right hand, while his head rests in the hollow of her arm. With a lit torch in his right hand he reaches out to burn the rose on the altar. Through a luminous break in the painting's background of dark clouds, a group of putti appears; one of them carries a (clearly symbolic) crown of flowers. The painting's chiaroscuro is the same as that which defines the other Allegories. In this case the light illuminates the body of the young woman rather homogenously, while also picking out the head, the shoulder, and the wings of Eros, as well as the first two putti entering the scene from the upper left.

 Of all the Allegories, the *Sacrifice* has the most elevated art-historical lineage. It is certainly the picture in the series most reminiscent of Correggio, particularly his *Jupiter and Io* [Figure 36], both in the treatment of the sfumato and chiaroscuro and in the ecstatic pose of the female figure. Fragonard's swooning maiden, however, has an even more direct source. Since the idea was first suggested by Edmond and Jules de Goncourt, it has become a cliché to see in her a salacious version of Gian Lorenzo Bernini's *Saint Theresa* [Figure 37], supposedly revealing the true, sexual nature of the saint's ecstasy. For his part, Eros is a direct descendant of the Mercury in Rubens's *Education of Marie de' Medici* [Figure 38], which Fragonard had numerous opportunities to study in the Luxembourg palace. The picture's overall setting, in its use of chiaroscuro to delineate a largely bare background, as well as in its conceit of putti descending into the scene through a luminous

FIGURE 32
Jean-Honoré Fragonard, *The Sacrifice of the Rose,* circa 1785–88. Oil on canvas, 64.1 × 54 cm (25¼ × 21¼ in.). Beverly Hills, Collection of Lynda and Stewart Resnick.

OVERLEAF

FIGURE 33
Jean-Honoré Fragonard, *The Sacrifice of the Rose,* circa 1785–88. Oil on panel, 54 × 43 cm (21¼ × 16⅞ in.). Private collection, Paris.

FIGURE 34
Jean-Honoré Fragonard, *The Sacrifice of the Rose,* circa 1785–88. Oil on canvas, 65 × 54 cm (25½ × 21¼ in.). Museo Nacional de Arte Decorativo, Buenos Aires, 322.

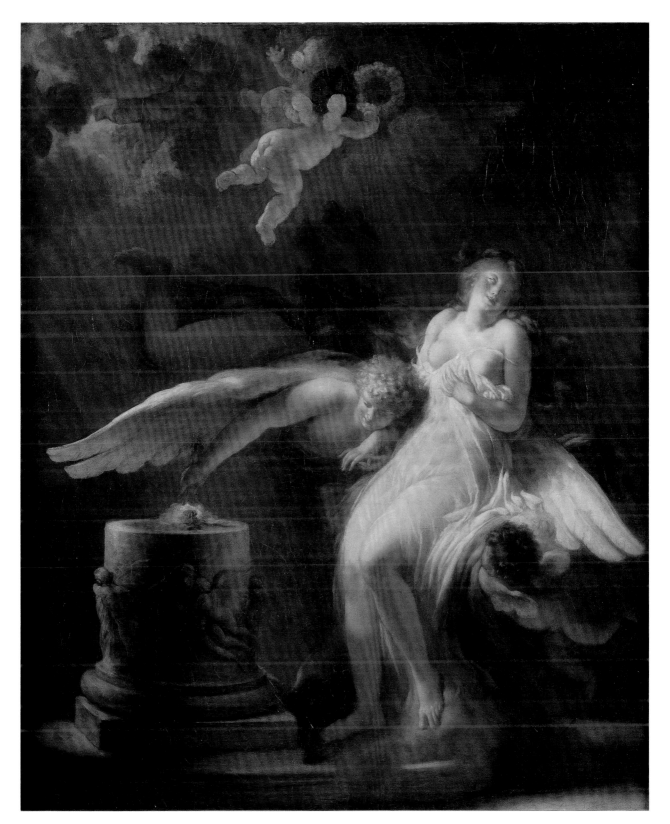

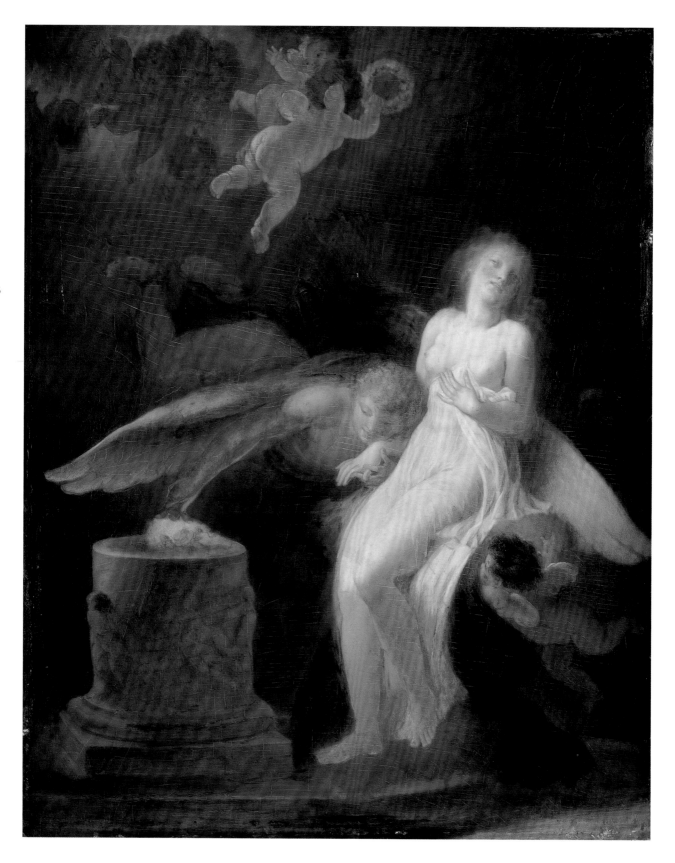

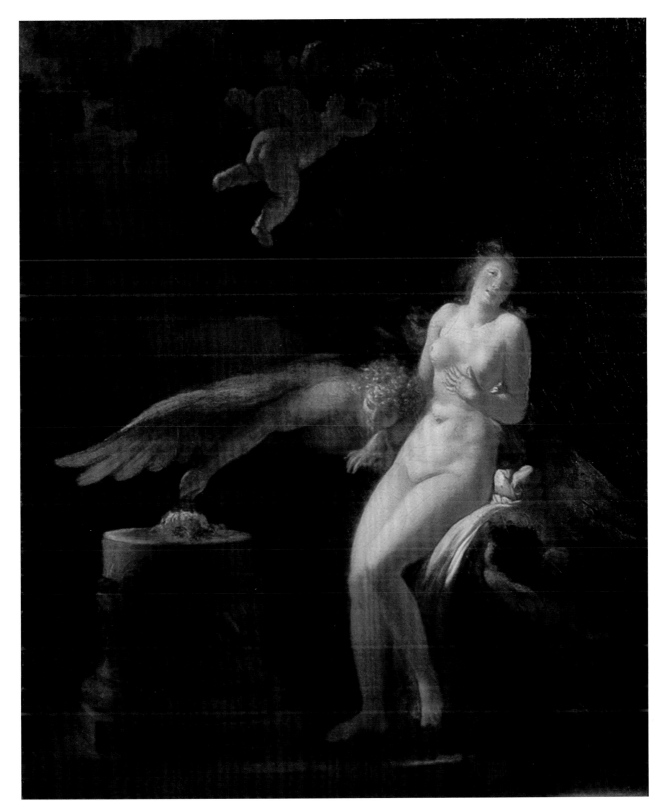

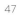

48

FIGURE 35
Henri Gérard (French, 1755–
circa 1835) after Jean-Honoré
Fragonard, *The Sacrifice of
the Rose,* 1790. Engraving.
Bibliothèque Nationale, Paris,
Cabinet des Estampes.

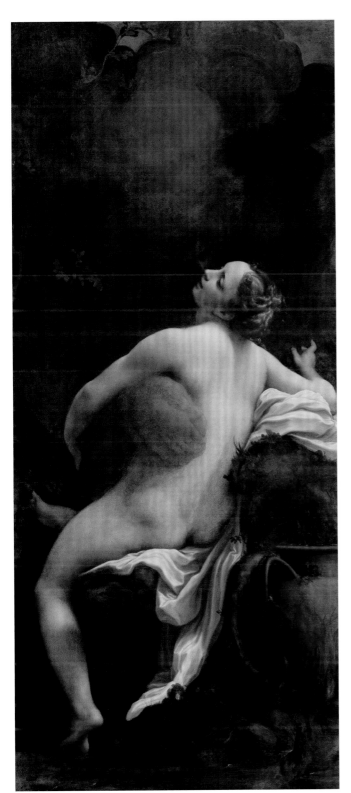

FIGURE 36
Antonio Correggio (Italian,
circa 1489–1534), *Jupiter and
Io*, circa 1530. Oil on canvas,
163.7 × 70.5 cm (64½ ×
27¾ in.). Vienna, Kunsthisto-
risches Museum, GG274.

FIGURE 37
Gian Lorenzo Bernini
(Italian, 1598–1680),
The Ecstasy of St. Theresa,
circa 1647–52. Marble.
Rome, Cornaro Chapel,
Santa Maria della Vittoria.

50 FIGURE 38
Peter Paul Rubens (Flemish,
1577–1640), *The Education of
Marie de' Medici,* 1621–25.
Oil on canvas, 394 × 295 cm
(12 ft. 11 in. × 9 ft. 7 in.).
Paris, Musée du Louvre, 1771.
Photo: Erich Lessing/Art
Resource, New York.

break in the darkness in the upper left-hand corner, derives from Rembrandt's *Holy Family
with Angels* [Figure 39], now in the Hermitage, which Fragonard had copied years before
[Figure 40].[81]

The earlier versions of *The Sacrifice of the Rose* differ so significantly from the
completed picture that they should be viewed as independent compositions in their own
right (this is the only one of the Allegories of Love for which this is the case). All of the
drawings, as well as one of the oil sketches, record a more planar composition than that of
the finished version. This quality brings these earlier compositions closer to the more Neo-
classical aspects of *The Fountain of Love* and *The Invocation to Love.* (Perhaps Fragonard
consciously chose to distance himself from such pictorial qualities in the final composi-
tion.) The earliest two drawings cast the composition in a horizontal, rather than vertical,
format. In what is probably the earlier of these works [Figure 41], Eros appears as an infant,

FIGURE 39
Rembrandt van Rijn
(Dutch, 1606–1669), *The Holy
Family with Angels,* 1645.
Oil on canvas, 117 × 91 cm
(46 × 36 in.). St. Petersburg,
The Hermitage. Photo: Scala/
Art Resource, New York.

FIGURE 40
Jean-Honoré Fragonard after
Rembrandt, *The Holy Family,*
circa 1755. Oil on canvas,
91 × 75 cm (35⅞ × 29½ in.).
Private collection.

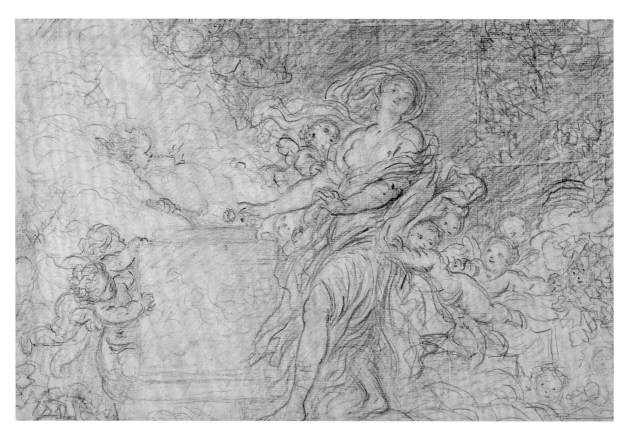

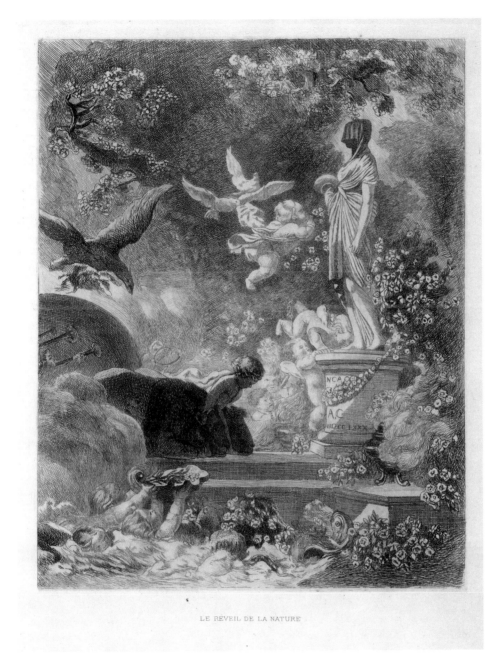

LE RÉVEIL DE LA NATURE

53

rather than as the adolescent figure of the later versions. The female protagonist in this drawing is closer to a standing position than her counterpart in the finished composition. With one hand she places her rose on the altar, while Eros, flying in from the left, burns it with his torch. The next drawing [Figure 42] records largely the same composition. Eros, however, has become an adolescent, and the girl's form approximates the swooning position of the final version. The generous use of washes over the drawing's ink lines gives it a much more atmospheric quality than its black-chalk predecessor, bringing it close to the nearly fairy-tale atmosphere of compositions such as the lost *Four Elements Paying Homage to Religion,* of 1780 [Figure 43].

Perhaps more important than these horizontal drawings are two vertical versions, either of which could have been converted into a very successful finished picture, and from both of which it is possible to garner iconographical details not used in the

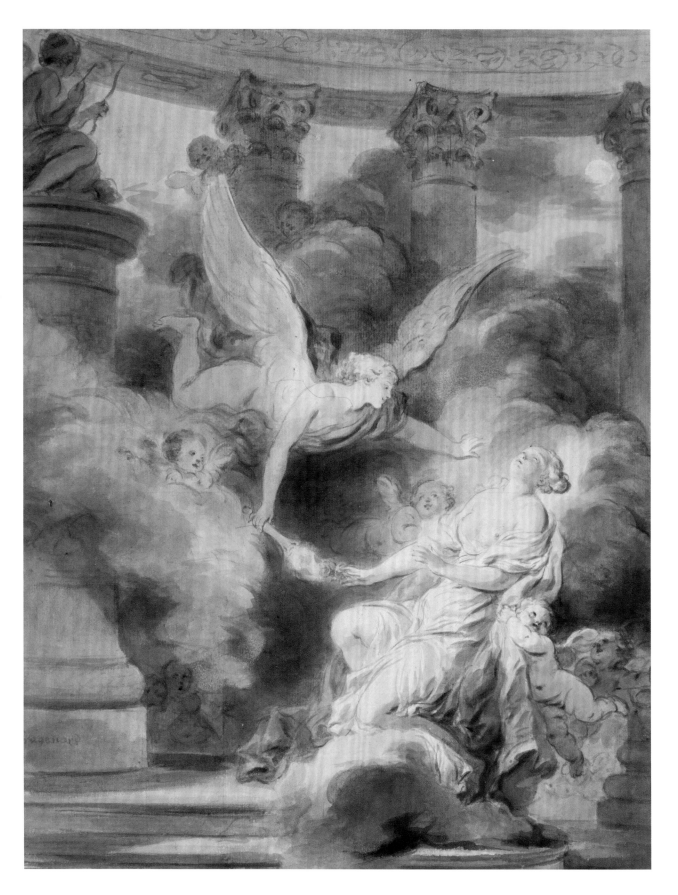

final version. A composition represented by a colored drawing in Minneapolis [Figure 44] and an oil sketch in a private collection [Figure 45] completely omits the small stone altar and shows Eros, now a much smaller figure within the overall design, touching his torch directly to the rose, which the young girl now holds in her hand. While the girl's ecstatic attitude is largely similar to that in the finished version, she reclines on a much more substantial pillow of clouds, some of which rise above her head and drift off into the picture's background. The scene is set at the foot of a statue of Eros on a high round pedestal, similar to the ones in *The Oath to Love* and *The Invocation of Love*. In the background three Corinthian columns support a curved entablature, suggesting that the scene is taking place inside a circular temple, the shape of which echoes the base of the statue. The statue's pedestal and the columns are wrapped in the dark clouds on which the girl rests. Between the two columns at the upper right, a full moon can be made out through the vapors.[82]

A different composition appears in an oil sketch [Figure 46] that relates quite closely to the finished version, with one significant variation. The ages and attire of the protagonists, as well as the overall stage décor—the circular altar, the lack of vegetation, and the inflection of the background through chiaroscuro alone—are exactly similar to those in the engraved state. Yet the picture presents a slightly later moment in time: Having made the young girl swoon, the adolescent Cupid now stands next to her and holds up her unconscious body, while his torch lies forgotten on the altar.

It is an interesting, though ultimately unanswerable, question as to how Fragonard, given all these options, decided upon the final version. Formally, he may have felt a need to distance himself from the prevailing Neoclassicism of the period by returning to the more emphatic, neo-Baroque style he had explored in the *Coresus,* and which is evident in his choice of art-historical sources. Iconographically, it is harder to fully explain his ultimate solution. He probably rejected the treatment of the story in the last sketch discussed out of a desire to capture the burning of the rose, that is to say, the specific moment of sexual ecstasy. More problematic is the disjunction that the final version introduces between the rose, lying isolated on the altar, and the girl's body. The torching of the flower—the allegorical loss of virginity—thus becomes a kind of magical action at a distance, as the girl is separated from the symbol of her sexuality. The first two drawings had depicted the girl still holding the flower, and laying it down on the altar, where Eros torched it. In the Minneapolis drawing, apparently dissatisfied with the tripartite juxtaposition of altar and hands with implements, Fragonard eliminated the altar in favor of direct contact between the rose, held in the girl's hand, and the torch. In the final version he clearly decided

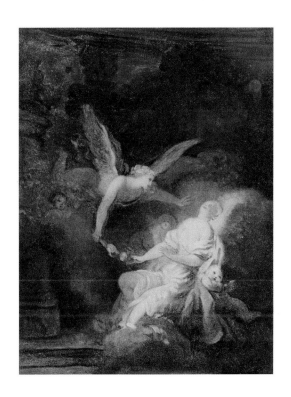

55

FIGURE 44
Jean-Honoré Fragonard, *The Sacrifice of the Rose,* circa 1785–88. Black chalk, graphite, and brown, red, yellow, and gray washes on paper, 42.2 × 33 cm (16⅝ × 13 in.). Minneapolis Institute of Arts, The Centennial Fund: Gift of Funds from Mr. and Mrs. Clinton Morrison, 83.109.

FIGURE 45
Jean-Honoré Fragonard, *The Sacrifice of the Rose,* circa 1785–88. Oil on canvas, 33 × 24.8 cm (13 × 9¾ in.). Private collection.

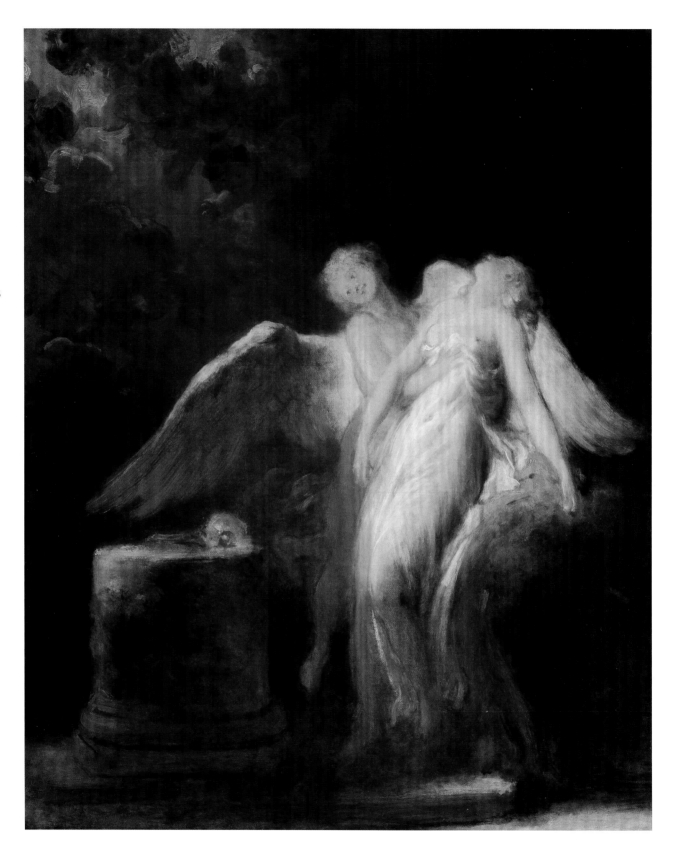

that reintroducing the altar was more important than direct contact between the girl and the flower. Alternately, he may have judged that the two demands imposed on the girl's body—laying the rose on the altar while swooning orgasmically—resulted in rather awkward contortions. Consequently, he may have chosen to give up one of these actions, in the process bringing the girl's pose significantly closer to that of Bernini's *Saint Theresa*.

The metaphorical representation of a girl's virginity as a rose that could be lost or stolen—inscribed in the very term "deflowering"—had a great number of precedents in the art and literature of the eighteenth century. Richard J. Campbell, in a long article primarily devoted to the Minneapolis version, has exhaustively traced the pervasiveness of similar rose imagery at the Salon, as well as in the literature of the period.[83] However, he identifies no other image in which the rose is torched, rather than stolen or plucked. That single change epitomizes the heightened level of passion that Fragonard introduced in his *Allegories*, and which is missing in all other comparable images of the period.

In the painted versions of the *Sacrifice* it is very hard to discern the decoration on the circular altar. In the print, however, we can see a winged figure holding up another, probably female, figure. This image may refer to the myth of Cupid and Psyche, which was a highly popular subject for artists in eighteenth- and early-nineteenth-century France. It is suggestive either of the moment when Zephyr brings the heroine to Cupid's palace or of other moments in the tale when Cupid himself would be the one holding his lover, such as after rescuing her from drowning. It is thus possible that the iconography of the

FIGURE 46

Jean-Honoré Fragonard, *The Sacrifice of the Rose*, circa 1785–88. Oil on canvas, 61 × 50 cm (24 × 19⅝ in.). Private collection.

FIGURE 47

François-Philippe Charpentier (French, 1734–1817) after Jean-Honoré Fragonard, *The Tumble*, 1766. Aquatint and etching in brown ink, 30 × 41.7 cm (11¹³⁄₁₆ × 16⁷⁄₁₆ in.). Washington, National Gallery of Art, Widener Collection, 1942.9.2312.

LA CULBUTE

Sacrifice—the erotic encounter of an earthly maiden with the god of Love—was intended to remind the viewer of the myth of Psyche.[84] On the other hand, the diagonal pose of the two figures is also quite similar to the imbalance of the protagonists in Fragonard's genre drawing, *La Culbute* (*The Tumble*) [Figure 47] (also the source for a print by François-Philippe Charpentier), to which it may jokingly refer. In that drawing, a young man is precipitating himself, with clear sexual intentions, on a young woman, causing them both to fall to the ground. Falling was a Rococo metaphor for the sexual act; this motif, whether it is a reference to the drawing or not, may have been intended as a cruder representation of the act symbolized by the burning of the torch.[85]

THE ALLEGORIES OF LOVE IN THE CONTEXT OF FRAGONARD'S OEUVRE

FIGURE 48
Jean-Honoré Fragonard,
The Warrior's Dream of Love,
circa 1775–80. Oil on canvas,
62 × 51 cm (24³⁄₈ × 20¹⁄₈ in.).
Paris, Musée du Louvre, R.F.
2149. Photo: Christian Jean,
Réunion des Musées Nation-
aux/Art Resource, New York.

A number of other images Fragonard produced during his late period partake of the same spirit as the four principal Allegories. The simplest and perhaps least interesting is *The Warrior's Dream of Love* [Figure 48], the print of which was later paired with *The Fountain of Love* engraving.[86] The *Warrior's Dream* depicts a much more complex allegorical construct than can be found in any of the principal Allegories: It shows a female divinity, her face half-veiled, descending, surrounded by cherubs or cupids, toward a sleeping male figure in antique, possibly Roman, dress. The title of the image derives from the print, where the female figure's face is unveiled, and she can be read as Venus. Iconographically, a half-veiled face was traditionally associated with representations of religion, not love, and it may be that Fragonard or his engraver found the painting's iconography too complex or muddled and chose to simplify it for publication. The image's allegorical program is made explicit in the print's caption: "Love and Voluptuousness charm the sleep of the warrior through the sweet illusion of pleasures."[87] Like *The Sacrifice of the Rose*, the *Warrior's Dream* depicts the encounter between a love divinity and a mortal. Furthermore, while the painting is in a poor state of preservation, it seems to have shared some of the pictorial treatment and overall atmosphere of its pendant. However, neither the print nor the painting comes close to the incandescent intensity of *The Fountain of Love.*

More intriguing is a small panel titled *Love Sacrificing His Wings for the Joy of the First Kiss* [Figure 49], which depicts an infant Cupid laying his wings on a small altar while stretching his head up to receive a kiss from a spectral, winged female figure shrouded in clouds and rays of bright light. High above the couple, in the strongest-lit area of the sky, the faint trace of a crown of flowers can be discerned. The composition could easily be mistaken for a simple Rococo conceit on a par with Fragonard's ever-popular *Love the Sentinel* and *Love the Jester;* yet its single-plane, almost Neoclassical composition, structured fully along the picture's diagonal axis, together with its handling of light and vapor effects, secures for it the impassioned intensity that eludes the *Warrior's Dream* and brings it into close company with the Allegories of Love. Even more important is the drawing *The Kiss* [*see* Figure 67], a print of which was executed by an amateur member of the Academy, the comte de Paroy, and which records a composition that, were it translated onto canvas, could easily stand alongside the four Allegories. I will discuss this drawing extensively at the end of Chapter IV.

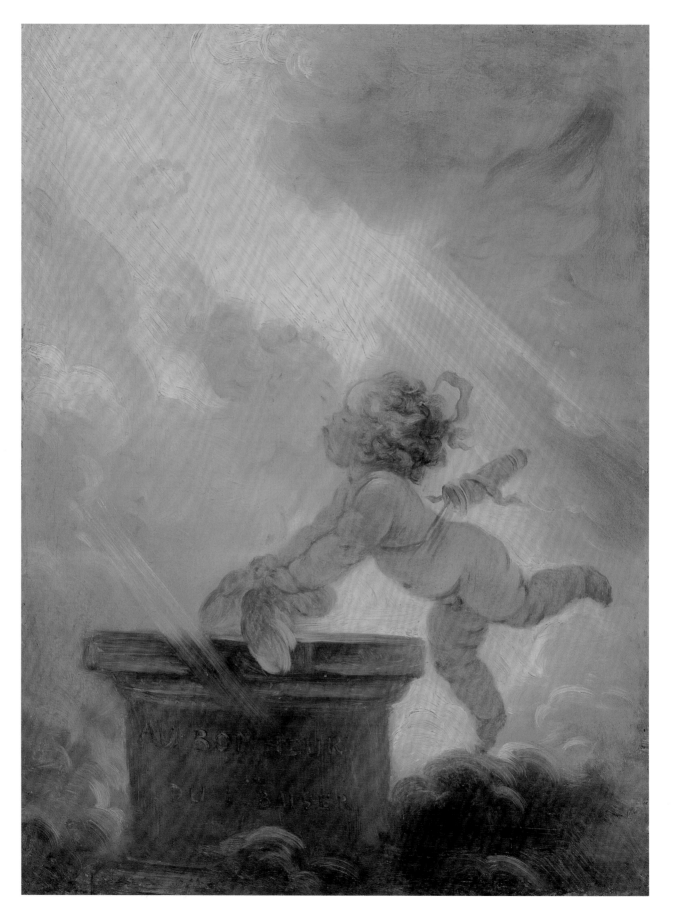

61

Several other pictures recapture the Romantic air of the Allegories without incorporating any supernatural or allegorical elements. Such is the case with the small panel entitled *Le Chiffre d'amour,* or *The Souvenir,* in the Wallace Collection [Figure 50], in which the hazy atmosphere complements the sentimental scene it surrounds—a young girl incising her lover's initial into a tree's bark—paralleling the way the natural background in *The Oath of Love* echoes the passion of its protagonists. At least three of Fragonard's landscapes—*The Little Swing* [Figure 51], *The Isle of Love,* also known as *The Fête at Rambouillet* [Figure 52], and the *Blindman's Buff* at the Louvre (Cuzin no. 322)—are imbued with the atmosphere of the Allegories. These images are characterized by the same overall darkening of the color scheme and higher emphasis on chiaroscuro seen in the Allegories, as well as by the de-emphasizing of any easily readable narrative, accounting for a heightened sense of mystery that cannot be found in Fragonard's earlier output.[88]

FIGURE 51
Jean-Honoré Fragonard,
The Little Swing, circa 1775.
Oil on canvas, 50 × 68.5 cm
(19⅝ × 27 in.). Private collec-
tion, Paris.

FIGURE 52
Jean-Honoré Fragonard,
The Isle of Love (*The Fete at
Rambouillet*), circa 1775.
Oil on canvas, 71 × 90 cm
(28 × 35⅜ in.). Lisbon, Museu
Calouste Gulbenkian, 436.

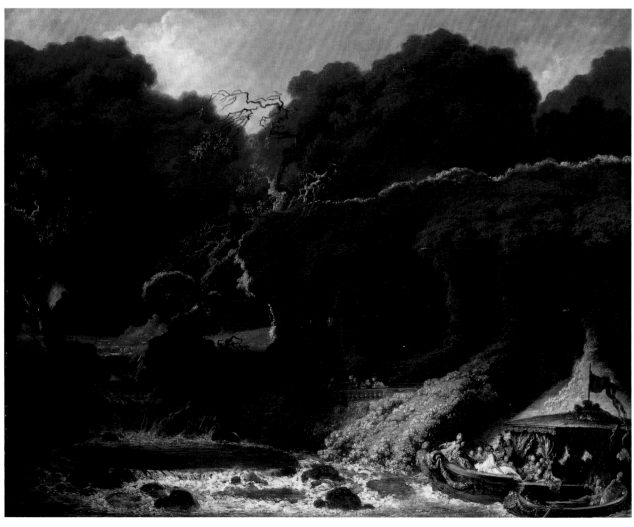

One should, of course, be wary of drawing up a list of Fragonard's "Preromantic" pictures. To be sure, many of the formal elements that characterize such works can be found throughout the rest of his corpus. But never before in Fragonard's oeuvre do these qualities come together in quite the same combination or convey the specific erotic mood of the Allegories. In order to highlight the uniqueness of the Allegories within Fragonard's oeuvre it is worth surveying his earlier paintings on similar themes.

Fragonard's earlier allegories on amorous subjects are signally different from the Allegories of Love. Many depict Cupids in various emblematic activities, such as *Love Setting the Universe Ablaze* [Figure 53], probably from the 1750s, or the Boucheresque *Love Triumphant* [*see* Figure 8] of around 1770.[89] In this category can also be placed *Love the Sentinel* and *Love the Jester* (Cuzin nos. 254–60), which will reappear in Fragonard's 1791 reinstallation and expansion of his Progress of Love cycle from Louveciennes. All these images are consistent with traditional Rococo allegorism and have none of the Allegories' mood or mystery.[90] The same could be said of the more libertine conceits of the early 1760s, *All in a Blaze* (Cuzin no. 100) and *The Stolen Shift* [Figure 54], which employ frolicking cupids to display the charms of female flesh and to allude to sexual activities in cruder ways than the pictures of the 1780s.

FIGURE 53
Jean-Honoré Fragonard, *Love Setting the Universe Ablaze,* circa 1750s. Oil on canvas, 116 × 145 cm (45⅝ × 57⅛ in.). Toulon, Musée des Beaux-Arts.

FIGURE 54
Jean-Honoré Fragonard, *The Stolen Shift,* circa 1760. Oil on canvas, 35 × 42 cm (13¾ × 16½ in.). Paris, Musée du Louvre, M.I. 1057. Photo: Erich Lessing/Art Resource, New York.

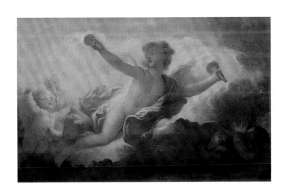

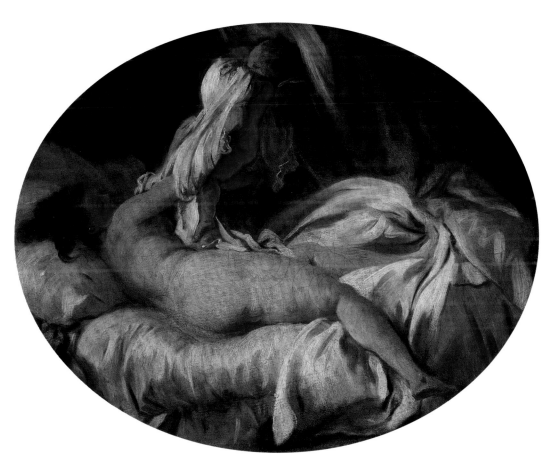

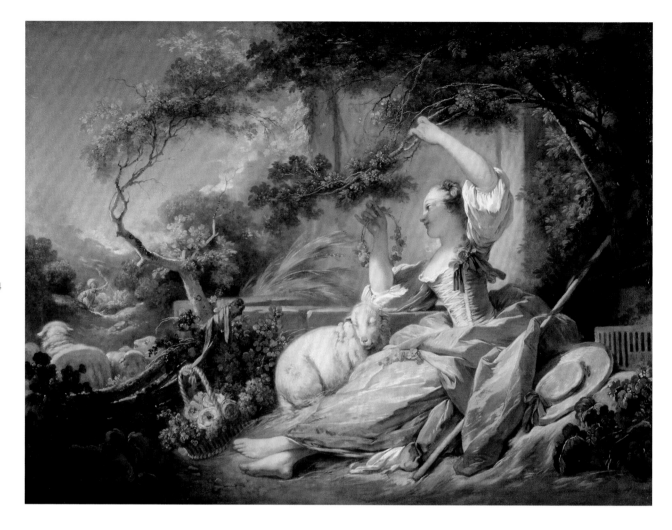

64

FIGURE 55
Jean-Honoré Fragonard,
The Shepherdess, circa
1732–1806. Oil on canvas,
118.7 × 161.6 cm (46¾ ×
65⅝ in.). Milwaukee Art
Museum, Bequest of Leon
and Marion Kaumheimer,
M1974.64.

FIGURE 56
Jean-Honoré Fragonard,
The Bolt, circa 1777. Oil on
canvas, 74 × 94 cm (29⅛ ×
37 in.). Paris, Musée du
Louvre. Photo: Erich Lessing/
Art Resource, New York.

FIGURE 57
Jean-Honoré Fragonard,
The Longed-for Moment,
circa 1755–65. Oil on canvas,
49.5 × 60.5 cm (19½ ×
23⅞ in.). Private collection.

Early on in Fragonard's career we find pastoral scenes created directly under Boucher's influence, such as *The Musical Contest* in the Wallace Collection [*see* Figure 10], *The Cage* (Cuzin no. 40), or *The Shepherdess* [Figure 55]. All dating from the mid-1750s, these images depict gallant characters in theatrical pastoral settings, engaging in playful activities. Their high Rococo qualities keep them a world apart from the Allegories of three decades later. These pictures also contain barely hidden erotic symbols—the crowning of the lover, or the freeing of the caged bird—evincing an allegorical language of the purest Rococo strain. Years later, Fragonard returned to the subject matter and even the style of these pictures in the Progress of Love cycle for Louveciennes, of about 1771–72.[91] As we saw in our discussion of *The Oath of Love,* it is largely this pictorial vocabulary that is taken up in the Allegories of Love: Their setting is a transformation of the traditional pastoral formula, and their symbolism evolves out of the encoded meanings of the pastoral subjects. Nevertheless, the Allegories constitute a quantum leap forward within this progression, expanding upon and rephrasing the iconography of the earlier images within an entirely new cultural environment.

A last category, which includes some of Fragonard's most intensely erotic pictures, consists of genre scenes that are not ennobled by a pastoral setting, and thus can sometimes appear blunter in their depiction of contemporary sexuality.[92] This group includes early

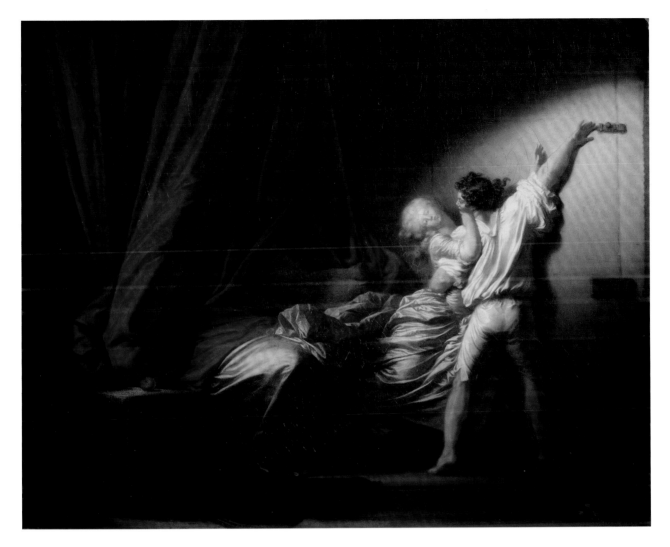

images of lower-class dalliance, such as *The Captured Kiss,* of 1759–60 (Cuzin nos. 76, 77), and more graphic erotic anecdotes, such as *In the Corn* (Cuzin no. 162), as well as the later narrative cycle comprising *The Bolt* [Figure 56], *The Contract* (Cuzin no. 376), and the print of *The Armoire. The Bolt* occupies a special place within this category: The energetic interlaced poses of its protagonists (which contrast with the otherwise placidly observed setting) form, in Diderot's coinage, a hieroglyph of the erotic passion depicted. A similar observation can be made about two other compositions, *The Longed-for Moment* [Figure 57] and *The Kiss* [Figure 58], which stage scenes of lovers so absorbed by their embraces as to appear utterly oblivious to their surroundings. Here Fragonard distills a further defining element of the Allegories—a single-minded, solipsistic erotic intensity. Apparently, this intensity needed to be defined first within the more realistic style of genre scenes before being introduced into, and allowed to change, the pastoral formula. Such images focus exclusively on depicting erotic passion isolated

FIGURE 58
Jean-Honoré Fragonard,
The Kiss, circa 1763–68. Oil
on oval canvas, 52 × 63 cm
(20½ × 24¾ in.). Private
collection.

from any ancillary narrative. This abandonment of narrative also characterizes the Allegories, which can be seen not so much as depicting actions within tales but as embodying notions such as endless love (*The Oath of Love*), passionate abandon (*The Invocation to Love*), the consummation of desire (*The Fountain of Love*), or the loss of virginity (*The Sacrifice of the Rose*).

66

ICONS OF ROMANTIC LOVE

As we have seen, *The Fountain* and the other
Allegories of Love synthesize elements from all of Fragonard's previous depictions of amo-
rous themes: Their overall emblematic quality comes from earlier allegorical compositions
such as the various Cupid subjects, their setting and some of their symbolism from the
pastorals, and their sexual intensity from the erotic genre scenes. Once brought together,
however, these elements fuse into a recognizably new formula that is notably different
from any of the earlier pictures. The difference lies in the heightened, "Romantic," passion
with which the Allegories are imbued. In the century's earlier representations of amorous
scenes (including many of Fragonard's own), the depiction of somebody being *in love* was
not essentially different from that of any other mental state. Antoine Watteau's pictures of
languishing lovers, for example, use basically the same visual vocabulary as his images of
soldiers at rest. On the other hand, Fragonard, in his late period, elaborates for the purpose
of depicting love scenes a new pictorial language that transcends the formulas of earlier
genre painting. Formally, this new language includes, but is not limited to, a stronger use of
chiaroscuro and *effets de lumière;* poses borrowed from religious and mythological paint-
ing, as well as, possibly, from ancient sources; and a certain idealization of the figures and
new emphasis on single-plane, friezelike compositions (especially in *The Fountain of Love*
and *The Invocation to Love*) that recall contemporary developments in Neoclassicism.

FROM ALLEGORY TO SYMBOL

These formal developments are related to a more subtle change in Fragonard's late work.
This transformation has been noticed by numerous art historians. Mary Sheriff points out
that more important than its use of a traditional iconographic vocabulary to the overall
effect of *The Fountain of Love* is its manipulation of poses and other pictorial effects so as
to convey more directly the represented passion: "More compelling than the symbolism of
objects represented in *The Fountain of Love* is the display of both desire and satisfaction,
for together these suggest a moment of consummation." She finds this passion actually
embodied in the stances of the protagonists: "Desire is represented both by and in the two
lovers who approach the fountain with their eyes focused on the cup."[93]

Michael Fried identifies in the Allegories and other related paintings, such as *L'Instant desiré* and *Le Chiffre d'amour,* "a penchant…in [Fragonard's] treatment of amorous subjects, which under his rapid, caressing, volatilizing brush become images not merely of absorption but of rapture and transport, and not merely images, but infinitely seductive tokens of the states themselves."[94] The distinction drawn here, between "mere images" and "tokens of the states themselves," clearly echoes the representation/embodiment dichotomy posited by Sheriff.

Donald Posner contrasts the emblematic Rococo vocabulary of earlier Fragonard pictures such as *The Swing* [Figure 3] and the "new emotional tone" pervading *The Little Swing* (one of the later pictures closely related to the Allegories [*see* Figure 51]): "The *Swing* of 1767 is gay, ebullient, 'rococo'; the *Small Swing* is subdued, warm, and full of incipient romantic sensibility." Posner defines the difference between the two images in terms of the lack of anecdotal elements in the later picture: "There is no flirtation, no play with shoes or flowers. Unlike the swinging scenes that have been discussed before, it is not an anecdotal situation, but a mood that dominates this picture."[95]

It is in this conceptual framework that the similar changes characterizing the relationship between the Allegories of Love and their iconographical precedents should be placed. In the Allegories, iconographical details are de-emphasized, and the painter suggests an emotionally heightened atmosphere primarily by manipulating pictorial devices such as lighting, composition, and the bodily stances of his personages. While none of the art historians mentioned here addresses this point specifically, it should be noted that the categories and dichotomies they use—representation versus embodiment, anecdote versus mood—have a deep history within the Romantic movement itself. Fragonard's abandonment of clear allegorical or other established iconographic signifiers in favor of a vaguer "presence" to convey an artwork's meaning corresponds to the well-known change, on the threshold of Romanticism, from the predominance of allegory in figural language to the predominance of symbol; that is to say, from a conventional vocabulary of explicit, emblematic meanings to a use of signifiers that eschews the one-on-one correspondence of allegory in favor of conveying notions of greater generality or import in a more implicit manner.[96] While this distinction was first developed by Friedrich Schiller and Johann Wolfgang von Goethe in Germany in the late 1790s, it can also be shown to constitute a defining aspect of the transition from Rococo to early Romanticism in France.[97]

The transition between the two rhetorical regimes was born out of a dissatisfaction with any pre-established system of signs, such as Rococo emblematics, which was too conventionalized to convey the personal passion and spontaneity cherished by the Romantic subject. This dissatisfaction often translated into a parallel distinction between "mere" representation and embodiment—that is to say, between a seemingly lifeless semiotic relationship of signifier and signified, and a deeply intuitive experience that comes alive in the work of art. This change came about as a result of the Romantics' need for a symbolic language that could signify higher, transcendental values—values that purportedly exercised a direct, unmediated effect upon the self and were not simply the product of social conventions. According to Hans-Georg Gadamer, "There is a metaphysical background to the concept of symbol which is entirely lacking in the rhetorical use of allegory. It is possible to be led up from the sensible to the divine…[T]he symbol is not a random choice or creation of a sign, but presupposes a metaphysical connection of vis-

ible and invisible."[98] In contrast, "allegory does not assume an original metaphysical relationship, such as a symbol claims but, rather, a connection created by convention and dogmatic agreement."[99]

Two issues then arise. First of all, is the new pictorial language of the Allegories of Love characterized by the Romantic rhetorical regime that privileges symbol over allegory, and, as a corollary, are the Allegories then Romantic works? Secondly, if so, to what purpose was the new rhetorical regime deployed? That is to say, what transcendental value were the images in this series supposed to depict? The Allegories, it can be argued, must be read as iconic representations of the period's new mythology of Romantic love, the development of which, in the late eighteenth and early nineteenth centuries, has been extensively chronicled by modern sociologists such as Niklas Luhmann and Anthony Giddens, and by historians of philosophy, such as Joseph Singer.[100] These writers have largely studied the rise of Romantic love in the context of German and English Romanticism; yet many of its elements can be traced back to Rousseau. Indeed, the basic lineaments of the new conception of love can be clearly discerned in France perhaps earlier than anywhere else in Europe.

A NEW AMOROUS PARADIGM:
THE CONCEPT OF ROMANTIC LOVE

Before moving on to discuss the notion of Romantic love, two caveats are in order. Many commentators have pointed out the problematic aspect of attempting to trace the historical evolution of a notion related to lived sexuality, one in which timeless, biological components are intertwined with those that are culturally determined and time-bound. Giddens, in *The Transformation of Intimacy,* differentiates between the (more) universal phenomenon of "passionate love" and the notion of "romantic love, which is more culturally specific."[101] Such a combination of temporal and atemporal components may account for important continuities over time, and indeed Romantic love does contain elements that come from deep within history, from Platonism and Neoplatonism, through the courtly love of the middle ages, to the *amour-passion* of the seventeenth century. My second caveat is a corollary of the first: "Romantic love," though its features crystallize during the Romantic age, is not restricted to that historical period (which is why some writers, such as Giddens, refuse to spell it with an uppercase "R"). In the more than two centuries since Fragonard the idea of Romantic love has remained the most important myth guiding sexual relationships, and its influence can still be seen from romance novels to TV movies to top-40 hits.

Despite these caveats, it is clear that this new paradigm shift is not just the discovery of modern historians or sociologists, but that Romantic love was experienced as a new idea very close to the time of its inception. At some point during the late ancien régime, a certain awareness developed that affairs of the heart were being conducted according to a radically new ethos. One of the earliest expositions of the historical evolution of amorous habits can be found in Claude-Joseph Dorat's preface to his 1771 novel *Les Sacrifices de l'amour.* There, Dorat outlined what has since become the accepted view of the changing social conceptions of love in seventeenth- and eighteenth-century France; indeed, his delineation of the timing is very close to that of modern-day scholars of the topic. He broke

the period into three stages: the chaste passion of the 1600s, the frivolity of the Rococo, and a new, sentimental age whose dawn he perceived in England, and whose influence he intended to import across the Channel. At the time of Dorat's writing, that desired British influence could already be perceived in Rousseau (whose *Julie* had appeared more than a decade earlier), and in Rousseau's followers, chief amongst whom was Dorat himself. Dorat's arguments can help us outline a genealogy of the cultural atmosphere in which Fragonard painted his Allegories.

 Dorat's stated purpose is to study "the nuances of the [French] national character [and] the changes it has undergone" by analyzing their reflection in "the variations that have occurred in the genre of our Novels."[102] The text makes it quite clear that by "caractère national" Dorat means primarily the amorous customs of his compatriots. After positing an earlier, legendary period of medieval romances, "almost fictitious centuries of heroism and chivalry," Dorat distinguishes a time of heightened passion and more intimate communication between the sexes. This new intimacy, though characterized by the "pains of resisting [seduction]…the intoxication of giving in…those touching contritions, which it is so sweet to have to conquer," nevertheless remains "always under the veil of decency."[103] Though Dorat does not provide any names, his description accords closely with his period's view of the *amour-passion,* which can be found in such seventeenth-century novels as *La princesse de Clèves* or the *Lettres Portugaises.*[104] Dorat then argues that the genteel customs of that earlier age were thrown into turmoil by the onset of Rococo libertinage: "those days of ease in manners and of upheaval in [moral] principles, when elegantly vicious men cheat and are cheated, only assail women in order to obtain, if possible, the right to despise them, and who are by this very fact even more despicable than they."[105] As a supreme example of such mores, Dorat offers the oeuvre of Crébillon *fils*—the novelist Claude Prosper Jolyot de Crébillon (1707–1777), author of libertine novels such as *Les Egarements du coeur et de l'esprit* (1736–38), the fictional memoirs of a roué recalling his "sentimental education," and *Le Sopha, conte moral* (1740), an "oriental" tale in which the sofa of the title recounts the various amorous encounters it has witnessed.[106]

 To remedy these modern ills, Dorat proposes a new kind of novel, in which "[true] manners should be depicted, and the passions as they move, and in which man can be found as he is in nature!"[107] Such a novel would distance itself from Rococo corruption, while at the same time being more realistic and more profound in its depiction of human passions than the enervated tales of the *siècle d'or.* It is only in England (and particularly in the work of Samuel Richardson) that he finds examples for such a new novel, which is clearly lacking in his own country. In establishing a brief for the new literary sensibility he envisions, Dorat trots out an entire arsenal of soon-to-be early-Romantic clichés:

> In order to wrest from nature some of its secrets, one must be nourished on meditations, on solitary recollections, on the enthusiasm for the good and on that melancholy which marks with an august stamp all the ideas that emanate from it. This is what distinguishes the English writers. They dig around in the depths of the soul, while we ceaselessly play around its surface.[108]

That Dorat's wishes had been amply fulfilled by the end of the century can be seen in a text that brackets the period with which we are concerned. In her 1796 treatise

De l'Influence des passions, Madame de Staël viewed love as a passion wholly apart, which had barely ever been understood or represented by earlier writers. Not only did she not find any true love in Rococo literature ("No, there is no love at all in the merry pieces [of writing], there is no love at all in graceful pastorals."[109]), she even denied—sacrilegiously in the eyes of many—that true love had been captured by the classics. She could not find it even in Anacreon, but only in "a few verses about Dido [in Virgil] and Ceyx and Alcyone in Ovid."[110] It was rather the modern period that, in her eyes, had finally been able to represent the intense emotions of love: "Voltaire, in his tragedies; Rousseau, in the *Nouvelle Heloïse; Werther,* scenes from German tragedies; a few English poets, parts of Ossian, etc., have brought profound feeling into love."[111]

Between Dorat and Madame de Staël, between 1771 and 1796—that is to say, over a period at the very center of which fall Fragonard's Allegories of Love—a whole new paradigm of love was constructed. What were its defining characteristics? For one, amorous passion came to be perceived as incompatible with the earlier age's emphasis on rationality, be it the *encyclopedistes'* reason in the service of morality or the cool reasoning of Rococo libertinage. This conflict was most famously outlined in Choderlos de Laclos's 1782 novel *Les Liaisons dangereuses,* in which Romantic love functions as a wrench thrown into the well-oiled sexual-exchange mechanism of Rococo society. If not for its influence, clearly both the vicomte de Valmont and the marquise de Merteuil would have survived their entanglements unscathed (as Valmont—who typifies one of Dorat's calculating and "elegantly vicious men" of the Rococo—imagines he will). Yet already over a decade before *Les Liaisons,* Dorat's novels (which clearly influenced Laclos) thematized the conflicts inherent in the paradigm shift from libertinism to Romantic love. The heroine of *Les Sacrifices de l'amour,* Madame de Sénanges, refers to the feeling of duty that prevents her from giving in to her lover (and thus to adultery) as "a cruel and impotent reason that only acts upon me to tear me apart."[112] Reason, one of the principal assets of the Rococo seducer, who—as Valmont often does—could manipulate logic to get his intended victim into bed, was now seen as the enemy of passionate love. The illustration from Jean-Benjamin Delaborde's *Choix de chansons* mentioned earlier [*see* Figure 27] is an appropriate emblem for the solution to this dilemma proposed by the new paradigm: In order to give in to love one must throw the goddess of Reason—that false idol!—off its pedestal, and break her statue to pieces.

Romantic love also implied an absolute commitment of one's person, no aspects of which were allowed to remain untouched by the experience. The thunderstruck amazement with which the hero of *Les Sacrifices de l'amour,* the chevalier de Versenai, discovers the possibility of a new way of loving continues the thesis proposed by the author in his preface. Once love-struck, the chevalier sees the emptiness of Rococo libertinism and reaches a new conception of love as an all-encompassing, divine passion, which alone makes life worth living. He addresses the personified passion in words that one could easily imagine being spoken by the heroine of Fragonard's *Invocation:* "O feeling that unites all feelings, heavenly emanation, unique pleasure of the beings cast upon this sad orb; sole compensation for the pains of life."[113] The chevalier's requited love magically changes his entire environment: "I inhabit a new world that she has created for me."[114] With the enthusiasm of a new convert, he discovers that the power of love focuses his attention exclusively upon his beloved, at the expense of the rest of the world: "I love with

a kind of excess…of which I didn't think myself capable. I never imagined that, in the tumult of this world one could collect oneself so, isolate oneself, belong entirely to a single purpose." The new paradigm establishes a novel kind of emotional economy in which everything in the environment fuels and is consumed by love's solipsism: "Everything magnifies my feelings, everything…My heart skips a beat; all my senses are on edge, and I no longer belong, I no longer want to belong, to anything but love."[115]

A similar all-consuming solipsism that isolates lover and beloved in a kind of tunnel vision, a communicative axis that makes them oblivious of any distractions in the surrounding environment, can be found in Fabre d'Eglantine's *Romance* of 1788. The *Romance* is perhaps the ultimate expression of Romantic love in prerevolutionary France, and it can be seen to provide a parallel to the Allegories in its stripping away of all conventionalized Rococo imagery in favor of the obsessive extension of a single trope—the lover's unyielding, obsessive attraction toward his beloved. As it provides a marker for the new consciousness of erotic intensity available to Fragonard in this period, it deserves to be quoted here in full:

> I love you so, I love you so!
> I cannot say this to you enough:
> And yet I repeat it
> Each time that I breathe.
> Whether I'm away or here, near or far
> "I love you" are all the words I find:
> I either think it or act it out.
>
> Alone with you, or before others,
> In the city, in the fields, at home, outside,
> Your sweet image I caress:
> It melts away, when I fall asleep,
> With my last thought.
> When I awaken, I see you
> Before seeing light;
> And my heart reaches you
> Faster than the day reaches my eyes.
>
> Though I'm away, I don't leave your side;
> I can guess everything you say:
> I count your cares and your steps;
> That which you feel, I can imagine.
> And when I'm back by you?
> I am in heaven, it's a delirium;
> I only breathe love,
> and it's your breath that I inhale.
>
> Your heart is everything to me, my good, my law;
> To please you is all that I desire:

In short, in you, through you, for you,

I breathe and hold on to life.

My well-beloved, oh my treasure!

What else could I add to these words?

God! How I love you! Well! and yet

I'd like to love you even more.[116]

The exacerbated early Romantic solipsism of Dorat's and Fabre d'Eglantine's lovers can also be found in Fragonard's Allegories. Isolated in their brightness from their darkened environment, Fragonard's lovers can devote themselves exclusively to one another or (in the case of the *Invocation*) to their desire. The subordinate surroundings—inasmuch as they pierce through the shadows—only echo and redouble the lovers' passion. The figures' ecstatic stances correspond not only to the delirium experienced by the poem's protagonist but also to Fabre d'Eglantine's breathless diction. In our very perception of the figures as making up a single entity, a burning hieroglyph of love, we recognize another concept that is of the highest importance for the Romantic ideology of love: the notion of merging, or fusion.

"MERGING" AND THE NEW RELIGIOUS DIMENSION OF LOVE

When taken to its logical extreme, the desire for absolute intimacy and transparency of communication demanded a shattering of the boundaries between two individuals in favor of the couple's quasi-metaphysical merging. Romantic love thus returned to the Platonic idea of the lover being made whole by his or her beloved. In the words of Singer, "In the Romantics as a whole, love is a metaphysical craving for unity, for oneness that eliminates all sense of separation between man and his environment, between one person and another, and within each individual."[117]

Many examples of such merging can be found in the literature of the late ancien regime. The heroine of one of Jean-François Marmontel's *Contes moraux* (*Moral Tales*), "Le Scrupule, ou l'amour mécontent de lui-même" (The Scruple, or Love Discontented with Itself, 1761), for example, sets off to verify some of the common ideas about love that she has read about in books: "I have read that love is a passion that of two souls makes but one, that enters them at the same time and fills them with each other, that separates them from everything, that is everything to them, and which makes their mutual happiness into their concern and their sole desire."[118] Once she discovers true love, all she has read is proven true as her soul unites with her lover's: "Freely giving in to each other, they forgot the universe, they forgot themselves: all the faculties of their souls, united into one, formed but a whirlwind of fire, the center of which was love, and the fuel of which was pleasure."[119] It is this same *tourbillon,* this same whirlwind of fire, that appears in *The Oath of Love:* Inextricably fused, the lovers' bodies form a single pictorial mass, while their colors of white and gold, juxtaposed with the darkness of the background, render them flamelike. Similarly, the poses of *The Fountain of Love*'s protagonists coincide so closely as to be duplicates of one another; the single-mindedness of purpose in the lovers' passionate rush forward fuses them together not just physically but also emotionally and mentally.

The notion of a couple merging to give birth to that higher unity which is their love approximates a dialectic movement whereby the product of the synthesis transcends the plane of the elements which entered into its creation. Indeed, as Singer points out, and as its Platonic origins also indicate, the new "craving for unity" was essentially "metaphysical." This craving is related to Romantic love's sources, as pointed out by Dorat, in English sensibility, which was itself a product of mid-eighteenth century British empiricism's emphasis on feeling. Yet the difference between sensibility and Romantic love is exactly the difference between empiricism and idealism. Singer, for example, finds an early trace of the notion of merging in Dr. Johnson's notion of "sympathetic identification," effected by means of the imagination, and which is essentially a corroboration "of what reason can also tell us."[120] In the Romantic period, such a reason-based identification that still acknowledged the utterly unbridgeable gap between two consciousnesses metamorphosed into a mystical notion of soul communion. Empiricist dualism could only be overcome through the idealist positing of a higher, metaphysical entity capable of uniting the two souls, and Love became transcendentalized.

It is this logic of fusion which underlies the connection of Romantic love to religion: amorous merging, in the new paradigm, anticipated an ultimate spiritual communion with the Divine. As Madame de Staël put it: "If the Almighty who cast man onto this earth wanted him to conceive an idea of celestial existence, he allowed him that, during a few instants in his youth, he can love passionately, he can live in another, he can complete his own being by uniting it with his desired object."[121] In fiction and poetry, this structure generally manifested itself through the (usually male) narrator's metaphorical turning of the beloved into a divinity, and his subsequent craving for merging with that divinity. (The relationship must of course be seen as symmetrical, with either member of the couple finding in the other, at the moment of merging, an intimation of godhood.)

Singer identifies the first full exposition of this maneuver in the German critic and novelist Friedrich von Schlegel. However, earlier examples abound in French early Romantic literature. When Evariste de Parny's narrator, in the poem "Les Serments," swears to his love by his very lover, whom he is also addressing, he says: "Finally, I swear by you / That is to say, by all my gods."[122] Similarly, the chevalier in Dorat's *Les Sacrifices de l'amour* describes the night of love as a mystical epiphany: "I no longer inhabited earth. The silence of the night, its touching calmness, the dark clearness of the skies split me up between ecstasy and madness; I believed myself in a sanctuary, whose divinity was Madame de Sénanges."[123] It is Loaisel de Tréogate who takes farthest this identification of lovemaking with a mystical encounter; his hero Dolbreuse, recounting his wedding night, describes his impression of his and his wife's bedchamber:

> That asylum seemed to me a temple, as soon as I was there alone with my beautiful lover…I no longer could see the chair on which she was seated; I saw an altar where the Divinity, descended from the heavens, deigned to offer itself under the most charming features to the gaze of a mere mortal, and to make itself an object of the senses, of touch, for him alone; and, in an unheard-of act of generosity, to grant him before his time all the delights of beatitude.[124]

The sources of such imagery—the lover as believer, beatified by the epiphany of the beloved—in Catholic mysticism are clear. We can see the deeper significance of Fragonard's use of a pictorial vocabulary borrowed from religious imagery, as evidenced in the formal relationships, previously noted, between *The Sacrifice of the Rose* and Bernini's *Saint Theresa* and the derivation of the ecstatic stances of all the Allegories' protagonists from images of Dionysiac fervor in works by Titian and Rubens, or on classical sarcophagi, as well as in his similar treatment of chiaroscuro and sfumato in his own religious subjects of the 1770s. Having noted such similarities, it is clear that what is at work here is no simple demystification of Theresa's ecstasy into a more mundane sexual orgasm but rather an acknowledgment of the religious dimension of love as perceived by the early Romantics. In the Allegories, love takes on some of the transcendent quality of the religious subjects that provided the models for Fragonard's new pictorial language.

Here, then, is the answer to our question about the transition to a symbolic vocabulary in Fragonard's Allegories. Beyond the variation in their specificity or generality of reference, the two regimes of signification—allegory and symbol—differ in the quality of transcendence granted to the ideas signified. Given the fact that the Schlegels (Friedrich's brother August was also a man of letters) and many of their colleagues later converted to Catholicism, it is hard not to perceive, underlying their conception of the symbol, the Catholic formulation of the Holy Sacrament. In the Catholic tradition the sacrament is seen to mark a moment when the divinity of God is literally made present in everyday life: magically, the bread and the wine eaten by the faithful become the body and blood of Christ; magically, the Holy Spirit is present at every baptism, every marriage. Having raised Love to the exalted plane of a divinity in its own right, the period's lovers had to posit similar moments of transcendence for their own newly fashioned religion.

It is exactly such "sacraments of love" that are found in the Allegories: Both the drinking from the cup, as well as the burning of the rose, have clear eucharistic overtones. Indeed, the *Sacrifice* literally depicts the moment of contact between a human and a divinity, while the ecstatic stances of the protagonists of the *Oath* and the *Invocation* symbolize the simultaneous presence in the scene of transcendental Love itself.[125] In order to depict such sacramental moments, the allegorical, emblematic language of the Rococo was simply no longer satisfactory. Thus Fragonard, in the Allegories, recast his entire pictorial vocabulary so as to suggest—as both Mary Sheriff and Michael Fried have pointed out—actual epiphanies of Love occurring at the depicted moments, in the depicted spaces.

SACRED SPACES OF LOVE

All writers on the concept of Romantic love have identified a close connection between the lovers' interpersonal fusion and a further symbolic symbiosis between the couple and its environment. The poet Samuel Taylor Coleridge captured this idea when he stated: "The very skies smile in unison with the feeling of true and pure love. It gives to every object in nature a power of the heart, without which it would indeed be spiritless."[126] This kind of identification with the natural world can span the register from the relatively empirical to the transcendental. On the one hand, it can consist of a solipsistic, one-sided projection of sentiment onto one's surroundings, which then become, as Luhmann puts it, "the sounding

board of love;"[127] on the other, it can lead to the more supernatural—though no less solipsistic—conception outlined by Singer: "The idea of merging presupposes a conception of the world as magical."[128] This higher enchantment of nature arises from the sacramental quality of the amorous act; it is not an ever-present quality of the environment but is as time-bound as the sacramental moment itself. Love functions as a spell, temporarily bringing together and raising to a higher plane both its protagonists and its surroundings; yet, once its transcendental presence vanishes, those surroundings return to an empirical existence fully distinct from that of the lovers.

Although Singer and Luhmann have identified such instances of the transformation of nature through love mostly in the texts of the English and German Romantics, similar notions abound in the French literature of the late eighteenth century. Madame de Staël, for example, wrote: "As long as one sees, as one experiences, nothing but through another, then he is the entire universe under different forms."[129] For Loaisel de Tréogate's Dolbreuse, on his first night of marriage, the fields and the groves become witnesses to the sacrament of marriage: "Flowery meadows, loving groves, and the entirety of peaceful nature heard the accents of our gratitude, and were witnesses to our pleasure."[130]

Similarly, the Allegories' sacraments of love are inseparable from their surroundings: in them all of nature is energized in harmony with the protagonists' feelings. The specific environment depicted in the Allegories follows a formula that had become quite common by the 1780s; however, one of Fragonard's primary achievements in this group of works is to have distilled this stereotypical structure into a space utterly apart, purely devoted to the unfolding of amorous passions.

Rousseau in his *Confessions* and Dorat in *The Sacrifices de l'amour* present typical examples of the ideal setting for Romantic love: the garden at night, where a full moon is of the essence, as are groves and fountains, or artificial waterfalls, bushes and flowering trees. If we are to believe in the veracity of Rousseau's *Confessions*, written in the early 1770s, the author had already, sometime around 1759, experienced perhaps his only moment of true love in an environment structured exactly in this way:

> One evening after having supped tête-à-tête, we went for a walk in the garden by a fine moonlight. At the bottom of the garden is a considerable copse, through which we passed on our way to a pretty grove, ornamented with a cascade of which I had given her the idea, and she had procured it to be executed accordingly…It was in this grove that, seated by her side upon a seat of turf under an acacia in full bloom, I found for the emotions of my heart a language worthy of them.[131]

As Rousseau admits, the grove and the waterfall were artificial constructions, the idea for which he had himself given to his beloved—so the origins of this stereotypical environment must go even deeper in history. Yet, if the exact beginnings of this setting are impossible to pinpoint, its reverberations in the works of Rousseau's followers are much easier to trace.

Dorat, for one, is sure to have known the passage quoted above: after all, it was at his house that Rousseau offered the first readings of his *Confessions*. In Dorat's *Sacrifices de l'amour* of 1771, we encounter a similar environment. When Mme de Sénanges invites

her chevalier to an intimate supper, she describes the setting of their future meal: "We will sup in the pretty grove that is under my windows; we will have the most beautiful moonlight in the world; its light is made for love."[132] Describing the same scene, in retrospect, the chevalier adds more details: "The moon that peeked through the bower seemed to take pleasure in lighting with its mysterious rays the happiness of two lovers. A cool wind barely stirred the candlelights, but brought with it all the perfumes with which the air was balmy. The stars shined with the softest fire."[133] The celestial bodies that witness the happiness of Dorat's lovers, together with the cool wind bringing forth the perfumes of the air, participate in creating a synesthetic environment that affects all the senses of the protagonists; the same effect can be felt in Rousseau's description, which evokes for the reader, besides the visible environment, the scent of the acacia flowers and the lulling rustle of the waterfall.

This setting received perhaps its most developed expression in Loaisel de Tréogate's 1779 novel *La Comtesse d'Alibre, ou le cri du sentiment.* An analysis of an extended passage allows us to trace the iconographic and structural relations between the writers' gardens of love and the environment of the Allegories. The novel tells the story of the title character's adulterous affair; the scene is set in and around the castle owned by the absent count. The first night together experienced by the countess, Lucile, and her lover, Milcourt, is described in ecstatic terms. Their symbiosis with nature is invoked as soon as the scene is set; it is the late spring, and the lovers' hearts, Loaisel tells us, have been touched by the same creative power that also causes nature to stir and grow in that season: "It was during the season in which the fire that fertilizes nature also heats all the hearts."[134] The two lovers wander into the castle's gardens:

> To follow a stream's current as it softly sighs amidst the reeds it caresses; to lose themselves in sinuous labyrinths, in darkened groves;…to stop by a cascade's foot, and bathe with delight in the humid and refreshing vapors which the water's foamy fall produces, in the distance; to wander in silence around voluptuous statuary groups which decorate this place; to contemplate them by the moon's silvered light, and let out sighs; to return to flowerbeds moistened by the beneficent dew, which exhale in great waves balmy clouds, and rest on beds of roses; such are their first joys upon entering this peaceful retreat.[135]

All the accessories that Fragonard placed in his Allegories appear here: fountains and waterfalls, together with the vaporous clouds they give off; moonlit statues and roses on garden terraces; as well as the very scents of the flowers, which Fragonard suggests through the juxtaposition of flowers with vapors filling the atmosphere. *The Oath of Love,* for one, could function as a perfect illustration to this passage. Again, as in Dorat, a synesthetic effect is suggested; such an exacerbation of sensory experience is particularly appropriate to symbolize the intoxicating moment of love's development.

This correspondence between nature and the lovers' states of mind is not, however, simply emblematic. Within the narrative's logic, a kind of metaphysical fusion occurs between the protagonists and their surroundings: such a fusion relates directly to the notion of amorous "ecstasy"—etymologically the concept implies a "standing outside" or a breaking down of the boundaries of individual subjectivity. The mechanism of such

77

merging is complex, and it is hard to pinpoint the specific direction of the cause-and-effect relationships between the lovers' desire and the synesthetic power of their environment. The continuation of the garden scene between Milcourt and Lucile is instructive in this regard:

> …they stand and lead their steps toward odoriferous groves; but their walk is slower now. The charms of this lonely place, the thickening shadow, the purity of the air, the cool of the evening, and the peacefulness of nature have thrown them into a vague unease. They no longer perceive the site's enchantments; they only feel the intoxication of being together. They need to lean upon each other. Given over to the instinct that guides them, they are drawn toward a round bower surmounted by myrtle and jasmine trees, where the ground is strewn with a thousand other kinds of flowers. They sink into the thick shadow of this retreat. There, they breathe in new passions with the torrent of scents, and their steps remain chained there as if by an irresistible force.[137]

While the surroundings work their magic on the couple (it is the charms of the garden that "have thrown them into a vague unease"), it is the lovers' natural inclinations (their "instinct") which render those surroundings magical. A constant interchange is established between inside and outside, subject and environment. Within this interchange, nature is not allowed to exist anymore as a purely external object. Loaisel's statement that the lovers at one point "no longer perceive the site's enchantments" must not be taken to mean that the effects of the environment cease to affect their passion, but rather that the charms of the site are no longer something to be admired; they have, in a process of ecstatic merging, invaded the lovers' very subjectivities.

Such a dialectic of subject and environment can also be identified in Fragonard's Allegories. The night in which they, as well as most of the love scenes retold in the literary texts, take place symbolizes love's irrationality. Darkness, in which objects lose their clear outlines and seem to melt into each other, allows for a merging between subject and subject, and between subject and nature, that would be impossible in clear, analytical daylight. Of course, for narrative purposes, the Allegories' protagonists still need to be highlighted, and thus to some extent distinguished from their environment. There is a parallel between such highlighting and the radical solipsism characteristic of the Romantic ideology of love (as discussed in Chapter II), but this solipsism does not contradict the notion of fusion between lovers and surroundings; rather, as evidenced by the above quote from Loaisel, the two concepts are essentially interrelated.

The Invocation to Love parallels an earlier passage in Loaisel's text. The enchanted environment of the garden of love by moonlight is not reserved for couples only but also for lonely souls pining for the fulfillment of their amorous yearnings. Having once known Milcourt, and long before encountering him again, Lucile used to wander by herself through the same landscape:

> On cloudy days, on darkened evenings, she would walk down to the thick groves.…She loved those solitary paths, that somber and lugubrious light, the very picture of her thoughts and of her soul; she would smile to the night's

shadows; alone, surrounded by darkness, she loved to hear the rustling leaves, the plaintive murmurs of the waters that flowed through those beautiful sites, and the birds, asleep on light branches, flapping their wings now and then when awakened by the breeze. She mingled her own moans to this muddle of sounds, and the voice of her lover, whom she thought she could see and hear, put the finishing touch to the delirium of suffering in which she liked to immerse herself.[136]

Here nature serves as the sounding board for a single enamored soul; and this soul's ecstatic dissolution into the elements of its environment finds a perfect expression in the energetic, distended pose of the *Invocation*'s protagonist.

THE ALLEGORIES, ROMANTIC LOVE, AND SOCIETY

Another, highly important characteristic of the new conception of Romantic love resides in its social functioning. Indeed, it is in its social specificity that many commentators identify the new paradigm's most profound difference from earlier notions of passionate love, such as the seventeenth century's *amour-passion.*

Like courtly love before it, *amour-passion* held as one of its principal tenets the lover's free choice of a beloved, independent of any societal constraints; this, of course, was also one of the primary goals of Romantic love. However, seventeenth-century thinkers were too aware of the force of such constraints to extend this freedom to love into a freedom to marry. As Luhmann points out, in that period, "the freedom to choose someone to love applies to the *extra-marital* relationships of *married* persons."[138] What a marital relationship ensured, however, was an aura of societal respectability, which then could shelter such extra-marital love affairs. There was no direct connection between passionate love and marriage, which occupied, more often than not, wholly separate realms of existence. It is only with the rise of Romantic love that the stipulated freedom to love gave rise to a desire for the freedom to marry one's beloved. As a result, passionate love, rather than occupying the subordinate place formerly allotted to it, came to play a central role in the social institutions, such as the family, that had earlier been meant to contain it. As Giddens suggests, "*Amour passion* was never a generic social force in the way in which romantic love has been…Together with other social changes, the spread of notions of romantic love was deeply involved with momentous transitions affecting marriage as well as other contexts of personal life."[139] Marriage could now be seen as resulting from the most natural, as well as the noblest, of instincts, and it is this naturalization of what had previously been seen primarily as a social convention that underlies the entire new morality of bourgeois marriage in the late eighteenth and nineteenth centuries.

Insistence on Romantic love and on love-based marriages naturally stressed the bourgeois values of monogamy and constancy, which (at least as represented in that bourgeois medium *par excellence,* the novel) were looked down upon by libertine aristocrats. In Dorat's *Les Sacrifices de l'amour,* for example, the marquis de *** warns the novel's enamored hero against "priding himself with a bourgeois heroism."[140] On the other hand, members of the lower classes who succumbed to the temptations of Romantic love were

FIGURE 59
Jean-Honoré Fragonard,
The Happy Household, circa
1778–80. Oil on circular
canvas, diameter: 32.5 cm
(12 ¾ in.). Private collection.

automatically ennobled simply by virtue of their love's purity. Perhaps the best-known artistic expression of this new leveling appears in Caron de Beaumarchais's *Marriage of Figaro* of 1784, which stages the complete breakdown of social hierarchy on the battle-field of love. As Figaro himself puts it in the play's closing vaudeville, when he sings of the "secret de l'amour": "This secret shows / how the son of a peasant / often is worth his weight in gold... / by the luck of birth, / one is king, another shepherd; / chance set them apart; / only spirit can change all."[141]

As early as the 1770s, Fragonard represented the ideal state of the new bourgeois family in a variety of genre scenes such as *The Happy Household* [Figure 59], *Happy Fertility* (Cuzin nos. 311, 312), *Young Couple Contemplating a Sleeping Child* (Cuzin nos. 319–21); and *The Visit to the Nursery* [Figure 60]. Such images can quite clearly be read as ideologi-cally prescriptive, representing the ideal behaviors of fathers, mothers, and children in the very midst of the new bourgeois household.

In this category can also be placed *The Good Mother* [Figure 61], which in its print format was a pendant to *The Oath of Love* [*see* Figure 14]. The two images present respon-sible motherhood and long-term monogamous relationships as desirable moral ideals that go hand-in-hand with each other. As Giddens points out, there was a direct connection between Romantic love's realization of the possibility of love within marriage and the new

cult of motherhood: "Idealisation of the mother was one strand in the modern construction of motherhood, and undoubtedly fed directly into some of the values propagated about romantic love."[142] The primary difference between the two compositions is, of course, the emblematic and supernatural aspect of the *Oath*—the putti flying in on vapors, the tablet with the inscribed motto—as opposed to *The Good Mother*'s more down-to-earth genre scene. Yet, in the print medium, the compositions are united by their size, shape, and pictorial treatment, particularly in their forest backgrounds. Such a setting might appear more appropriate in the *Oath,* echoing as it does, through the trees' contortions and the plays of lights and dark, the passion of the lovers; yet in *The Good Mother* the forest's turmoil may have been intended to suggest the equally intense, though more outwardly restrained, passion of motherhood.

 If the *Oath of Love* can so easily be incorporated in the bourgeois ideology of marriage, is the same true of the other Allegories of Love? On one level, yes. We need not imagine that the exalted passion and all-consuming intensity painted by Fragonard actually characterized all, or even most, of the period's marriages. Rather, such representations of intense passion constructed the myths by which lovers and spouses of the time led their love lives, the sources whence they culled their ideals and aspirations. It is here that we find a connection between Fragonard's impassioned Allegories and his more realistic

FIGURE 60
Jean-Honoré Fragonard,
The Visit to the Nursery,
before 1784. Oil on canvas,
73 × 92.1 cm (28¾ ×
36¼ in.). Washington, D.C.,
National Gallery of Art,
Samuel H. Kress Collection,
1946.7.7.

depictions of happy families: Rather than presenting two utterly different conceptions of love, they represent two sides of the same coin. The Allegories of Love function as icons for the new religion, presenting the very myths that fed the much more mundane relationships depicted in the genre scenes of the period. In creating such icons, Fragonard participated in the period's social upheavals by indirectly supporting the new democratization implicit in the ideology of Romantic love.

82

THE ALLEGORIES AND THE
TEMPORALITY OF LOVE

What is our happiest, most cherished dream

Of paradise? Not harps and fugues and feathers

But rather arrested action, an escape

From time, from history, from evolution

Into the blessed stasis of a painting.[143]

—Anthony Hecht, "The Venetian Vespers"[143]

We could stop here our reading of *The Fountain of Love* and the other Allegories, having unearthed in them ideological constructs that support a new ideal of bourgeois monogamy; yet such an interpretation is still incomplete. Having created icons for the new ideal of Romantic love, Fragonard also, at least implicitly, explored in them a contradiction that is inherent in this ideal and which was widely discussed in French Preromantic literature. This contradiction has to do with the temporal status of love, and, consequently, with the possibility of securing a long-term relationship based on the new ideal. It is in Fragonard's seemingly paradoxical representation of this contradiction within the atemporal medium of painting that the Allegories' true power of fascination resides.

THE TEMPORALITY OF ROMANTIC LOVE
AND THE CULT OF THE MOMENT

In the nineteenth-century ideology of bourgeois monogamy, which grew directly out of the new paradigm, marriage figures as the happy end of the tale, after which point the lovers, now safely arrived at their destinations, drop out of the progress of history. Their further existence, presumed to be both happy and consistent with the tenets of bourgeois morality, is unproblematic. Throughout the French Preromantic texts, however, the temporal experience of high Romantic passion is so distinctive as not to allow for a smooth continuity into its more mundane aftermath. For the generation of writers following Rousseau, an early passage in *La Nouvelle Héloïse* provided the template for construing this experience:

Days of pleasure and glory, no, you were not those of a mortal! You were too beautiful to perish. A sweet ecstasy absorbed all your duration, and gathered it to a point, like that of eternity. For me, there was neither past nor present, and I tasted at once the delights of a thousand centuries. Alas! You disappeared, as fast as lighting! That eternity was but one instant of my life. Time has resumed its slowness in the moments of my despair, and boredom measures in long years the unfortunate remainder of my days.[144]

Here we have the full structure of the Preromantics' conception of the temporality of love: the period of happiness is experienced, in the present tense, as an eternity or a flight out of time; the seemingly magical arrest of time is also accompanied by a similar transformation of the surrounding space. As soon as this period ends, however, it is perceived to have barely lasted an instant; and the Romantic subject, expelled from its atemporal Eden, suffers the resumption of the painful flow of mundane temporality. This experience is particularly acute when, like Rousseau's St. Preux and Julie, the lovers are forced to separate; but it also informs relationships, such as that of Dolbreuse and his wife, in Loaisel de Tréogate's novel, where no such outside pressures intervene.

The conflict arises from a perceived contradiction between, on one hand, the transcendent, sacramental quality of the moments of love, filled with passion and ecstatic happiness, and, on the other hand, the more banal quality of everyday existence which, due to the quotidian demands of society, dampens the erotic enthusiasm and prevents the lovers from dedicating their entire beings to each other. The disjunction between the two states was made clear by Madame de Staël, who emphasized the utter separateness of the love experience from the rest of one's life: "One surrenders one's soul to feelings that discolor the rest of existence; one experiences, for a few instants, a happiness that has no connection to the common circumstances of life."[145] The amorous moment "discolors" the rest of existence, presenting to the lover's soul a fullness of perceptions that no other period of his or her life can equal. While the later nineteenth century will both tame the erotic ecstasy of Romantic love and sentimentalize the everyday aspects of marriage, thereby mitigating the disjuncture between such peaks of ecstasy and valleys of banality, during the late ancien régime the gap between the two was perceived as too wide for any continuity. Having once been lifted by amorous ecstasy out of the mundane world and into a heaven of their own making, true lovers, as understood by the Preromantic culture's ideology of love, will not be able to maintain their passion intact upon returning to the everyday world.

In almost all of the texts that display this structure, the disjunction between the two temporal experiences is paralleled by the distinction between enchanted spaces such as the garden and the environments of more mundane pursuits. Loaisel, Rousseau, and Dorat all described the enchanted environment as it was perceived at the height of amorous passion, and it was this environment that Fragonard depicted in the Allegories. In the literary works, the aftermath of the period of loving enchantment is experienced as an alienation from the sacramental moment of perfect symbolic synthesis between subject and subject, as well as between subject and the natural environment. The loss of this magic is made poignantly clear in Antoine de Bertin's poem, "Le bonheur perdu." published in 1780. After the end of a love affair, the narrator laments that "those moments of happiness and of

intoxication / those sweet moments are forever lost." He returns to the scene of his former trysts and fails to recognize in the landscape the enchanted place he had once known:

> This cool vale, closed in by mountains,
> No longer offers my eyes but arid greenery;
> The bird keeps silent, the air is less perfumed,
> And the brook's waves are less immaculate:
> Everything in nature is changed for me:
> Everything displeases me; I am no longer loved.[146]

For Bertin's protagonist, neither the preternatural clarity of perception nor the synesthetic effects characteristic of the environment of Romantic love pertain any longer.

The feeling of return from a magic, atemporal realm of love to the prosaic environment of day-to-day existence is perhaps best expressed by the narrator of Vivant Denon's 1772 novella *Point de lendemain* (*No Tomorrow*), which chronicles a one-night fling. After having perceived the environment as transformed by love throughout the night, the narrator tells us that at dawn, "Everything rushes away from me with the same quickness with which the moment of awakening destroys a dream…Instead of an enchanted nature, I saw but a naïve one."[147] Similarly, when Loaisel de Tréogate's Dolbreuse is called back to military duty and away from his young bride, he describes the disappearance of his magic world in terms very close to Denon's: "Alas! One instant dispelled the most beautiful of dreams…Cruel duty suddenly snatched away from me the magical mirror that made me the inhabitant of an enchanted world."[148]

While Loaisel's and Denon's narrators use essentially the same metaphors to describe their experiences—the dream and the awakening—an important difference appears in how they construe their amorous affairs. Denon's hero, in many aspects still a self-possessed Rococo figure, plays at the game of Romantic love without allowing himself to be consumed by it; he is ready to accept the night's seeming enchantment as a (self-) delusion, and the morning as a return to reality.[149] Loaisel upends Denon's schema: for Dolbreuse only the world of love, once experienced, can still be real; once thrown out of its enchantment, he perceives the outside world as "a confusing tumult, a frightening and despair-inducing chaos," and all its pleasures as "vain and unreal."[150] The Preromantic mind ultimately agrees with Loaisel in stressing the higher reality of its delusions: it sees post-amorous disenchantment as a painful lack in a nature that was once whole and harmonious, rather than as a return to a normal state of affairs. The moment of love is more real, more true, than any other experience a subject can have. It can be argued that Fragonard's *Allegories* also demonstrate this valorization. He depicts love not as a diverting self-delusion, as the Rococo would have it, but as the be-all and end-all of existence. Can one even imagine the characters of the *Fountain* or the *Invocation* in other, more prosaic settings?

Despite the clear distinction on this point between the Preromantic and the Rococo understandings of love, a subtler correspondence can still be drawn between them. The new understanding of the temporal structure of love indeed seems to be very different from the Rococo view of amorous play as circular and unending, with no peaks of irrational passion or depths of despair. However, in its emphasis on moments of the

highest intensity, and in its depreciation of ordinary amatory relationships, the ideology of Romantic love takes the Rococo's emphasis on pure pleasure to its logical extreme. The notion of love proposed by Loaisel, Bertin, and their contemporaries ultimately proved as unable to secure a safe, bourgeois monogamous marriage as the preceding generation's libertinism. The perceived disjunction between two radically different temporal universes seems to be the reason why most of these texts end in tragedy, rather than blissful married life. Loaisel's *Comtesse d'Alibre* ends in sheer gothic blood-splattering; the protagonist of the same author's *Dolbreuse,* called away to the capital after three months of married happiness, falls into Rococo libertinism and gambling. He is finally rescued by his wife and led to a life of Rousseauian happiness, only to see her fall ill and die in his arms. The lovers in Nicolas-Germain Léonard's novel *Letters of Two Lovers from Lyon,* whose story was based on true events, end up committing double suicide. Valmont and Madame de Tourvel, in Choderlos de Laclos's *Les Liaisons dangereuses,* briefly taste true love only to be robbed of it by the manipulations of the marquise de Merteuil, and their fates equally end in death. Indeed, of all the novels mentioned here, only the protagonists of Claude-Joseph Dorat's *Les Sacrifices de l'amour* come to a happy ending, but even then only after a transfiguring near-death illness for the chevalier and a year-long mourning period for his adulterous lover, conveniently freed by her husband's sudden passing.

Furthermore, during moments of ecstasy, morality itself, which is presumed to underlie the Christian, bourgeois notion of marriage, is in danger of being annulled. A direct connection is drawn in the literature between the suspension of temporality and the suspension of guilt: Loaisel's Milcourt and Lucile, like many other Preromantic couples, are adulterous lovers and thus necessarily guilty at the moment of their highest ecstasy. And yet, for the novel's narrator, the very experience of enchantment raises the possibility of their (at least temporary) redemption: "Ye gods! Let us tremble, and not look upon their pleasures, fearful that an imprudent rapture might make us say: *'They are too happy, they cannot be guilty.'*"[151] Guilt, imposed by morality, is reasserted only with the fatal return of temporality.[152] Romantic love, in threatening to suspend guilt and therefore morality, has the potential to be as much a socially destructive as a socially constructive force.

Thus, the cultural products that were most responsible for propagandizing an ideology that posited monogamous marriage as its ideal also seemed to declare that very ideal impossible to attain. From this perspective, there is not as direct a line as might be imagined between Fragonard's iconic Allegories of Love and his more realistic-looking, but also more ideologically prescriptive, genre scenes of happy families. French culture during this period seems not so much to accept Romantic love as an unproblematically constructive social force (as it will be seen during later periods) but to struggle actively with the question of how a continuity could be established between the intoxication of first love and the reality of an actual marriage.

Did French Preromantic culture propose a solution to the contradiction outlined here? Occasionally some authors, such as Dorat at the conclusion of *Les Sacrifices de l'amour,* implicitly urged that Romantic passion be tempered by Christian morality (thereby sowing the seeds of nineteenth-century bourgeois morality). However, most authors did not take into account this possibility—which would necessarily temper the passion of Romantic love. Rather, Preromantic lovers tended to opt for a less realistic solution: Faced by the realization that their intense love affair cannot last forever, they dream instead of arrest-

ing time. As expressed by the lovers in *La Comtesse d'Alibre:* "They wished that time suspended its flight, and that night let its helpful shadows still weigh over the world."[153] Of course, in real life, as well as in the time-based narratives of novels, such an outcome is not an option. But how about in paintings?

LOVE AND TIME IN THE ALLEGORIES

The comparison drawn above between the Rococo and the early Romantic notions of the temporality of love can help us better understand Fragonard's achievement in the Allegories. It is perhaps more than a coincidence that the Allegories, situated between Rococo and Romanticism on the art-historical spectrum, also partake of, and synthesize, both ideological conceptions of love. Yet this synthesis must be very carefully outlined. The Allegories do not simply occupy a position somewhere in between Rococo circularity and Romantic fatality. Rather, they attempt to establish permanence within the very awareness of the early Romantic predicament. Simply put, for their protagonists, they *do* arrest time. This interpretation also points out the basic differences between the treatment of time in images and in the written word. Literature has as a basic element the unfolding of narratives over time; narrative painting, on the other hand, as traditionally conceived, could only select a single moment to depict. Of course, painters since the Renaissance had developed a panoply of devices that, by recalling or foretelling other elements of the illustrated story, enabled them to incorporate into their images a wider sense of temporality. Fragonard, however, rejected all such ploys and, to express the deeper meaning of the Allegories, fully exploited painting's ability to freeze a single instant for eternity.

Let us begin by analyzing *The Sacrifice of the Rose.* While obviously an allegory of the loss of virginity, the *Sacrifice* is unlike most other allegories of this subject from the period in that it represents symbolically the very moment of the deflowering, rather than the actions leading up to it or its regret-filled aftermath. Most libertine prints, such as Philibert Louis Debucourt's *La Rose mal défendue* [Figure 62], depicted actions that (allegorically) preceded the characters' lovemaking—actions whose ultimate resolution, however, was not in doubt (the rose is poorly defended, and therefore the viewer knows it will be stolen). More moralizing subjects, such as Jean-Baptiste Greuze's *The Broken Jug* [Figure 63], also alluded to more than one moment in time: They show the regret that follows the sexual act, while the attributes that justify the paintings' titles represent the girls' now irretrievably lost innocence. A few images did show

FIGURE 62
Philibert-Louis Debucourt (French, 1755–1832), *The Poorly Defended Rose*, 1791. Aquatint and engraving, 54.5 × 40.2 cm (21¾ × 15⅞ in.). Fine Arts Museums of San Francisco, de Young Museum. California State Library Long Loan _.

FIGURE 63
Jean-Baptiste Greuze
(French, 1725–1805),
The Broken Jug, 1771.
Oil on canvas, 109 × 87 cm
(42⅞ × 34¼ in.). Paris,
Musée du Louvre, 5036.
Photo: Daniel Arnaudet,
Réunion des Musées
Nationaux/Art Resource,
New York.

FIGURE 64
Louis-Simon Boizot (French,
1743–1809), *The Theft of
the Rose,* circa 1788. Pale buff
terracotta Sèvres porcelain
with traces of original coat of
grayish-white pigment, height:
30.5 cm (12 in.). New York,
The Metropolitan Museum of
Art, Purchase, Charles Ulrick
and Josephine Bay Founda-
tion, Inc., Gift, 1975.312.2.

the specific moment of the theft or plucking of the rose (rather than
its torching), such as Simon-Louis Boizot's Sèvres design, *The Theft
of the Rose,* of about 1788 [Figure 64], or Michel Garnier's *La Rose
mal défendue* of 1789 [Figure 65]. However, these compositions are
still worlds apart from Fragonard's image: Neither Boizot's old-fash-
ioned Rococo idiom nor Garnier's *petite manière* even come close
to the *Sacrifice's* extraordinary sense of passion. While presenting
the allegorical action in the present tense, they do not endow that
present with the kind of sexual ecstasy found in the *Sacrifice,* and
thereby do not embody the passion they are meant to connote.

As opposed to these images, Fragonard's painting depicts
(allegorically) not only the very moment of the loss of virginity but
also the orgasmic intensity that accompanies this act and which,
according to the concept of Romantic love, helps to overcome its
momentariness. No place is left within the *Sacrifice* for consider-
ation of any moral consequences the action of the lovers might
have. Fragonard's passionate figures inhabit a world wholly unaf-
fected by the temporal emotions of loss and regret; they are ideal
embodiments of lovers transfigured by ecstasy into eternity.

FIGURE 65
Michel Garnier (French,
1753–1819), *The Poorly De-
fended Rose*, 1789. Oil on can-
vas, 46.2 × 37.6 cm (18³/₁₆ ×
14¹³/₁₆ in.). Minneapolis Insti-
tute of Arts, Gift of Mr. and
Mrs. Jack Linsky, 64.63.1.

Can the same be said of the other Allegories of Love? The movement of *The Foun-tain of Love*'s protagonists is arrested by the necessarily momentary nature of a painted image, yet the élan of their bodies leaves no doubt as to the very proximate fulfillment of their desires. This kind of premonition differs considerably from the one in Debucourt's *La Rose mal défendue;* while that print alludes to the action that will probably follow the one depicted (from the *fight for* to the *taking of* the rose), Fragonard's painting shows a single act which, once begun, cannot be stopped. Like the *Sacrifice,* the *Fountain* leaves no place for the consideration of any other action; it seems nearly impossible (and, what is more, meaningless) to imagine the seduction that led to its lovers' mad rush, or any pangs of conscience once the cup has been drunk, let alone the couple's contented married life years down the road. Here, as in the *Sacrifice,* Fragonard exploits painting's ability to freeze a single instant of a movement in order to suggest both that movement's inevitability and the seeming eternity of the action depicted. Timeless, the protagonists of the *Fountain* are no longer characters in an anecdotal narrative. The painting, instead, becomes an emblem for passion's highest moment, which, through the magic of art, can be prolonged indefinitely. For once, the otherwise unattainable dream of a flight out of time has been achieved.

That this dream could still be read in the *Fountain* more than half a century after its creation is shown by the decoration on a clock owned by Prince Paul Démidoff, who also owned the Wallace Collection's version of the painting, and who probably commissioned

90

— 19 —

77 — Très riche et très importante PENDULE EN MALACHITE et bronze doré et argenté, *qui n'a jamais été reproduite et est garantie unique.*

Elle représente *la Fontaine des Amours,* d'après le tableau de Fragonard.

Toutes les figures, au nombre de quinze, sont très finement ciselées et dorées au mat.

N° 77.

La base est de style rocaille.

Cette pendule forme, avec les deux candélabres (n° 76), une garniture tout à fait exceptionnelle.

Haut., o m. 91 cent.; larg., o m. 89 cent.; profond., o m. 6o cent.

FIGURE 66
Clock from the collection of
Prince Paul Demidoff, Cata-
logue of Prince Paul Demidoff,
San Donato, Florence (sale,
March 15, 1880, no. 77).

the timepiece [Figure 66].[154] The clock, now known only from an illustration, restaged and amplified Fragonard's painting with figures of gilt and silvered bronze against a background of malachite. Set on an asymmetrical rocaille base flanked by tritons, it was a typical piece of Rococo Revival design and probably dated to the mid-nineteenth century.[155] To the *Fountain*'s lovers was added another couple, rushing in from the opposite direction, the fountain's water basin was omitted, and cupids offered the couples drinks from a waterfall flowing down from the clock's face. The most important iconographical addition, however, was the figure of Father Time, lying atop the rocks that constitute the clock's body. He has fallen asleep, and a cupid is taking away his scythe. This added iconographical element clearly signifies the underlying meaning of *The Fountain of Love:* the arrest of

the unforgiving march of time and the blunting of its power to bring everything, even the most passionate love affair, to an end. To convey this message, however, the clock necessarily moved away from the painting's subtler symbolism and reverted to a more explicit allegory typical of the Rococo.

The other two Allegories of Love also participate in this fantasy of arresting time. This is particularly clear in *The Oath of Love,* where the wish for love to last forever is stated in so many words on the plaque the male protagonist touches. The image's pictorial treatment alludes to the same notion: a presumably momentary action—a kiss—is painted so as to recall, in both the protagonists' stances as well as in their flamelike fusion, the highest peaks of amorous passion, and thus to transcend momentariness. *The Invocation to Love* has fewer iconographical details than any of the other Allegories, but its heroine's stretched, unbalanced pose, which fully embodies the sense of her sexual ecstasy as she offers herself to Love, easily lends itself to the same interpretation. Her passion is fully *there* in the moment depicted, which, while it lasts, seems to last forever.

The Allegories of Love, then, must be understood against the ideological background of their period: Fragonard depicts in them the very moment of onrushing passion, the single instant when reason and guilt are suspended. In doing so, he also suspends time, and his protagonists, for the duration of a breath, live an eternity in an enchanted world wholly unlike our own. We should recall here Madame de Staël's reference to love "discoloring" the rest of existence: "one experiences, for a few instants, a happiness that has no connection to the common circumstances of life." It is from that separate world of ecstasy that the Allegories seem to emanate, and, in comparison to them, all other contemporary depictions of love appear, so to speak, colorless.

Having established this interpretation, we can return to our own, twenty-first-century version of a moralized reading. To what extent do the Allegories reflect the bourgeois ideology of marriage? Yes, they depict, in iconic form, myths to be consumed by real-life couples, who might have felt enjoined to strive for the ardent passion that the pictures symbolize. Yet the Allegories also present such striving to be ultimately useless: In their explicit refusal to countenance a larger story, the before and after of ecstasy, they reveal these myths to be utterly unrelated to, and unattainable in, the banal world of everyday existence. This radical disjunction between the fantasy world of the Allegories and the viewers' reality gives the paintings the poignant overtone of despair and nostalgia that has been read into them by some modern viewers.

LOVE FOREVER AND LOVE AFTER DEATH: THE VIENNA *KISS*

If the seeming permanence of the moment of ecstasy proved in the end to be an illusion, upon the dissolution of which the lovers were inexorably returned to an unforgiving world, the Preromantic writers did not abandon the search for another way of securing permanence for a love affair. Unable to find any such sense of permanence within the mutability of everyday existence, they ended up taking recourse in a state beyond life: death itself. Fragonard also depicted the same solution in a drawing that, it can be argued, must be associated with the Allegories of Love, possibly even as a sketch for an Allegory that was never painted.

Within the early Romantic ideology of love awareness of death could take two forms: a demystified understanding of death's utter destruction as the only foreseeable conclusion to the lovers' situation or else a reversal of this structure into a more enchanted view of the lovers' fate after death. Both views are captured in Nicolas-Germain Léonard's 1780 novel *Letters of Two Lovers from Lyon.* The novel's male protagonist, writing to his beloved at a time of despair, and surrounded by the kind of forlorn autumnal landscape that, as in Bertin, symbolizes the tragic end of the love affair, describes his state of mind: "I sigh, finding myself alone in the midst of time's ravages; its destructive power, spread out across the universe, makes me think of the moment when you and I will no longer be."[156] However, this perception of ultimate destruction can be turned on its head, and the desired immortality of the love affair can be found in the very eternity of death. Only a few pages later, Léonard's hero, confronted with death's nihility, chooses to believe instead that death will mark the liberation of the loving souls from the materiality of their bodies and the mutable world of the senses and that they will ultimately find reunification, as eternal souls, in a realm beyond change: "I flatter myself with the thought, I hope that the same attraction that brought together in this life two sensitive souls will be able to survive the destruction of matter, and to preserve itself in them like the elementary fire that had inhabited them both."[157] Such hopes clearly rested on a parallel being drawn between ecstasy's illusory flight out of time and death's ultimate and more stable permanence. As Loaisel's Dolbreuse put it:

> Our intellectual powers, by dint of concentrating and melding together in the soul of a beloved spouse, train themselves and perhaps learn to do without the dealings of the senses, and to separate themselves from all that is earthly around them. It is usually after such fleeting and so fortunate hours that we see without fear, and that we even desire sometimes the instant of that dissolution.[158]

Despite the passage's metaphysical language, this analogy between love and death must have also owed something to the popular euphemism that designates orgasm as a *petite mort* (little death), or, in Dolbreuse's more involved circumlocution: "that enchanting death whose symptoms evinced pleasure and forced one to envy its victims."[159]

A reliance on the afterlife to provide permanence for otherwise doomed love affairs had, of course, been a part of the vocabulary of passionate love at least since the Middle Ages. Already in the mid-twelfth century Héloïse's lover, Abelard, addressed the Lord in a prayer sent to his distant beloved: "And those whom, for a brief time, you separated on Earth, reunite them in yourself in the eternity of heaven."[160] More immediately, however, the writers of Léonard and Loaisel's generation derived this construct, like many of their other metaphors and inspirations, from Rousseau. The paradigmatic instance, in this case, is the powerful ending of *La Nouvelle Héloïse,* one of the many instances where Rousseau's novel demonstrates its fidelity to its medieval source. There, the dying heroine takes pleasure in her fate, knowing that in death lies her last hope for a reunion with her lover St. Preux: "No, I am not leaving you, I'll wait for you. The virtue that separated us on earth will reunite us in the eternal abode. I die with this sweet expectation."[161]

Fragonard himself proposed a similar answer to the urgent question of love's temporality in a drawing, *The Kiss,* now in the Albertina [Figure 67]. This drawing has been dated to various periods of Fragonard's life, but it must be related to the Allegories of the 1780s,[162] particularly since the only secure date we have for it is 1785, when an *amateur,* the comte de Paroy, engraved a version of it as his *morceau de réception* and then exhibited it at the Salon [Figure 68].[163] The association with the Allegories is also supported by the closeness of the drawing in handling to the preparatory sketch for *The Oath of Love* [*see* Figure 15].

The Kiss shows a large Roman sarcophagus in the center of a forest clearing surrounded by cypresses and low bushes. The sarcophagus has a break in its side wall. In the foreground its lid lies on the ground; several jagged lines suggest an inscription, which is, however, unreadable. An adolescent Eros with a quiver of arrows on his back flies in from the left and plunges his torch into the tomb; his position echoes that of his counterpart in *The Sacrifice of the Rose.* Inside the sarcophagus, an urn, lying on its side, releases vaporous clouds that merge with the smoke of Cupid's torch. Out of these clouds an embracing couple materializes, kissing passionately. While Fragonard created most of the drawing in varying shades of wash, he constructed the clouds as well as the lovers of simple, thin chalk lines against the white reserve of the paper. A multitude of putti are strewn around the clouds of smoke, and the surrounding cypresses lean down over the open sepulchre, seeming to look down tenderly onto the resurrected lovers. On the trunk of one of the cypresses hangs a panpipe, a detail which, more explicitly than in any of the painted Allegories, places the scene in a mythical Arcadia. (De Paroy's print includes, in addition to the panpipes, the kind of flared flute satyrs were often seen to play, making the Arcadian reference even more specific.)

Eros' torch illuminates the entire scene. Its fire, highlighted by its contrast with the dark wood of the handle, renders the interior of the sarcophagus nearly incandescent; in the midst of this brightness, the thin lines out of which the embracing lovers are fashioned look almost like the consuming filaments of an electric bulb. Narratively, the flame functions as the agent that brings the lovers back to life; symbolically, its glow inside the sarcophagus represents the eternal life of love in the midst of death. Once again, however, this allegorical meaning is not rendered just emblematically: the pictorial power of the burst of brightness at the picture's center, combined with the forcefulness of the spectral lovers' embrace, directly conveys the message of passion.

The allegorical meaning of *The Kiss* is made explicit in the motto appended by the comte de Paroy to his print: "Spirat adhuc Amor / Vivuntque commissi calores." The line, from the *Odes* of Horace, can be translated as "Love still breathes, and passions still live."[164] This motto was particularly appropriate, inasmuch as the word for "passions," "calores," can also be translated as "heat" or "glow"—an ambiguity that parallels the double function entrusted by Fragonard to Eros' torch.

Elements of the iconography of *The Kiss* can be found throughout the literature of the period; Fragonard, however, puts his own twist on these tropes by reversing their usually pessimistic import. *The Kiss*'s equation of the grove of love and a bower of funerary cypresses, for example, has a parallel in one of Antoine de Bertin's odes from his *Les Amours* of 1780. Bertin retells his poet-narrator's impressions upon returning to the site

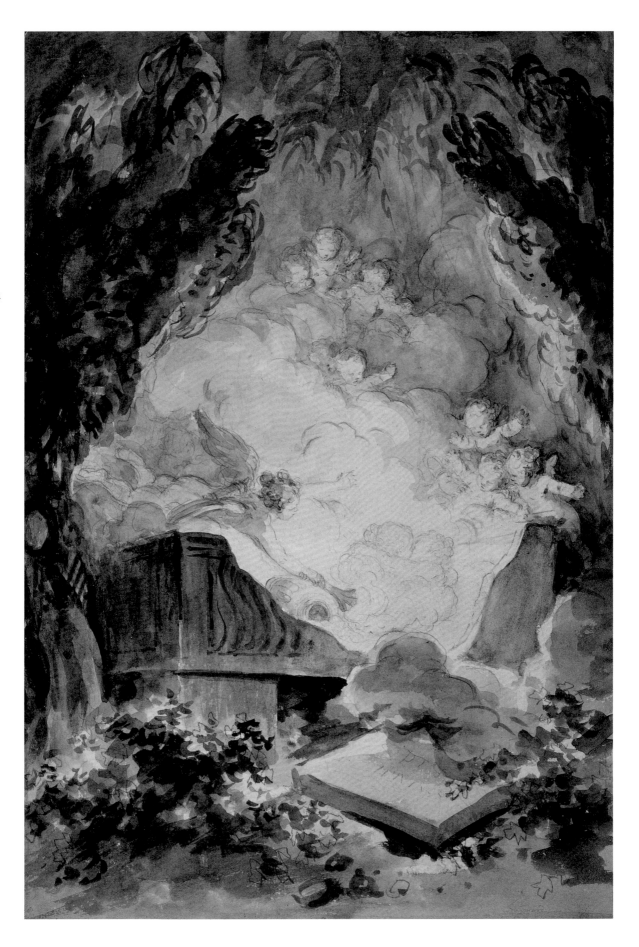

94

Spirat adhuc Amor
Vivunt que commissi calores.

OPPOSITE

FIGURE 67
Jean-Honoré Fragonard,
The Kiss, circa 1785. Brush
and brown wash over black
chalk underdrawing on paper,
45.3 × 31 cm (17⅞ × 12¼ in.).
Vienna, Albertina, 12.726.

FIGURE 68
Jean-Philippe-Guy Le Gentil,
comte de Paroy (French,
1750–1824), after Jean-Honoré
Fragonard, *The Kiss*, 1785.
Engraving. Bibliothèque
Nationale, Paris, Cabinet des
Estampes.

95

of his former love affair, a typical "solitary bower / bed of greenery impenetrable by light."
Metaphorically, the poet envisions the grove's vegetation to have changed in harmony
with his feelings and finds himself "in these dark woods [that are] into cypresses trans-
formed."[165] For Bertin, this transformation is clearly part of the demystified acceptance
of temporality that follows the end of a love affair. In Fragonard's drawing, however,
the metamorphosis occurs in the opposite direction: the mourning cypresses have been
transformed back into a newly joyous grove of love.

We can find a closer parallel to *The Kiss* in poem XIX of Dorat's *Baisers* (*The
Kisses*), which outlines its fantasy of eternal life by drawing a parallel between the terres-
trial love-garden and the heavenly realms that await the lovers after death. The groves of
Paradise, as described by Dorat, "those gardens / that in the Elysian fields are open to the
virtuous humans," follow exactly the formula of the enchanted garden as setting for a love
affair analyzed in the last chapter:

> On all sides there are spouting fountains,
> Whose crystalline water falls and flees under the laurels;
> Zephyr murmurs and plays among the reeds,
> Waves the flowers' odoriferous harvests,
> Disperses their scents, and in this beautiful abode,
> Blows with pure air the passions of love.[166]

Even the incandescence of Fragonard's lovers can be found in the poem. It is the
very fire of their passions that will protect Dorat's lovers from death's blow:

Believe me, young Thaïs, death isn't to be feared.

Its scythe will break on Love's altar.

Come, we burn with a fire it cannot extinguish.

Tell me, is it to die, to love forever?

Our souls will survive the end of our days;

To soar up toward him by new paths,

The god that shaped them will lend them wings…[167]

Throughout the Preromantic literature that outlines this fantasy, the surviving souls of the forever-united lovers are compared to flames, suggesting both their immateriality and their passion. In Dorat's heaven, "tender lovers' shades chase each other; / These lovers are no longer, but their fires live on."[168] In similar fashion, Léonard took refuge in an image of death liberating the amorous souls from their physical bodies and reunifying them into a single fire, an image that the drawing makes concrete and which also finds a parallel in the "whirlwind of fire, the center of which was love"[169] into which the souls of Jean-François Marmontel's lovers in "Le Scrupule" merged during their passion. Loaisel's *Dolbreuse* likewise describes the detachment of the lovers' souls from "everything terrestrial around them"[170] as they experience the moment of highest passion, or orgasm. Death, then, as the stripping away of all materiality that kept the lovers' souls separate, is the ultimate form of merging, the one instance when such a fusion can be imagined as more than metaphorical. This merging is also represented in Fragonard' drawing: United throughout eternity, the two lovers' souls form a single entity, born out of fire and smoke, a merging made incandescent through its pictorial treatment.

The Kiss serves as the crowning piece of evidence in an important study by Erwin Panofsky exploring the notion of temporality as expressed in the medium of painting. Having traced the treatment of the theme of "et in Arcadia ego" from the early seventeenth to the late eighteenth century—that is, from the saying denoting an awareness of Death's presence in even the happiest of Arcadias to the attribution of the words to a former human inhabitant—Panofsky closes his argument with Fragonard's drawing. For him, *The Kiss* occupies at the same time a central and an eccentric place within this tradition:

Fragonard, on the other hand, retained the idea of death; but he reversed the original moral. He depicted two cupids, probably spirits of departed lovers, clasped in an embrace within a broken sarcophagus while other, smaller cupids flutter about and a friendly genius illuminates the scene with the light of a nuptial torch. Here the development has run full circle. To Guercino's "Even in Arcady, there is death," Fragonard's drawing replies "Even in death, there is Arcady."[171]

Despite Panofsky's slight mangling of the picture's iconography,[172] his decipherment of the picture's message is fully in accordance with the reading offered here. In *The Kiss* Fragonard assumes the inevitability of death and then pierces through to its other side, to rediscover there, in a form that is now presumably insulated from the devastating effects of time, the paradise of love, or Arcady. We cannot know whether Fragonard was

consciously aware of the tradition outlined by Panofsky, or whether he intended to "reverse its original moral." What he did accomplish in *The Kiss*, however, was to counter the idea that it is impossible for any powerful erotic passion to have a happy ending, that any love caught within temporality is of necessity doomed. To this attitude he offered one type of counter-argument in the entire series of the Allegories; the retort offered by *The Kiss* does no more than continue and extrapolate that counter-argument, following the same logic that led, in Preromantic literature, from the fantasy of escaping temporality during the moment of love to the dream of love after death.

THE TEMPORALITY OF LOVE AND THE TEMPORALITY OF ART IN THE ALLEGORIES

Fragonard's overturning of the idea that love must end tragically, in both the Allegories and the Albertina drawing, may be seen as purely fanciful, a mythologizing self-delusion that tries to avert the viewer's eyes from the unforgiving march of time, from a more "authentic" or demystified acceptance of fatality. Yes, the lovers in *The Fountain of Love* live their fantasy—but it is only the frozenness of the painting's image that allows them to live it forever. Yes, *The Kiss* may depict a wonderful dream—but that's all it is, just a dream, is it not? The wonder of Fragonard's images, however, is that through their pictorial power, for a few minutes at least, we can be convinced of the reality of this delusion. We are confronted with love's eternal enchantment each time we gaze at *The Fountain of Love;* each time *The Kiss* is exhibited, that enchantment comes alive. If the Allegories ultimately have little to say about our everyday experience of love, they have much more to say about art's ability to record, and eternalize, an otherwise unattainable dream. The enchanted realm of pure ecstasy may never be completely realizable in our day-to-day world; yet, in its ideality this state bears an uncanny resemblance to that secondary world onto which every work of art opens. If love is somehow to be rendered eternal, it is only through art that this can be accomplished: this may be the ultimate message of the Allegories.

While this kind of understanding of art's power is never explicitly stated in the meager contemporary commentaries on the Allegories, at least one eighteenth-century viewer appears to have perceived such magical power in *The Kiss:* the comte de Paroy himself, as evidenced in the motto he attached to his print. If Sappho's "love still breathes, and passions still live," it is not by virtue of some magical survival, but because these emotions were recorded, confined to writing: Love and passion live on in art, in the written word, which will help them outlast the ravages of time. As Horace explains elsewhere in the same ode, many heroes had fought and loved before those of whom Homer sang. "Many heroes lived before Agamemnon; but all are overwhelmed in unending night, unwept, unknown, because they lack a sacred bard. In the tomb, hidden worth differs little from cowardice."[173]

De Paroy's use of the Horatian motto, at least as we first interpreted it, can be seen as a misreading of the passage's original import: for Horace, love is not to survive supernaturally, as iconographically depicted by Fragonard, but is to live on in art, which will help it outlast the ravages of time. Perhaps de Paroy, however, placed his motto on the

print advisedly: perhaps it is not only to the image's iconography that it refers but also to the power of Fragonard's drawing to record the passion of love and preserve it, unchanged, across time.

What De Paroy implies about *The Kiss* can also be said about the Allegories proper. Fragonard's exploitation in the Allegories of painting's ability to freeze a single moment in time has already been discussed above. It can be argued that the Allegories highlight the close relationship between art's physical endurance and its ability to freeze a moment in time: That ability would not mean so much to us if we were not aware that the lovers in the *Fountain* not only kept reaching for the proffered cup long before our own existence but also will continue to do so long after we are gone.

To further explore the relationship between art's Horatian vocation and its temporal frozenness, as exploited in the Allegories, we can briefly turn to viewer-response theory, in order to study the actual confrontation between the work of art and the spectator—specifically, how the time of the represented events relates to the actual time of the viewing experience. From this point of view, traditional representational painting can be broadly divided into two categories. One, which can be dubbed "poetic," includes subjects such as still lifes or (most) landscapes. The referent reality for these works remains basically unchanged over a significant period of time (making allowance for small details, such as traveling clouds or flickering candles). One does not expect the subject of a still life or landscape to change significantly over the one, five, or even ten minutes devoted to its viewing, and thus there is no contradiction between the temporality of the depicted scene and that of the viewer looking at it. In the other category, which can be designated "dramatic," are images, such as most history or genre painting, in which a single moment in an ongoing action is depicted and therefore movement and life are necessarily frozen. Here, the time depicted and the viewer's time coincide for only the duration of a glance, if even that. The longer we stand before these scenes, the stranger they appear: horses remain in bucking position for a day, a month, or an eternity; Brutus' knife never quite gets to murder Caesar; and the lovers of *The Fountain* never stop running toward the cup proffered to them by the cupids.[174]

"Dramatic" painting thus reveals a paradox inherent in all static works of art, a paradox that such images highlight, while those belonging to the "poetic" category do their best to tame.[175] The experience of this paradox—the eternal freezing of a dramatic action in a work of art, but also the promise such a freezing holds of rendering that action, and the larger concept or feeling it symbolizes, eternal—was analyzed in great detail at the other end of the Romantic period, three and a half or so decades after Fragonard painted *The Fountain of Love,* by John Keats, in his "Ode on a Grecian Urn," which provides some fascinating parallels to the Allegories. A closer reading of Keats's poem not only highlights those parallels but provides a fitting conclusion to this commentary on the temporal aspects of Fragonard's paintings.[176]

The urn, according to Keats, is a marble vessel decorated with relief scenes of youths in a pastoral setting playing music and chasing each other in amorous dalliance on one side, and a religious sacrifice with a priest leading a heifer to an altar on the other. Although described as a "bride of quietness" and a "foster-child of silence and slow time," the urn nevertheless carries images of unbridled passion and energy: "What mad pursuit? What struggle to escape? / What pipes and timbrels? What wild ecstasy?"[177] The temporal

paradox is embodied in the dissonance between the qualities of the two worlds to which the urn belongs—the outward silence, quietness, and "slow time" of the viewing experience, and the sound, struggle, and action of the represented scenes. The conjunction of these two dimensions insures that the frozen passion of the represented characters, especially in the case of the scene of amorous dalliance, which fits the "dramatic" category, is projected into eternity:

> Bold lover, never, never canst thou kiss,
> Though winning near the goal—yet, do not grieve;
> She cannot fade, though thou hast not thy bliss,
> For ever wilt thou love, and she be fair! [178]

These lines provide a surprisingly apt description of the viewer's experience before Fragonard's *Fountain*. For Keats, the image on the urn defeats the inexorable fatality of time: "Ah, happy happy boughs! That cannot shed / Your leaves, nor ever bid the Spring adieu."[179] More importantly for our purposes, it insures that love itself is not subjected to that fatality: "More happy love! More happy, happy love! / For ever warm and still to be enjoy'd, / For ever panting, and for ever young."[180] Because love is purified in the work of art, this situation also solves the Preromantic dilemma of the return to mundane temporality; the urn is above "all breathing human passion…That leaves a heart high-sorrowful and cloy'd."[181]

We can clearly see here how the two paradoxes with which this chapter has been concerned—the Preromantic predicament of love and the temporal contradictions of "dramatic" painting—are conjoined. The first paradox's two disjunct temporal universes—that of perfect passionate love, and that of everyday life—in Keats are translated as the difference between the realm of art and the realm of the viewer, our own realm. Similarly, the longer we stand before *The Fountain,* the more pronounced we feel this disjunction: Eternal love is possible there, where time is arrested, whereas we, as viewers, live in unforgiving temporality. The Preromantics' bane has been lifted, but at a heavy price: that of love's possible survival only in the world of art and not in our sublunary realm, where hearts are left "high-sorrowful and cloy'd." Nevertheless, love at least survives *somewhere,* and its power can be activated each time that a viewer—be it in Paris in 1785, in Victorian England, or in twenty-first century Los Angeles—interacts with one of the Allegories as Fragonard intended, and allows himself or herself to be fascinated by the image before them.

AFTER THE ALLEGORIES: ROMANTIC LOVE AND REVOLUTION

Although the chronology of Fragonard's late period is notoriously hard to establish, he does not appear to have created during the remainder of the 1780s any more images that relate to the theme of the Allegories. Indeed, his production seems to have begun to fall off around then, perhaps in response to the rising fashion of Neoclassicism or to the public's perception of him, perpetuated by the Salon critics, as an artist increasingly out of step with his time, one who had wasted his early promise by holding on to a superannuated style and by refusing to show at the Salon and follow the grand manner of history painting. Such a perception was exemplified by the anonymous author of the *Discours sur l'état actuel de la peinture,* of 1785:

> M. Fragonard, born with an amount of genius sufficient to create several art-
> ists, does not seem to us to have fulfilled all his obligations toward nature [i.e.,
> the source of his genius]. Far from following the royal road of his art, where
> the greatest successes would have been guaranteed to him, he strayed onto
> small unknown paths, to fashion for himself a manner more appropriate to the
> delirium of the imagination than to exact truth.[182]

Granting that Fragonard had had a few "deserved successes," the writer nevertheless criticized him for not having fulfilled his talent's true potential, and discussed him as strictly belonging to the past: "His ambition limited itself to shining a few flashes, in the course of a career in which his genius could have cast a greater and more durable light…it will always be regretted that M. Fragonard did not choose to soar to greater heights than he did."[183]

Interestingly enough, this critical view echoes the formal differences which, by 1785, were evident between Fragonard's work and the kind of Neoclassical painting, such as David's *Belisarius* or *The Oath of the Horatii,* which the anonymous writer championed. The critic's citing of a "few flashes" might as easily refer to the *effets de lumière* that defined Fragonard's Rococo *papillotage,* and which are still found in the Allegories of Love. On the other hand, the reference to the "greater and more durable light" that could have been his eminently describes the treatment of light in David's pictures. Similarly, the grand "royal road of his art" which he could have taken is opposed to the "small unknown paths" onto which Fragonard had strayed, and which immediately put us in mind of the labyrinthine arabesques of Rococo decoration. Such formal differences had now become

the rhetorical figures of Fragonard's failure; and the condemnation of his style of painting was inscribed in the very vocabulary used by the critics.

The author of the *Discours* seems not to have known about the Allegories, which constituted Fragonard's principal attempt during this period to keep up with its changing fashions. Of course, we cannot expect him to have known about them, as by the date of his writing none of them had been published as engravings, and the author most likely did not have access to the cabinets of the rich collectors who had commissioned them. But maybe it would have made no difference had he known them. From the point of view of a Salon critic, the earliest of the Allegories to be reproduced in print form, *The Fountain of Love,* might have been seen as a radical achievement had it come out, say, in the late 1770s. However, published as it was in December 1785, and thus in the immediate wake of David's Salon triumph with *The Oath of the Horatii,* it could not have the same impact. Yes, the *Fountain* formally echoed the planar compositions of Neoclassicism, but while David's *grandes machines* made loud public statements about the citizen's duty to his country, the erotic theme of the *Fountain* could easily be seen as nothing but a continuation of Rococo hedonism. Furthermore, its proto-Romantic touches, so clear to us in retrospect, might have simply escaped a writer primarily concerned with the social and moral reform of French painting as a public phenomenon, and who thus had little interest in the solipsistic, private realm of love.

Moreover, when it comes to Fragonard's career, the author of the *Discours* may have been more right than not. The Allegories constitute the single coherent statement Fragonard made in his art in the 1780s (unless we consider his series of prints of domestic scenes, many of which were based on much earlier compositions). At the Salon de la Correspondance, the private exhibition space where Fragonard exhibited between 1778 and 1785, he showed primarily watercolors, gouaches, and oil sketches of landscapes, as well as a couple of genre scenes and at least one religious subject; none of the Allegories were exhibited, and many of the works on show were likely painted years before the date of their exhibition. It is clear that, despite having had a chance to make a public statement in a forum different from the official Salon, and thus free of the Salon critics' ideologically based rhetoric, Fragonard chose to think of this venue as primarily a clearing house for his lower-priced works.[184]

The latter part of the 1780s, as well as, perhaps, the early 1790s seem to have been taken up by a series of illustration cycles, for Ariosto's *Orlando Furioso* [Figure 69], for Cervantes's *Don Quixote,* and for Madame du Genlis's *Les Veillées du chateau.* Yet here Fragonard, intentionally or not, repeated the pattern he had fallen

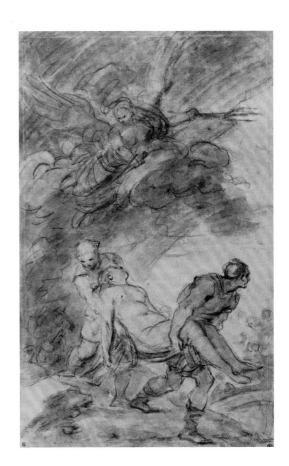

FIGURE 69
Jean-Honoré Fragonard, *Angelica Abducted by the Inhabitants of the Isle of Ebuda,* circa 1790. Black chalk and brown wash on paper, 39 × 25 cm (15$\frac{3}{8}$ × 9$\frac{7}{8}$ in.). Dijon, Musée des Beaux-Arts.

into with his decorative commissions of the late 1760s and early 1770s: None of these illustration cycles were completed or published, and they survive primarily as drawn sketches, not worked up enough to lend themselves immediately to engraving. One wonders if they were ever meant for publication. It is tempting to think of the *Orlando Furioso* and *Don Quixote* cycles, especially, as the responses of an ardent leisure reader who, feeling bypassed by contemporary fashions and no longer concerned about making art professionally (by the time he was drawing some of these images, Fragonard may already have started working as a curator at the newly founded Louvre museum), sketched as he read, for his private enjoyment or for that of his family and intimate friends, for no other purpose than to give concrete form to the mental images evoked by the writings.

Fragonard returned to the theme of the Allegories, though not necessarily to their formal treatment, only once more, but spectacularly so, in what may very well have been his very last artistic statement. Sometime around the turn of the decade he got a chance to redeem the most spectacular failure of his decorative commissions, namely the Progress of Love cycle which he had painted for Madame du Barry's pavilion at Louveciennes. After the panels had been rejected, they were returned to the painter and seem to have remained rolled up in his studio for the next two decades. In 1790, he took them along when he left Paris for his native town of Grasse, and by 1791 he had reinstalled them, along with ten other panels of varying size and importance which completed and amplified the cycle, in the central salon of his cousin Maubert's villa there.[185]

After the breakthrough of the Allegories, the decorative program at Grasse may seem a throwback: in order to match the formal qualities of the four original paintings, Fragonard had to return to a more Rococo palette, treatment of light, and compositional structure. However, the Villa Maubert ensemble can also be seen as an attempt to rethink a high Rococo decorative program in the spirit of French early Romanticism. Just as the Louveciennes paintings had influenced the Allegories—most notably in the case of *The Oath of Love*—Fragonard now took the lessons of the Allegories and applied them to his reinstallation and amplification of the original panels. The end result makes not only for a fascinating hybrid but also for what may be Fragonard's final word on the master theme of his entire career—Love itself.

To the original four paintings, Fragonard added two new panels of comparable size, *Reverie* [Figure 70] and *Love Triumphant* [Figure 71]. He also added four narrow decorative panels of hollyhocks and four overdoors with emblematic scenes of Cupid, two of which repeated compositions created by Fragonard as early as 1777. *Reverie,* which shows a young woman alone at the foot of a high sundial, the needle of which is the arm of a sculpted Cupid, can be interpreted not simply as the first episode of the story but also as the representation of an act of imaginative conjuring—the young girl's dream of the amorous possibilities that are still in the future. The painting then becomes a kind of invocation of love, akin to the Allegory of the same title, which also features an interaction between a passionate female figure and a marble statue of Eros.

Directly across the room from the *Reverie* hung an allegorical representation of the intense love for which the young woman is longing, *Love Triumphant*—indeed, the

FIGURE 70
Jean-Honoré Fragonard, *The Progress of Love: Reverie,* 1790–91. Oil on canvas, 317.8 × 197.1 cm (125⅛ × 197.1 in.). New York, The Frick Collection, Henry Clay Frick Bequest, 1915.1.49.

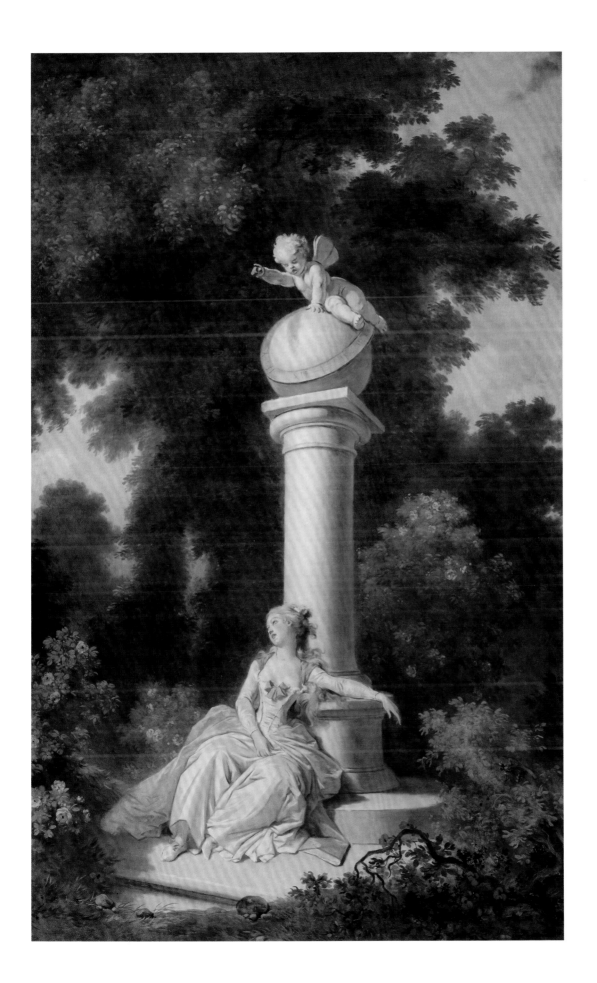

FIGURE 71
Jean-Honoré Fragonard,
*The Progress of Love: Love
Triumphant,* 1790–91. Oil on
canvas, 317.5 × 143.51 cm
(125 × 56½ in.). New York,
The Frick Collection, Henry
Clay Frick Bequest, 1915.1.50.

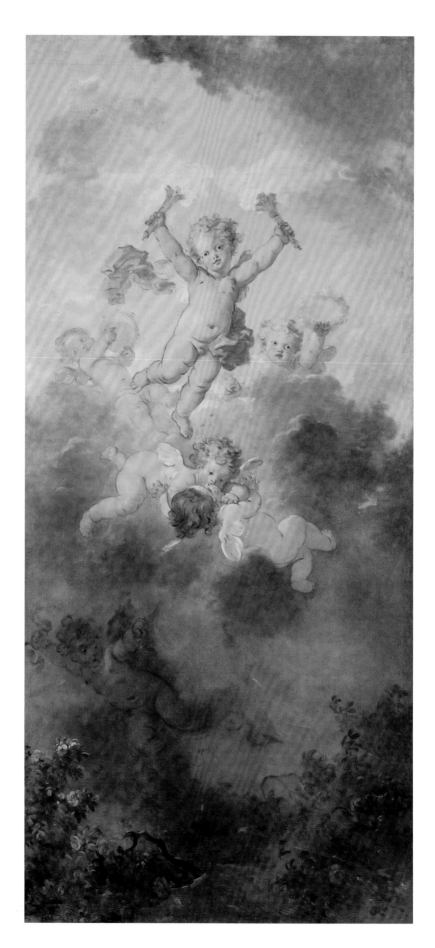

cupid on the sundial in *Reverie* could be said to have pointed directly across the room to this panel. In this painting, a glorious Cupid soars into the skies with two torches in his hands, while his assistants frolic about him; he erupts from and rises above a fiery cloud, in which we can make out the shape of a darker, demonic putto, carrying serpents and a dagger. While Fragonard clearly returns here to a more established, Rococo allegorical vocabulary, more important than the painting's iconography is its immediate visual impact, the incandescent painterly treatment that embodies the fieriness of Cupid's torch and the ardent intensity of passionate love. In its combustive atmosphere, *Love Triumpant* recalls the overall effect of *The Kiss,* in which the primary signifier of passionate love is also fire. Like that drawing, it mobilizes all the formal means at its disposal to suggest, pictorially, an overwhelming intensity of the amorous feeling than cannot be dubbed anything other than Romantic.

The hollyhock panels in the corners of the room, designed to cover all the remaining wall space, continued the garden setting of the other images, thus helping to turn the entire Maubert salon into a trompe l'oeil garden of love. They unified the previously discrete images, which might have been read as separate panels in a sequential narrative, each assigned a different point along a timeline, into a single, three-dimensional space shared by a variety of lovers engaged in their trysts, as well as by the triumphant Cupids who came to life between the two windows. In all these aspects the Grasse ensemble, as originally installed, moved toward the dissolution of the boundaries between levels of representation, as well as between art and real life. This move shifts the series from an allegorical mode of signification to a symbolic one, yet another indication of its underlying early Romantic sensibility.

Fragonard signed a receipt for the Grasse ensemble on March 10, 1791, by which time the paintings were probably all in place. Within a year, the region around Grasse was erupting in riotous violence (by that time, however, the painter and his family were back in Paris).[186] The juxtaposition of the private, magical love-haven inside the Villa Maubert and the social realities of the time seems, to say the least, somewhat surreal, especially when we realize that Grasse's Parc du Clavecin, which is about two hundred feet from the Villa, was during 1793–94 the site of the local guillotine, where over thirty men were put to death.[187] That one could, in a few minutes' walk, bridge the gap from the Terror's mindless bloodshed to the painted ecstasy of *Love Triumphant* is almost beyond comprehension—as if some black-hole-like shortcut had been established between two utterly separate, dissimilar universes.

Is this apparently unbridgeable gap the same as that between the private and the public, with which we began our discussion of the social context of Fragonard's late production? By absenting himself from the Salon and by retreating into an imaginary world of ethereal, orgasmic couples, had Fragonard completely severed himself from the social realities of his time? In other words, is there any conceivable way of situating within the same social context the painter's magical depictions of love and the murderous violence which followed them by only a few years?

As has been argued here, the Allegories of Love did respond to important cultural impulses of the period, even though those were not the same impulses as those reflected on the very public walls of the Salon. Fragonard is not David: We cannot read in his pictures any of the clear foreshadowings of the French Revolution found in *The Oath of the Horatii*

or in the *Brutus*. It is impossible to place his images in the same immediate, expressive relation to their social and political environment as those of his younger colleague.

But there may be a subtler solution to this conundrum. On one hand, the Allegories can be seen to advocate, in the face of the coming social tumult, the isolated, magical world of love and the private sphere, and to dream of an escape from the path of time: not just from the mortality that catches up with all lovers in the end but also from historical time itself, the realm of political strife and revolutions. The great gap between the satisfactions of private amorous experiences and the duty of public life was much discussed at the time. As one example among many, we can take a *Dialogue sur l'amour* from the pen of a young aspiring writer who went on to find fame far beyond the literary world: Napoleon Bonaparte. In his unfinished dialogue Napoleon casts himself as the reasonable voice of public duty as he confronts his love-struck friend, the chevalier de Mazis, who has chosen to withdraw from society:

> Ah, chevalier, what do you care any longer about the State, your fellow citizens, society!…It used to be that your only ambition was to do good, but these days even that good is a matter of indifference to you. What is the depraved feeling that has taken the place of your love of virtue? Your only wish is to live, ignored by others, in the shadow of your poplars![188]

Napoleon argues in his writing (as he chose in real life) for public action over personal erotic satisfaction, for the abandonment of amorous passion in favor of service to society. Yet as a faithful reader of Rousseau, he is continually tempted by an alternative conception of society as a decline from the state of natural man and finds himself presenting a counterargument:

> It is true, chevalier, that we are born to be happy, that happiness is the supreme law that nature has etched in the depths of our souls. It is true that it is the ground which was given to us to serve as rule for all of our conduct. Each of us, born able to judge what best serves him, thus has the right to do as he wishes with his body and with his affections, but this state of independence is in truth opposed to the state of servitude in which society has placed us.[189]

If society is based on a forced curtailing of the natural desire for love or happiness ("Thus, we had to replace the voice of our feelings with that of conventions. This is the basis for all social institutions."[190]), then the choice of public duty over private satisfaction can no longer be supported with the nature-based arguments so beloved of the *philosophes*. The choice becomes a moral one, and the basis of judgment is no longer what is more natural but what benefits current society the most. Napoleon's fragment ends with a grandiose call for service to the state, a path that seems that much more virtuous inasmuch as, not being natural, it is the path of greater resistance. As for the pursuit of private love, it can only lead to chaotic immorality. In the text's last complete sentences can be found what Napoleon's verdict on Fragonard would have been:

I deplore your error. Do you really think, chevalier, that love is the path of
virtue? It corrupts you with each step. Be honest. Since this fatal passion has
started troubling your rest, have you imagined any other happiness but that
of love? Thus, you will do good or evil according to the symptoms of your pas-
sion. But, what am I saying! You and your passion are no longer but a single
being. As long as it lasts, you will only act on its behalf...[191]

FIGURE 72
Anne-Louis Girodet de Roussy-
Trioson (French, 1767–1824),
The Sleep of Endymion, 1793.
Oil on canvas, 198 × 261 cm
(78 in. × 8 ft. 7 in.). Paris,
Musée du Louvre, 4935.
Photo: Erich Lessing/Art
Resource, New York.

Love and public life, love and civic duty, and, ultimately (since for Napoleon
such duty implies helping the less fortunate), love and a progressive revolution are utterly
opposed.

Such a reading is strengthened when we study the images that felt the stron-
gest the influence of Fragonard's Allegories: the Anacreontic painting of the Directory and
the Napoleonic period. Foreshadowed by Anne-Louis Girodet's *Sleep of Endymion* of 1793
(consciously painted in direct opposition to David's official style) [Figure 72], Anacreontic
paintings' most important representatives include Baron Gérard's *Cupid and Psyche* of
1798 and *Flora* of 1802, Antoine-Jean Gros's *Sappho Leaping from the Rock of Leucatus*
[Figure 73], and Pierre-Paul Prud'hon's *Abduction of Psyche* [*see* Figure 2]. The reverbera-
tions from these works would be felt all the way to the full-blown Salon Romanticism
of Ary Scheffer's *Francesca da Rimini* [Figure 74]. Most of these paintings contain the
same amalgam of elements that characterizes the Allegories: classical figures and planar

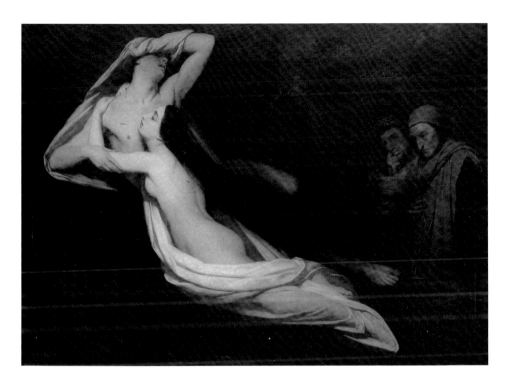

FIGURE 73
Antoine-Jean Gros (French, 1771–1835), *Sappho Leaping from the Rock of Leucatus*, 1801. Oil on canvas, 122 × 100 cm (48 × 39³/₈ in.). Bayeux, Musée Baron Gérard. Photo: Réunion des Musées Nationaux/Art Resource, New York.

FIGURE 74
Ary Scheffer (Dutch, 1795–1858), *Francesca da Rimini*, 1835. Oil on canvas, 166.5 × 234 cm (65¹/₂ × 92¹/₈ in.). London, Wallace Collection, P3116.

compositions contrasted with a deep, nocturnal chiaroscuro, resulting in an intensely Romantic emphasis on private experience. When compared to the social conscious-ness that was found in David's paintings in the period preceding and during the French Revolution, Anacreontic painting can be interpreted as opting for a solipsistic retreat into the private realm, a choice arising from a disappointment with the Revolution's violence and from an increasing alienation from post-revolutionary society. Such a reading could then be translated to the prerevolutionary period to obtain an explanatory schema for Fragonard.

This explanatory schema is tempting and, to a certain extent, accurate. But it is also incomplete. The opposite point of view was expressed succinctly by Charles Baude-laire: "The revolution was made by voluptuaries."[192] The same generation that produced the Preromantic writers of the 1770s and 1780s (all in their early twenties when they began publishing), also produced the leaders of the Revolution: for all of them, Rousseau was a primary, if not principal, reference. Often, the writer and the revolutionary were one and the same person: a case in point is the young Napoleon, whose Preromantic novella, *Clisson et Eugénie,* is indebted not so much to Rousseau himself as—heavily—to Loaisel de Tréogate. The early Romantic passion that took over young men and women in the last years of the ancien régime translated itself into revolutionary fervor only a few years later. This shift also largely explains the waning of the Preromantic literary mode during the Revolution: there was no more need for intense literature when, as the poet William Wordsworth for one discovered, life itself was intense and Romantic enough.[193] Further-more, the precepts of Romantic love recognized the equality of all people before love, that great leveller, an equality not so different from that desired by the revolutionaries. From Rousseau on, to be on the side of love was also to be on the side of social justice: it was the unfairness of the social hierarchy that prevented St. Preux from marrying Julie, and it was the moral decadence of the ancien régime that kept Dolbreuse away from his wife. One

FIGURE 75
Jean-Honoré Fragonard,
Cupid Holding an Arrow,
circa 1770–75. Oil on canvas,
55 × 45 cm (21⅝ × 17¾ in.).
Private collection.

could even say that the Preromantic lovers' longing to arrest time was no less utopian than the desires of the most fervent revolutionaries.

To make this argument is neither to redeem Romantic love through its association with the Revolution, nor vice-versa. After all, it could be argued that a ferocious solipsism on the part of the leaders of the Revolution, akin to that of the couples in Fragonard's *Allegories,* was what led to the murderousness of the Terror. For Karl Marx, the failure of the French Revolution resided precisely in its passionate intensity, which brought about a specific chronology quite familiar to us from the works of Rousseau and his followers:

> Bourgeois revolutions, such as those of the eighteenth century, storm quickly
> from success to success. They outdo each other in dramatic effects; men and
> things seems set in sparkling diamonds and each day's spirit is ecstatic. But
> they are short-lived; they soon reach their apogee, and society has to undergo
> a long period of regret until it has learned to assimilate soberly the achieve-
> ments of its period of storm and stress. [194]

For Marx, the French Revolution, in its ecstatic beauty, had exactly the same temporal structure as a Preromantic love affair: the orgasmic flight out of time, followed by the long and painful fall back into the banality of normal existence. Given these parallels, Fragonard's *Allegories* could easily be seen as allegorical representations of the revolutionary spirit at its most intense. In fact, in a print of about 1792, one of Fragonard's Cupids,

painted around 1770–75 [Figure 75], was given a set of Roman fascia and a Phrygian cap instead of the previously held love-arrow and turned into *L'Amour de la liberté* (*The Love of Liberty*) [Figure 76]. The same characteristics that made the Romantic ideology of love ultimately useless for guaranteeing the longevity of monogamous marriage could be invoked to predict the ultimate inefficiency of a Romantic political revolution. Romantic love and Romantic revolution end up doomed to the same tragic fate.

The Allegories can be understood both as signs of a retreat into the private realm, away from the forces of history, and as recordings of extreme emotional states, the effect of which would in later years be brought to bear upon other fields of social conflict, with much more incendiary results. Paradoxically, then, they encode the very passions that lay at the base of those forces of history they are seen to be fleeing. If the first option derives primarily from a reading imbued with the social spirit of the Enlightenment, the second, and perhaps more complex, reading is Romantic in its refusal to draw strict borderlines between the private and the public and in its view of the two realms as essentially interconnected. It was this latter perspective that informed Wordsworth's response to the French Revolution in *The Prelude* and Thomas Carlyle's monumental history of that cataclysmic event.[195] But perhaps we need not choose between the two options. Allowing both readings to stand reflects more accurately the complex world of the late ancien régime in which Fragonard's paintings were irrevocably caught, and perhaps it is only fitting that our reading no more attempt to offer a univocal solution to their interpretation than they did to the insoluble paradoxes of Romantic love.

FIGURE 76

Anonymous, *The Love of Liberty,* circa 1792. Engraving. Paris, Musée Carnavalet, G 26852. Photo: Andreani/ © Photothèque des Musées de la ville de Paris.

NOTES

1 On the erotic aspect of Fragonard's paintings, especially as echoed in his pictorial handling, see Mary Sheriff, *Fragonard: Art and Eroticism* (Chicago, 1990), especially pp. 95–116, 185–202.

2 This survey of Fragonard's career draws on primary sources quoted in the documentary portions of Pierre Rosenberg, *Fragonard*, exh. cat. (Paris, Musée du Louvre, and New York, Metropolitan Museum of Art, 1987); hereafter referred to as Rosenberg 1987, particularly pp. 35–39, 66–70, 151–52, 227–28, 299–302, 364–65, 419–31, 582–95. For full references and a much more thorough discussion of Fragonard's career, see Andrei Molotiu, "Allegories of Love in the Late Work of Jean-Honoré Fragonard" (PhD diss., Institute of Fine Arts, New York University, 1999), pp. 43–115.

3 On the École, see Thomas E. Crow, *Painters and Public Life in Eighteenth-Century Paris* (New Haven, 1985), p. 117, and Jean Locquin, *La Peinture d'histoire en France de 1747 à 1785* (Paris, 1912), pp. 10–11.

4 "obligé par ce besoin de se livrer à des ouvrages peu conformes à son génie et qui retarderont les succès que l'on a droit d'en attendre." Rosenberg 1987, p. 152.

5 "Mr. Fragonard, quand on s'est fait un nom, il faut avoir un peu plus d'amour propre. Quand après une immense composition qui a excité la plus forte sensation, on ne presente au public qu'une tête, je vous demande, à vous-même, ce qu'elle doit être." Denis Diderot, *Ruines et paysages: Salon de 1767*, ed. Else Marie Bukdahl et al. (Paris, 1995), p. 420.

6 For more on financial considerations as the primary reason for Fragonard's break with the Academy, see Mary D. Sheriff, "For Love or Money? Rethinking Fragonard," *Eighteenth-Century Studies* 19, no. 3 (Spring 1986), pp. 333–54.

7 "Pourquoi M. Fragonard, sur lequel on avait fondé de si grandes espérances au salon dernier, dont les talents s'étaient annoncés avec un fracas bien flatteur pour son amour-propre, s'est-il arrêté tout à coup?" Baron R. Portalis, *Honoré Fragonard: Sa Vie, son oeuvre* (Paris, 1889), p. 55.

8 "M. Fragonard, ce jeune artiste, qui avoit donné, il y a quatre ans, les plus grandes espérances pour le genre d'histoire, dont les talens s'étaient peu développés au *Sallon* dernier, ne figure d'aucune façon à celui-ci. On prétend que l'appas du gain l'a detourné de la belle carrière ou il étoit entré et pour la posterité, il se contente de briller aujourd'hui dans les boudoirs et dans les gardes-robes." Rosenberg 1987, p. 228.

9 "M. Fragonard! Il n'y sera pas…c'est qu'il a abandonné le grand genre." Rosenberg 1987, p. 300.

10 "M. Fragonard? Il perd son temps et son talent; il gagne de l'argent." Rosenberg 1987, p. 300.

11 "L'homme habile à qui l'homme riche demande un morceau qu'il puisse laisser à son enfant…ce n'est plus pour la nation, c'est pour un particulier qu'il travaillera, et vous n'en obtiendrez qu'un ouvrage médiocre et de nulle valeur. On ne saurait trop opposer de barrières à la paresse, à l'avidité, à l'infidélité; et la censure publique est une des plus puissantes." Diderot (note 5), pp. 58–59.

12 In addition to Rosenberg 1987, p. 227, see Christian Michel, *Charles-Nicolas Cochin et l'art des lumières* (Rome, 1993), p. 524.

13 There are other indications from this period of Fragonard's new career goal: The small painting of "groups of children in the sky," which the painter exhibited at the Salon of 1767 and which belonged to the *financier* Pierre-Jacques-Onésyme Bergeret, one of the painter's most devoted private patrons, is clearly a sketch for a ceiling decoration, which may relate to the Voyer d'Argenson project or may have been executed as an exercise in the new format that Fragonard was trying to master. From this period may also date the round sketch in the Musée des Beaux-Arts et d'Archèologie in Besançon, *The Triumph of Venus* which, though in a much lighter register, takes its direct inspiration from Jean-Baptiste Lemoyne's Versailles ceiling.

14 On the Demarteau salon, see Jacques Wilhelm, "Le Salon du graveur Gilles Demarteau peint par François Boucher et son atelier, avec le concours de Fragonard et de J.-B. Huet," *Bulletin du Musée Carnavalet* 1 (1975), pp. 6–20.

15 "qu'il craint de ne pouvoir faire assés promptement pour satisfaire la Compagnie." Rosenberg 1987, p. 420.

16 "dans la forme ordinaire de ceux de l'Académie." Rosenberg 1987, p. 420.

17 "Fragonard P. s'est présenté, mais est parti en disant qu'il allait revenir, et n'est point revenu." Rosenberg 1987, p. 430.

18 "qui ne satisferont pas et même sont dans l'impossibilité de fournir leur morceaux de reception." Rosenberg 1987, p. 430.

19 "par légéreté et insouciance." Rosenberg 1987, p. 430.

20 "jusqu'à présent, il n'a pu y travailler ayant été occupé des tableaux dont il était chargé pour Madame du Barry. Présentement, il assure qu'il va y travaillé avec tout le zèle et l'assiduité." Rosenberg 1987, p. 302.

21 On Fragonard's print production during his late period, see Anne L. Schroder, "Genre Prints in Eighteenth-Century France: Production, Market, and Audience," in Richard Rand, ed., *Intimate Encounters: Love and Domesticity in Eighteenth-Century France*, exh. cat. (Hood Museum of Art, Dartmouth College, 1997), pp. 69–86. Schroder's analysis of the print advertisements in the press of the period reveals that "Fragonard's presence in the print market was consistent throughout the 1780s and into the 1790s" and,

indeed, announcements for prints after Fragonard compositions constituted a disproportionate percentage of the overall print ads in 1791 and 1792, despite the political turbulence of those years (p. 80). According to her findings, Fragonard prints were priced at between six and twelve *livres,* the higher end of the market, yet nowhere near the sixteen and even thirty-six *livres* that Jean-Baptiste Greuze charged for some of his prints (pp. 77, 80). Furthermore, despite the fact that "almost no documentation exists for [transactions between] Fragonard and his engravers," she speculates that "the number of real estate purchases and financial investments he made in the 1780s, 1790s, and beyond suggests that he greatly benefited from the success of his prints" (p. 80). See also Molotiu (note 2), pp. 100–110.

22 For more on Fragonard's late period, see Rosenberg 1987, pp. 415–31; Jean-Pierre Cuzin, *Jean-Honoré Fragonard: Vie et oeuvre* (Fribourg, 1987), pp. 207–32; and Anne L. Schroder, "Reassessing Fragonard's Later Years: The Artist's Nineteenth-Century Biographers, the Rococo and the French Revolution," in Elise Goodman, ed., *Art and Culture in the Eighteenth Century: New Dimensions and Multiple Perspectives* (Newark, Del., 2001), pp. 39–58. On the Salon de la Correspondance, see Molotiu (note 2), pp. 84–99.

23 According to his obituary in the *Journal de Paris* (no. 237, p. 1742): "M. Fragonard père est mort vendredi matin, à la suite d'une assez courte maladie. Il étoit âgé de 74 ans et demi, et extraordinairement replet. L'école française perd en lui un peintre justement estimé. *Callirhoé, La Fontaine d'Amour, Le Sacrifice de la Rose* et divers autres sujets reproduits et multipliés par la gravure, ont attaché au nom de Fragonard l'idée même des Grâces." Rosenberg 1987, p. 595.

24 Crow (note 3), p. 169. My italics.

25 "Fragonard a tiré profit de la reconnaissance de son talent par les instances officielles, pour se retourner vers le public et pour pratiquer un genre plus lucratif." Michel (note 12), p. 525. My italics.

26 "Vous savez qu'il y a plusieurs types de public, celui que vous composez, siffle; un autre est indifferent; un troisième applaudit par mauvais goût, ou sur parole." *Dialogues sur la Peinture, seconde édition, enrichie de notes, A PARIS, imprimé chez TARTOUILLIS, aux dépens de l'Académie, & se distribue à la porte du Salon* (1773), p. 26.

27 "distinguez bien entre le public qui répète & le public qui voit. C'est le dernier qui prononce au parterre & au sallon, l'autre ne juge que sur parole." *Dialogues sur la Peinture* (note 26), p. 30.

28 It is clear from the passage cited above (note 11) that Diderot would have agreed with the Salon critics and not accepted that such an assembly of private patrons could constitute a "public."

29 For examples, see symphonies no. 26 in D minor, "Lamentation" (1768 or 1769), no. 39 in G minor (1767), no. 45 in F-sharp minor, "Farewell" (1772), and no. 49 in F minor, "La Passione" (1768) by Joseph Haydn; symphony opus 12, no. 4 in D minor, "La Case del diavolo" (1771) by Luigi Boccherini; symphony in A minor (ca. 1770) by Karl Ditters von Dittersdorf; symphony in G minor (1770) by Johann Baptist Vanhal; and symphony no. 25 in G minor, K 183 (1773) by Wolfgang Amadeus Mozart.

30 James H. Johnson, *Listening in Paris: A Cultural History* (Berkeley, Calif., , 1995), pp. 53–95.

31 Sarah Maza has argued that, in the work of Rousseau and his followers, "Sentimentalism was represented as a binding, socially conjunctive force"; see Maza, "The Bourgeois Family Revisited," in Richard Rand (note 2), p. 45. This is true; yet this force has its power only in the parallel yearnings of individual subjectivities and is quite far from the super-personal moral duty implicit in Neoclassicism's emphasis on Roman virtue.

32 Isaiah Berlin, *The Roots of Romanticism* (London, 2000), p. 1.

33 Berlin (note 32), pp. 16–18

34 Berlin (note 32), pp. xii, 20.

35 Richard J. Campbell, "The Sacrifice of the Rose by Jean-Honoré Fragonard: A Late Eighteenth-Century Inflection of a Traditional Erotic Symbol," *Minneapolis Institute of Arts Bulletin* (1983–86), p. 38.

36 Eunice Williams, *Drawings by Fragonard in North American Collections,* exh. cat. (Washington, D.C., National Gallery of Art, 1978), p. 128.

37 Cuzin (note 22), p. 209.

38 Quoted in Hugh Honour, *Romanticism* (New York, 1979), p. 23.

39 See, for example, Albert Béguin, *L'Âme romantique et le rêve* (1937; repr., Paris, 1991), the entire first part of which—devoted to the transition from Enlightenment to Romanticism—is titled "Du jour a la nuit."

40 "Quelques peintres du moins ne se contenterent pas des symboles galants à la Boucher: lorsque Fragonard représente la *Fontaine d'Amour,* il anime ses personnages d'une fougue, il les projette avec un emportement déjà romantique." Louis Hautecoeur, "Les Origines du Romanticisme," in Hautecoeur et al., *Le Romantisme et l'art* (Paris, 1928), p. 5.

41 "Tous ces mouvements exagérés qu'on reproche aux romantiques, les artistes de 1775 ou 1780 les ont déjà exécutés…Les *Serments d'amour,* par Fragonard, sont accompagnés de tremblements convulsifs." Hautecoeur (note 40), p. 9.

42 "Delacroix continuera Fragonard et Watteau, lancera comme eux des touches hardies, appliquera des tons purs, fera jouer aux couleurs la plus éclatante des symphonies." Hautecoeur (note 40), p. 19.

43 Monglond was responsible for a series of re-editions of late ancien régime authors in addition to his original works, which include *Vies préromantiques* (Paris, 1925) and his magnum opus, *Le Préromantisme français,* 2 vols. (Grenoble, 1930).

44 For the end of Preromanticism, see especially Monglond, *Le Préromantisme français,* vol. 1, pp. 88–96.

45 Du préromantisme au romantisme, l'enchaînement est manifeste." Monglond (note 44), p. xiii.

46 "…la notion de préromantisme n'est pas innocente, parce qu'elle établit une continuité là ou il y a une rupture…cette rupture que la notion de préromantisme tend à camoufler, à occulter, à atomiser, selon le vocabulaire de référence que l'on voudra adopter, c'est la Revolution de 89." Paul Viallaneix, ed., *Le Préromantisme: hypothéque ou hypothése? Colloque organisé a Clermont-Ferrand les 29 et 30 juin 1972 par le Centre de Recherches Revolutionnaires et Romantiques de l'Université* (Paris, 1975), p. 91.

47 "Il se trouve qu'à un moment donné, probablement vers le milieu du 18e siècle, on observe au niveau des textes, mais aussi des manières de penser, de croire et de sentir collectives qu'il n'y a aucune raison de dédaigner, puisque la littérature y est attachée, divers phénomènes qui s'opposent a la culture dominante et qui, ce qui est encore important, ne semblent pas intelligibles. Il s'agit alors de les comprendre a partir d'une telle opposition." Viallaneix, ed. (note 46), p. 84.

48 The issue of the continuity between the Rococo and the Romantic styles has been explored by Carol Duncan in *The Pursuit of Pleasure: The Rococo Revival in French Romantic Art* (New York and London, 1976), especially in Chapter I, "The Survival of the Rococo," pp. 5–27. She discusses Fragonard on pp. 8–10, and specifically *The Invocation to Love* on p. 9.

49 Cuzin (note 22), no. 363 (oil on oval canvas, 64 × 55 cm [25^1/4 × 21^5/8 in.]). From here on, Fragonard's paintings will be identified by their number in Cuzin's catalogue. We do not know the original buyer of this version. According to Cuzin's catalogue entry, its provenance can be traced back only to the Saint sale of May 4–7, 11–14, 1846, and possibly to an anonymous sale of 1842.

113

50 Cuzin (note 22), no. 364 (oil on canvas, 62 × 51 cm). This version may have remained in the painter's possession and been passed down through the family, as, according to Cuzin, it was bequeathed to the Louvre in 1912 by the granddaughter of Fragonard's brother-in-law, Henri Gérard.

51 The engraving by Jean Mathieu was announced on July 22, 1786, as pendant to Nicolas Delaunay's earlier (1779) print of the *Good Mother.* See Rosenberg 1987, pp. 428–29.

52 See *The Arts of France from François I^er to Napoléon I^er,* exh. cat. (New York, Wildenstein, 2005), no. 120.

53 The absence of these two statues is the most significant variation in the Grasse version.

54 See Denis Diderot, *Essais sur la peinture, Salons de 1759, 1761, 1763* (Paris, 1984), p. 284, which reprints the definition of the term from the *Encyclopédie.*

55 For the definition of "papillotage" see Diderot (note 54), p. 279.

56 See Denis Diderot, *Lettre sur les sourds et les muets, in Le nouveau Socrate: Idées II* (Paris, 1978).

57 Cuzin (note 22), no. 377 (oil on canvas, 52 × 63 cm). According to Cuzin, this work's provenance can be traced back to the La Rochefoucauld-Liancourt sale of June 20, 1827. François-Alexandre-Frédéric, duc de la Rochefoucauld-Liancourt (1747–1827), "grand master of the royal wardrobe," social reformer, and moderately liberal (though royalist) member of the Estates-General, had accumulated an impressive collection of Fragonard paintings. In his cabinet, the *Invocation* was accompanied by at least eight other pieces by the painter, including a landscape (Cuzin no. 132), a religious scene, *The Rest on the Flight to Egypt* (Cuzin no. 316), a sentimental genre figure, *The Letter* (Cuzin no. 91), three moralizing scenes of family life (Cuzin nos. 281, 311, and L 207) and two other genre subjects, one more frankly erotic, *The Useless Resistance* (Cuzin no. 284), one more playful, *The Blindman's Buff* (Cuzin no. 326). For the duke's biography, see the entry in the *Catholic Encyclopedia,* at http://www.newadvent.org/cathen/09005a.htm (accessed May 2007).

58 "une jeune fille invoquant l'amour, au pied de sa statue; le fond présente une intention de Paysage." Rosenberg 1987, p. 545.

59 "une jeune fille se jetant au pied de la statue de l'amour dans un bosquet." Rosenberg 1987, p. 545.

60 See Rosenberg 1987, p. 545, fig. 3.

61 Rosenberg 1987, p. 542. On the duc de la Rochefoucauld-Liancourt, see note 57 above.

62 Cornelius Vermeule, *European Art and the Classical Past* (Cambridge, Mass., 1964), p. 129. For the sarcophagi in question, see Carl Robert, *Die Antiken Sarkophag-Reliefs,* vol. 2, *Mythologische Cyklen* (Rome, 1968), pl. LXII, figs. 194–96, and pl. LXIV, fig. 200. Fragonard is likely to have seen such images when in Rome; for example, during the nineteenth century, the Medea sarcophagus now in Dresden (inv. Sk 834 b) was in the open before the Porta San Lorenzo. I would like to thank Jens Daehner of the Department of Antiquities, J. Paul Getty Museum, for this information.

63 For examples of such images, see Kenneth Clark, *The Nude* (Princeton, 1956), figs. 212, 215–17, and 219.

64 Delaborde (also referred to as de Laborde and de La Borde) met Fragonard and Bergeret in Italy in 1774, and his manuscript on Italy was a source for the Abbé de Saint-Non's *Voyage pittoresque.* He also owned the famous *Isle d'Amour,* also known as *The Fête at Rambouillet,* the landscape by Fragonard that is closest in spirit to the Allegories of Love; see Rosenberg 1987, pp. 355–57.

65 "Le cruel poison / de la raison / ne glace plus mon âme / je l'abandonne a toi." Jean-Benjamin Delaborde, *Choix de chansons mises en musique* (Paris, 1773), p. 105.

66 "Un bosquet dans lequel est placée une fontaine, entourée de petits Amours qui soutiennent la coupe où deux jeunes gens s'empressent de boire pour augmenter leur amoureuse ivresse." Duclos-Dufresnoy sale, 1–4 fructidor, an III (Aug. 18–21, 1795), quoted in Pierre Rosenberg, *Tout l'oeuvre peint de Fragonard* (Paris, 1989), p. 133.

67 The Wallace version is Cuzin no. 373 (oil on canvas, 64 × 56 cm). The Getty version (oil on canvas, 64 × 52.4 cm) is not catalogued by Cuzin, but appears in Rosenberg, *Tout l'oeuvre* (note 66), as no. 409 B. While the Getty version's provenance cannot be traced back any farther than the late nineteenth century, the Wallace version, as mentioned in the previous note, figured in the Duclos-Dufresnoy sale in 1795. The economist Charles-Nicolas Duclos-Dufresnoy (1733–1794), managing syndic (*syndic-gérant*) of the company of notaries and, later, victim of the Terror, had accumulated, besides *The Fountain of Love,* three other paintings by Fragonard: the powerful landscape *The Fete at Rambouillet* (Cuzin no. 193), a genre scene of childhood education, *Say "Please"* (Cuzin no. 348 or 350), and a genre figure, *Young Girl with a Marmot* (Cuzin no. 366). For more on Duclos-Dufresnoy, see Colin B. Bailey, *Patriotic Taste: Collecting Modern Art in Pre-Revolutionary Paris* (New Haven, 1999), pp. 131–62.

68 The Getty Museum condition report notes that X-rays have revealed several pentimenti under the surface of the Getty picture, the most important of which is in the male figure's head, which was originally turned toward the woman. Based on this information, Mark Leonard, conservator of paintings at the Getty Museum, has determined that the Getty painting was the first version of the finished composition to be painted, while that in the Wallace Collection is an autograph replica.

69 "Pour la première fois nous bûmes à longs traits le philtre de l'amour." Joseph-Marie Loaisel de Tréogate, *Dolbreuse ou l'Homme du siècle ramené à la verité par le sentiment et par la raison* [originally published 1777] (Paris, 1785; repr., Paris, 1993), p. 11.

70 "pour épuiser par tous me sens la coupe de la volupté." Loaisel de Tréogate, *Dolbreuse* (note 69), p. 60. For the second, more graphic meaning of the cup, see also Dominique Vivant Denon, *Point de lendemain* (1777 version), in Michel Delon, ed., *Vivant Denon, "Point de lendemain," suivi de Jean-François Bastide, "La Petite Maison"* (Paris, 1995), p. 96.

71 See Andrei Molotiu, "The *Progress of Love* and the Magic Garden: Jean-Honoré Fragonard's Decorative Ensemble for the Villa Maubert in Grasse," *Gazette des Beaux-Arts* (February 2001), pp. 91–114, nn. 21 and 22.

72 Ludovico Ariosto, *Orlando Furioso,* trans. Guido Waldman (Oxford, 1983), p. 10 (canto 1, line 78).

73 Ariosto, *Orlando Furioso,* ibid.

74 D'Alembert mentioned performances of *Roland* in 1759, and Diderot's interlocutor in *Rameau's Nephew* (1760) praised a monologue from the opera. See Enrico Fubini, *Music and Culture in Eighteenth-Century Europe: A Source Book* (Chicago, 1994), pp. 86, 110. A letter to the *Mercure de France* in 1774 complained about women leaving "during the last acts of *Atys* and *Roland.*" See Johnson (note 30) p. 31 and p. 294 n. 100. See also Louis Rosow, "Lully's *Armide* at the Paris Opera: A Performance History, 1686–1766" (Ph.D diss., Brandeis University, 1981).

75 "L' amour vous appelle. / Que sa flame est belle! / L' amour vous appelle tous. / Aimez, aimez-vous….Qui gouste de ces eaux ne peut plus se deffendre / de suivre d' amoureuses loix: / goustons en, mille et mille fois, / quand on prend de l' amour, on n' en sçauroit trop prendre." *Roland: Tragédie en musique, représentée devant S. M., à Versailles, le huitième janvier 1685, paroles de Quinault, musique de Lulli,* vol. 2, p. 5. The entire libretto is available at http://sitelully.free.fr/livretroland.htm. For eighteenth-century performances, see Rosow (note 74).

114

76 "Tendres amours, / enchantez-nous toûjours. / Triste raison nous fuyons ton secours." *Roland* (note 75), vol. 2, p. 5.

77 In her discussion of the *Fountain,* Mary Sheriff (note 1, p. 20) has pointed out how the painting goes beyond the message encoded in its iconographic details to embody the represented passion: "But more compelling than the symbolism of objects represented in *The Fountain of Love* is the display of both desire and satisfaction, for together these suggest a moment of consummation…Desire is represented both *by* and *in* the two lovers who approach the fountain with their eyes focused on the cup" (my italics). For Sheriff's entire discussion of *The Fountain of Love* and of the Goncourts' description of it, see pp. 18–21.

78 "un jardin fait pour le doux mistere / Des jeux des Amours." Delaborde (note 65), p. 98.

79 Los Angeles version: Cuzin no. 385 (oil on canvas, 65 × 54 cm [25⅝ × 21¼ in.]). Paris version: Cuzin no. 386 (oil on panel, 54 × 43 cm [21¼ × 16⅞ in.]). According to Cuzin, the version now in Los Angeles remained in the extended Fragonard family—probably passed to Marguerite Gérard, the painter's sister-in-law, by her brother, Henri Gérard, who had engraved it—until the mid-nineteenth century. The Paris version first appears in the Godefroy sale of December 14, 1813. François Godefroy (1743–1819) was primarily known as an engraver; however, given the number of Fragonard paintings and drawings that passed through his hands, and that he sold at various times, we can suspect he also functioned as an art dealer.

80 Cuzin no. 387.

81 Cornelius Vermeule has suggested that the design of the circular altar is based on "a circular cinerarium long in the Museo Capitolino." However, I have not been able to substantiate this claim. See Cornelius Vermeule, *European Art and the Classical Past* (Cambridge, Mass., 1964), p. 129.

82 This composition may have an important architectural source. The circular temple where the sacrifice takes place, with its Corinthian capitals and its inside (as well as outside) frieze of spiraling, interlacing tendrils, is strongly reminiscent of the Temple of Love in the gardens of the Petit Trianon, built by Edmé Mique for Marie Antoinette in 1778–79; moreover, that temple housed, and still houses, a copy of Edmé Bouchardon's statue of *Eros Carving His Bow out of the Club of Hercules,* itself placed atop a relatively high circular pedestal and presenting a young-adolescent type of the god of Love. See Gérald Van Der Kemp, *Versailles* (New York, 1978), p. 211. Of course, there are differences: the pedestal in Fragonard's composition is much taller, while the statue is different and does not appear to be centered within the building's circular plan. Nevertheless, it is tempting to see in Fragonard's design a reference to the actual garden of love built on the grounds of Versailles in an attempt to make real the same kind of fantasy world which the Allegories depicted.

83 See Campbell (note 35), pp. 19–47. In this important article, Campbell also identifies many points of iconographic comparison between Fragonard's works and the writings of Claude-Joseph Dorat, Evariste de Parny, Antoine de Bertin, and others, parallels which have informed the connections I draw (especially in the next chapter) between the writers and the artist.

84 There is a certain similarity between the design on the altar and a drawing by Fragonard in the Louvre often referred to as *Cupid and Psyche.* The classical images closest to the altar design that I have been able to find are putti, on various sarcophagi, holding up shields with the portrait of the deceased, for example on the Cupid and Psyche sarcophagus in the cathedral of S. Lorenzo, Genoa. See *Lexicon Iconographicum Mythologiae Classicae (LIMC),* vol. 7 (Zurich and Munich, 1994), Psyche 25b and ill.

85 See Molotiu (note 71), p. 111, n. 20.

86 The print by N. F. Regnault was announced in the *Mercure* on April 19, 1791, as a pendant to the *Fountain.*

87 "L"Amour et la Volupté charment le sommeil du guerrier par la douce illusion des plaisirs."

88 On this point, see Donald Posner's comparison of the 1767 *Swing* and the *Little Swing* in his "The Swinging Women of Watteau and Fragonard," *Art Bulletin* 64, no.1 (March 1982), pp. 75–88.

89 See also *Cupid Sleeping* (Cuzin no. 159); *Cupid Holding an Arrow* (Cuzin no. 225), and *Cupid Holding a Quiver* (Cuzin nos. 225, 226); *Cupid with a Bow and Cupid Sleeping* (Cuzin nos. 245–48).

90 The later panels of Cupids painted for Grasse (Cuzin nos. 391–95) are discussed in Molotiu (note 71).

91 The reuse of these panels and the additions to them in Fragonard's cousin's house in Grasse, in 1790–91, postdate the Allegories and may be seen as Fragonard's last statement on love.

92 *The Captured Kiss,* of 1759–60 (Cuzin nos. 76, 77); *In the Corn* (Cuzin no. 162), as well as the later narrative cycle seemingly comprising *The Bolt* (Cuzin nos. 336, 337, fig. II.23), *The Contract* (Cuzin no. 376), and the print of *The Armoire.*

93 Sheriff (note 1), p. 20. My italics.

94 Michael Fried, *Absorption and Theatricality: Painting and Beholder in the Age of Diderot* (Chicago, 1980), p. 138. Fried makes it clear that he is referring to the Allegories and to the erotic genre scenes in the footnote he appends to this sentence (p. 233, n. 65).

95 Posner (note 88), p. 88.

96 I am fully aware of the seeming paradox in attempting to argue that images we have come to call "Allegories" function rather in a symbolic register. Their traditional labeling clearly depends upon such purely conventional iconographic elements as the torched rose (representing the loss of virginity) or the cup drunk by the lovers (representing sexual union). My argument, however, is that the importance of such details as sole signifiers of erotic feeling is diminished by Fragonard in paintings such as these, in which the entirety of the pictorial handling combines to suggest amorous passion and does so in a manner largely exceeding such emblematic meanings. Nevertheless, relishing the paradox (itself a Romantic stance), I choose to retain the traditional designation given to the series.

97 See Hans-Georg Gadamer, *Truth and Method,* trans. Garret Barden and John Cumming (New York, 1986), p. 66. For a useful survey of the transition from allegory to symbol in German Romanticism, see Tzvetan Todorov, *Théories du symbole* (Paris, 1977). I first encountered this dichotomy in Paul de Man's "The Rhetoric of Temporality" (1969), reprinted in his *Blindness and Insight: Essays in the Rhetoric of Contemporary Criticism,* 2nd rev. ed. (Minneapolis, 1983), pp. 187–228, esp. section I, "Allegory and Symbol," pp. 187–208. While I end up disagreeing with de Man's ultimate valuation of the terms of the dichotomy, I realize that his discussion of it, and especially his discussion of the different temporal effects of the two notions, has deeply influenced my reading of the Allegories in this chapter and the next.

98 Gadamer (note 97), p. 66.

99 Gadamer (note 97), p. 67.

100 Niklas Luhmann, *Love as Passion: The Codification of Intimacy* (Cambridge, Mass., 1986); Irving Singer, *The Nature of Love,* vol. 2, *Courtly and Romantic* (Chicago, 1984); and Anthony Giddens, *The Transformation of Intimacy: Sexuality, Love, and Eroticism in Modern Societies* (Stanford, Calif., 1992).

101 Giddens (note 100), p. 38.

102 "les nuances du caractère national, les altérations qu'il a soufferte "les variations arrivées dans le genre de nos Romans." Claude-Joseph Dorat, *Les sacrifices de l'amour* [1771] (Paris, 1996), p. 29.

103 "siècles presque fabuleux d'héroïsme et de chevalerie;" "douleurs de la résistance,…l'ivresse de la défaite"; "ces repentirs touchants, dont il est si doux d'avoir à triompher"; "toujours sous le voile de la décence." Dorat (note 102), p. 30.

104 Pierre Carlet de Marivaux's *La Réunion des Amours*, of 1731, records the Rococo's more jaded view of the old-fashioned *amour-passion*; as the play's thoroughly modern Cupidon puts it, at that time "les amants n'étaient que des benêts; ils ne savaient que languir, que faire des hélas! et conter leur peines aux échos d'alentour. Oh! parbleu! ce n'est plus de même…Langueurs, timidité, doux martyre, il n'en est plus question: fadeur, platitude du temps passé que tout cela." ("lovers were nothing but simpletons; all they could do was to languish, utter alas, and tell their troubles to the surrounding echoes. Oh! By Jove! Things have changed…Languishing, timidity, sweet sufferings are out of the question; by now they're just insipid platitudes of times gone by.") Marivaux, *Théatre Complet* (Paris, 1964), p. 294. For the novels mentioned, see Henri Coulet, *Le Roman jusqu'à la Révolution*, 2nd ed. (Paris, 1967), vol. 1, 223–37, 244–72.

105 "ces jours d'aisance dans les moeurs, et de bouleversement dans les principes, où des hommes, élégamment vicieux, trompent et sont trompés, n'attaquent les femmes que pour obtenir, s'ils le peuvent, le droit de les mépriser, et sont en cela même plus méprisables qu'elles." Dorat (note 102), p. 30.

106 On the libertine novel of the Rococo, see especially Philip Stewart, *La Masque et la parole* (Paris, 1973).

107 "les moeurs soient peintes, et les passions en mouvement, où l'homme se retrouve tel qu'il est dans la nature!" Dorat (note 102), p. 31.

108 "Pour arracher à la nature quelques-uns de ses secrets, il faut être nourri de méditations, de recueillements solitaires, de l'enthousiasme du bien et de cette mélancolie, qui marque d'une empreinte auguste toutes les idées qui en émanent. Voilà ce qui distingue les écrivains anglais. Ils fouillent dans les profondeurs de l'âme; nous jouons sans cesse autour de sa superficie." Dorat (note 102), pp. 31–32.

109 "Non, il n'y a point d'amour dans les ouvrages gais, il n'y a point d'amour dans les pastorales gracieuses." Madame de Staël, *De l'influence des passions*, in *Oeuvres de Madame la Baronne de Staël-Holstein* (Paris, 1838), vol. 2, p. 52.

110 "quelques vers de Didon, Ceyx et Alcyone dans Ovide." De Staël (note 109), p. 52.

111 "Voltaire, dans ses tragédies; Rousseau, dans la Nouvelle Heloïse; Werther, des scènes des tragédies allemandes; quelques poëtes anglais, des morceaux d'Ossian, etc., ont transporté la profonde sensibilité dans l'amour." De Staël (note 109), p. 53.

112 "une cruelle et impuissante raison qui n'agit sur moi que pour me déchirer." Dorat (note 102), p. 184.

113 "O sentiment qui les réunis tous, émanation céleste, charme unique des êtres jetés sur ce triste globe; seul dédommagement des peines de la vie." Dorat (note 102), p. 166.

114 "J'habite un monde nouveau qu'elle a créé pour moi." Dorat (note 102), p. 168.

115 "J'aime avec un excès…dont je ne me croyais pas susceptible. Je n'imaginais pas que, dans le tumulte du monde on pût se recueillir, s'isoler, être entièrement à un seul objet." "Tout ajoute à mes sentiments, tout…Mon coeur tresaille; tous mes sens sont agités, et je ne suis plus, je ne veux plus être qu'à l'amour." Dorat (note 102), p. 169–70.

116 Je t'aime tant, je t'aime tant!
Je ne puis assez te le dire:
Et je le répète pourtant
À chaque fois que je respire.
Absent, présent, de près, de loin,

Je t'aime est le mot que je trouve:
Ou je le pense ou je le prouve.

Seul avec toi, devant témoin,
En ville, aux champs, chez moi, dehors,
Ta douce image est caressée:
Elle se fond, quand je m'endors,
Avec ma dernière pensée.
Quand je m'eveille, je te voie,
Avant d'avoir vu la lumière;
Et mon coeur est plus vite à toi
Que n'est le jour à ma paupière.

Absent, je ne te quitte pas;
Tous tes discours, je les devine:
Je compte tes soins et tes pas;
Ce que tu sens, je l'imagine.
Près de toi, suis-je de retour?
Je suis aux cieux, c'est un délire;
Je ne respire que l'amour,
Et c'est ton souffle que j'aspire.

Ton coeur m'est tout, mon bien, ma loi;
Te plaire est toute mon envie:
Enfin en toi, par toi, pour toi,
Je respire et tiens à la vie.
Ma bien aimée, ô mon trésor!
Qu'ajouterai-je à ce langage?
Dieu! que je t'aime! eh bien! encor,
Je voudrais t'aimer davantage!

Reprinted in Jacques Bousquet, *Anthologie du dix-huitième siècle romantique* (Paris, 1972), pp. 496–97. The very prosaic translation is the author's.

117 Singer (note 100), p. 288.

118 "J'ai lu que l'amour est une passion qui de deux âmes n'en fait qu'une, qui les pénètre en même temps et les remplit l'une de l'autre, qui les détache de tout, qui leur tient lieu de tout, et qui fait de leur bonheur mutuel leur soin et leur désir unique." Jean-François Marmontel, *Contes Moraux* (Paris, 1829), vol. 1, p. 77.

119 "Livrés l'un à l'autre en liberté, ils oubliaient l'univers, ils s'oubliaient eux-mêmes: toutes les facultés de leurs âmes réunies en un seul ne formaient plus qu'un tourbillon de feu, dont l'amour était le centre, dont le plaisir était l'aliment." Marmontel (note 118), p. 102.

120 Singer (note 100), p. 287.

121 "Si l'Etre tout puissant qui a jeté l'homme sur cette terre a voulu qu'il conçût l'idée d'une existence céleste, il a permis que dans quelques intants de sa jeunesse il pût aimer avec passion, il pût vivre dans un autre, il pût completer son être en l'unissant à l'objet qui lui était cher." De Staël (note 109), p. 53.

122 "Enfin, j'en jure par toi-même, / Je veux dire par tous mes dieux." Evariste-Desiré Parny, *Oeuvres de Parny: élégies et poésies diverses*, ed. A.-J. Pons (Paris, 1862), p. 65.

123 "Je n'habitais plus la terre. Le silence de la nuit, son calme attendrissant, la clarté sombre des cieux me partageaient entre l'extase et le délire; je me croyais dans un sanctuaire, dont madame de Senanges était la divinité." Dorat (note 102), p. 209.

124 Cet asyle me parut un temple, dès que j'y fus seul avec ma belle maîtresse…Je ne voyois plus le siege où elle étoit assise; je voyois un autel ou la Divinité descendue des cieux, sous les traits les plus adorables, daignoit s'offrir aux regards d'un foible mortel, se rendre sensible, palpable pour lui seul; & par une faveur inouie, l'associer d'avance à toutes les delices de la béatitude." Loaisel de Tréogate, *Dolbreuse* (note 69), p. 59.

125 I want to emphasize, however, that arguing that Romantic love had taken over the formal structures of sacrament and (at least iconographically) the eucharist from Catholic rite is not to argue that, deep down, early Romanticism, at least when it came to amorous relationships, was nothing but a disguised Catholicism—anymore than one could argue a similar point about Jacobinism based on the similarities between David's *Death of Marat* and the traditional iconography of the Pietà. Quite the contrary: in its fashioning of a new divinity, and particularly one to be celebrated in frankly carnal rites, Romantic love might even have appeared to some as a sacrilegious attempt to replace the Christian god with one with much more secular origins (similarly, David, who was probably much more alert to the full implications of his borrowing than Fragonard was to his, was trying not to perpetuate Catholicism but to usurp it by appropriating one of its most important images). Rousseau's well-known decision not to end *Julie,* as originally planned, with Julie and St. Preux's double suicide for love, but to have them renounce their passion for the sake of Christian morality, demonstrates an early awareness of this possibility. From this point of view, the Allegories' references to Dionysian rituals are particularly relevant.

126 Samuel Taylor Coleridge, *Shakesperean Criticism,* ed. Thomas Middleton Raysor (London, 1960), vol. 2, p. 106; quoted in Singer (note 100), p. 289.

127 Luhmann (note 100), p. 132.

128 Singer (note 100), p. 294.

129 "tant qu'on ne voit, qu'on n'éprouve rien que par un autre, l'univers entier est lui sous des formes différentes." De Staël (note 109), p. 54.

130 "des prés fleuris, des bocages amoureux, & toute la nature paisible entendirent les accens de notre reconnoissance, & furent les témoins de nos plaisirs." Loaisel de Tréogate, *Dolbreuse* (note 69), p. 62.

131 *The Confessions of Jean-Jacques Rousseau: The Anonymous Translation into English of 1783 & 1790 Revised and Completed by A. S. B. Glover, with an Introduction by Mr. Glover* (Norwalk, Conn., 1955), p. 426. Original version: "Un soir, après avoir soupé tête-à-tête, nous allâmes nous promener au jardin par un très beau clair de lune. Au fond de ce jardin était un assez grand taillis, par où nous fûmes chercher un joli bosquet orné d'une cascade dont je lui avais donné l'idée, et qu'elle avait fait exécuter…Ce fut dans ce bosquet, qu'assis avec elle sur un banc de gazon, sous un acacia tout chargé de fleurs, je trouvai, pour rendre les mouvements de mon coeur, un langage vraiment digne d'eux." (vol. 1, p. 200).

132 "Nous souperons dans le joli bosquet qui est sous mes fenêtres; nous aurons le plus beau clair de lune du monde; sa lumière est faite pour l'amour." Dorat (note 102), p. 204.

133 "La lune qui perçait a travers les charmilles, semblait se plaire à éclairer de ses rayons mystérieux le bonheur de deux amants. Un vent frais agitait à peine les bougies, mais nous envoyait tous les parfums, dont l'air etait embaumé. Les étoiles brillaient du feu le plus doux." Dorat (note 102), p. 207.

134 "C'était dans la saison où le feu qui féconde la nature, échauffe aussi tous les coeurs." Joseph-Marie Loaisel de Tréogate, *La Comtesse d'Alibre ou le Cri du sentiment, anecdote française* (Hague and Paris, 1779), p. 96. The scene I will discuss can be found on pp. 96–100.

135 Suivre le cours d'une onde qui soupire doucement entre les roseaux qu'elle caresse; se perdre dans des labyrinthes sinueux, dans des bosquets sombres;…s'arrêter au pieds d'une cascade, et se baigner avec délices dans les vapeurs humides et rafraîchissantes que produit au loin la chute écumeuse des eaux; errer en silence autour des groupes voluptueuses qui décorent ce séjour; les contempler à la lueur argentée de la lune, et pousser des soupirs; revenir dans des parterres humectés de la rosée bienfaisante,

qui exhalent à grands flots des nuages embaumés, et se reposer sur des lits de roses; telles sont leurs premières jouissances en entrant dans cette paisible retraite. Loaisel de Tréogate, *La Comtesse* (note 134), p. 64.

136 "Dans les jours nébuleux, dans les soirées obscures, elle descendoit dans les épais bocages…Elle aimoit ces allées solitaires, ce jour sombre & lugubre, image de ses pensées & de son âme; elle sourioit aux ombres de la nuit; seule, entourée des ténèbres, elle aimoit à entendre le bruissement des feuillages, le murmure plaintif des nappes d'eau qui arrosoient doucement ces beaux lieux, & les battements interrompus des ailes des oiseaux assoupis sur des branches légeres, & reveillés quelquefois par les zéphyrs. Elle mêloit ses plaintes à ces sons confus, & la voix de son amant qu'elle sembloit voir & entendre, venoit achever ce délire de la douleur où elle aimoit à se plonger." Loaisel de Tréogate, *La Comtesse* (note 134), p. 64.

137 "… ils se lèvent et dirigent leurs pas vers des bocages odoriférants; mais leur marche est plus lente. Les appas de cette solitude, l'ombre qui s'épaissit, la pureté de l'air, la fraîcheur, le calme de la nature, les ont jetés tous les deux dans un trouble confus. Ils n'aperçoivent plus les enchantements du lieu; ils ne sentent que l'ivresse d'être ensemble. Ils ont besoin de l'appui l'un de l'autre. Abandonnés a l'instinct qui les guide, ils sont attirés vers un berceau qui s'arrondit sous des touffes de myrte et de jasmin, et où la terre est semée de mille autres fleurs diverses. Ils s'enfoncent dans l'ombre épaisse de ce reduit. Ils y respirent de nouveaux feux avec des torrents de parfums, et leurs pas y restent enchaînes par une force irrésistible." Loaisel de Tréogate, *La Comtesse* (note 134), p. 64. A similar schema can be found in Delaborde's lyrics to the song, "Le Premier soupir de l'amour." The song's heroine gives in to love when the lush atmosphere of her garden overwhelms her: "En ne voulant qu'admirer la Nature / Son oeil enchanté / Trouve partout la naïve peinture / De la volupté / Son coeur s'agite, elle soupire / Dieu d'amour, c'en est fait, je céde / A ton Empire." (Desiring only to admire Nature / her enchanted eye / Finds everywhere the artless image / Of voluptuousness / Her heart flutters, she sighs / God of love, it's done, I give in / To your dominion.) Delaborde (note 65), p. 98.

138 Luhmann (note 100), p. 50.

139 Giddens (note 100), p. 44.

140 "se piquer d'un héroïsme bourgeois." Dorat (note 102), p. 93.

141 "Ce secret met en lumière / Comment le fils d'un butor / Vaut souvent son pesant d'or… / Par le sort de la naissance, / L'un est roi, l'autre est berger; / Le hasard fit leur distance; / L'esprit seul peut tout changer." Beaumarchais, *Théâtre,* ed. R. Pomeau (Paris, 1965), pp. 241–42.

142 Giddens (note 100), p. 42.

143 Anthony Hecht, "The Venetian Vespers," *Collected Earlier Poems* (New York, 1997), p. 44.

144 "Jours de plaisir et de gloire, non, vous n'étiez pas d'un mortel! vous étiez trop beaux pour devoir etre périssables. Une douce extase absorbait toute votre durée, et la rassemblait en un point comme celle de l'eternité. Il n'y avait pour moi ni passé ni avenir, et je goûtais à la fois les délices de mille siecles. Hélas! vous avez disparu vite comme un éclair! Cette éternité de bonheur ne fut qu'un instant de ma vie. Le temps a repris sa lenteur dans les moments de mon désespoir, et l'ennui mesure par longues années le reste infortuné de mes jours." Jean-Jacques Rousseau, *La Nouvelle Héloïse* (1761; repr., Paris, 1967), book 3, letter 6, p. 232; for a further discussion of this passage, see Mark J. Temmer, *Time in Rousseau and Kant: An Essay on French Pre-Romanticism* (Geneva, 1958), p. 19.

145 "L'on abandonne son âme à des sentiments qui décolorent le reste de l'existence; on éprouve, pendant quelques instants, un bonheur

sans aucun rapport avec l'état habituel de la vie." De Staël (note 109), p. 53.

146 "Ces moments de bonheur et d'ivresse, / Ces doux moments sont perdus sans retour… / Ce vallon frais, par les monts renfermé / N'offre à mes yeux qu'une aride verdure; / L'oiseau se tait, l'air est moins parfumé, / Et ce ruisseau roule une onde moins pure: / Tout est changé pour moi dans la nature: / Tout m'y déplaît; je ne suis plus aimé." Reprinted in Bousquet (note 116), p. 434.

147 "Tout m'échappe avec la même rapidité que le réveil détruit un songe…Au lieu d'une nature enchantée, je ne vis qu'une nature naïve." Vivant Denon (note 70), p. 97.

148 "Hélas! un instant dissipa le plus beau des songes…Le cruel devoir m'enleva soudain le miroir magique qui me rendoit l'habitant d'un monde enchanté." Loaisel de Tréogate, *La Comtesse* (note 134), p. 62.

149 Such an understanding of the morning's disenchantment as a reassertion of correct reason is echoed even by the poet Parny, in his poem *La Rechute:* "Ils viendront ces paisibles jours, / Ces moments du réveil, ou la raison sévère / Dans la nuit des erreurs fait briller sa lumière / Et dissipe à nos yeux le songe des Amours." Parny (note 122), pp. 44–45. Parny seems to some extent to be looking forward to the moment of reason's reassertion as the re-establishment of a clear-headed peace untroubled by the torments and errors of love. Yet, his verses also reveal an underlying feeling that the narrator himself does not believe in the face value of his statements and would rather, if possible, believe in the truth of his errors.

150 "…un tumulte confus, un chaos affreux et désespérant…vains & sans réalité." Loaisel de Tréogate, *Dolbreuse* (note 69), p. 62.

151 "Dieux! fremissons, et ne voyons pas leurs plaisirs, de peur qu'un imprudent transport ne nous fasse dire *'Ils sont trop heureux, ils ne peuvent etre coupables.'*" Loaisel de Tréogate, *La Comtesse* (note 134), p. 124

152 It is interesting to relate this structure to Maynard Solomon's discussion of atemporality and guiltlessness in Mozart's arias: "As they slip into the timeless dimension where arias are sung, [Mozart's] characters strip away the limitations of their types; and when they reemerge onto the stage, it is as though they are stepping from that timeless world into the 'real' world of adventitious character. We are asked for the moment to forget their limitations and to forgive their sins, disturbing prospects that stir unaccustomed emotional responses in us…If a villain is also capable of profound love, we may have difficulty in condemning his actions." Solomon, *Mozart: A Life* (New York, 1995), p. 511.

153 "Ils voudraient que le temps suspendît son vol, et que la nuit laissât ses favorables ombres peser encore sur l'univers." Loaisel de Tréogate, *La Comtesse* (note 134), p. 124.

154 Prince Paul Demidoff sale, San Donato, March 15, 1880, cat. no. 77. I obtained this information from a photocopy of the relevant catalogue page in the *Fountain of Love* file at the Wallace Collection archives.

155 It is interesting to note that here already Fragonard's reputation as a purely "Rococo" painter overrides the obvious Neoclassical qualities of the painting: the figures, typical of the 1780s, are juxtaposed to a base closer to the style of the 1730s or 1740s.

156 "Je soupire de me trouver seul au milieu des ravages du temps: cette puissance destructive répandue dans l'univers me fait songer au moment où vous et moi ne serons plus." Nicolas-Germain Léonard, *Lettres de deux amants habitant Lyons,* quoted in Bousquet (note 116), p. 443.

157 "Je me flatte, j'espère que le même attrait qui rapprocha dans ce monde deux âmes sensibles pourra survivre à la destruction de la matière, et se conserver en elles comme la flamme élémentaire dont elles furent pénétrées." Bousquet (note 116), p. 447. On the

problematic issue of love after death, see also Rudolph Binion, *Love Beyond Death: The Anatomy of a Myth in the Arts* (New York, 1993). Binion argues that "erotism broke the death barrier in the arts beginning around 1775" (p. 2). He sees this development as a "whole new departure," wherein love and death, formerly seen as utter opposites (death always marking the outer boundary of love, and thus bringing about entreaties of *carpe diem*), now become reconciled (p. 1).

158 "Nos facultés intellectuelles, à force de se concentrer, de se confondre dans l'âme d'une épouse adorée, s'exercent, aprennent peut-être à se passer du commerce des sens, & à se detacher de tout ce qu'il y a de terrestre autour d'elles. C'est ordinairement à la suite de ces heures si rapides & si fortunées, que nous voyons sans frayeur, que nous desirons même quelque fois l'instant de cette dissolution." Loaisel de Tréogate, *Dolbreuse* (note 69), p. 57.

159 "…cette mort enchanteresse dont les symptômes accusoient le plaisir & forçoient d'envier ses victimes." Loaisel de Tréogate, *Dolbreuse* (note 69), p. 61.

160 "et ceux que tu as, pour peu de temps, separes sur la terre, unis-les en toi dans l'eternite du ciel." Héloïse and Abelard, *Correspondance* (Paris, 1979), p. 199.

161 "Non, je ne te quitte pas, je vais t'attendre. La vertu qui nous separa sur la terre nous unira dans le sejour eternel. Je meurs dans cette douce attente…" *La Nouvelle Héloïse,* book 7, letter 12, p. 566.

162 The coincidence in time with the Allegories, as well as the closeness of its iconography and its pictorial treatment to the pictures of the 1780s should warn us against trying to attach it to any earlier period of the painter's career. Iconographically, it resolves the primary dilemma raised in the Allegories as to the survivability of love; given this thematic similarity, it fits better in the context of the Allegories than in that of any of Fragonard's earlier works.The related drawing reproduced in Rosenberg, *Tout l'oeuvre* (note 66), as fig. 1 under no. 408, and dated by Rosenberg to 1767, might not even be by Fragonard himself but simply a copy of the de Paroy print, which it reproduces closely, without reversal.

163 The provenance for the Albertina's *Kiss* goes back only to Albert, Duke of Saxe-Teschen, the Albertina's founder (Rosenberg, *Tout l'oeuvre* [note 66], p. 408), but it seems reasonable to suggest that the comte de Paroy owned a different, and now lost, horizontal version of the composition on which he based his print; the Albertina drawing may be a sketch for that (seemingly more finished) work.

164 Horace, *The Odes and Epodes,* Loeb Classics Library, rev. ed. (Cambridge, Mass., 1988), p. 318 (book 4, ode 9, ll. 10–11).

165 "Ombrage solitaire, / Lit de verdure impénétrable au jour… / Dans ce bois sombre en cyprès transformé." Quoted in Bousquet (note 116), p. 434.

166 "Ce sont de toutes parts des sources jaillissantes, / Dont le cristal retombe et fuit sous les lauriers; / Zéphir murmure et joue à travers les rosiers, / fait ondoyer des fleurs les moissons odorantes, / Disperse leur parfums, et dans ce beau séjour / Souffle avec un air pur les chaleurs de l'amour." Claude-Joseph Dorat, *Les Baisers* (Geneva, 1770), pp. 115–16.

167 "Crois-moi, jeune Thaïs, la mort n'est point à craindre. / Sa faux se brisera sur l'autel des Amours. / Va, nous brûlons d'un feu qu'elle ne peut éteindre. / Est-ce mourir, dis-moi, que de s'aimer toujours? / Nos âmes survivront au terme de nos jours; / Pour s'élancer vers lui par des routes nouvelles, / le dieu qui les forma leur prêtera des ailes." Dorat, *Les Baisers* (note 166), p. 115.

168 "Des tendres amants les ombres se poursuivent; / Ces amants ne sont plus, et leurs flammes revivent." Dorat, *Les Baisers* (note 166), p. 116.

169 "Tourbillon de feu, dont l'amour était le centre." Dorat, *Les Baisers* (note 166), p. 116.

170 "Tout ce qu'il y a de terrestre autour d'elles." Dorat, *Les Baisers* (note 166), p. 116.

171 Erwin Panofsky, "Et in Arcadia Ego: Poussin and the Elegiac Tradition," in *Meaning and the Visual Arts* (Garden City, N.J., 1955), pp. 319–20.

172 It is rather amusing that the father of iconology saw cupids in the two lovers, who are very specifically depicted as an adult man and an adult woman by Fragonard—the woman's hair being done up in a chignon, while her companion's masculinity is indicated by the strong gesture of the arm that he places around his beloved, as well as by the pattern of his hair, and that he misidentified Eros—complete with wings and a quiver full of arrows on his back—as a "friendly genius."

173 Horace (note 164), book 4, ode 9, p. 321.

174 My definition of the two categories draws upon, though it does not fully coincide with, Etienne Souriau's distinction between "poetic" and "dramatic" time, in "Time in the Plastic Arts," in Susanne K. Langer, ed., *Reflections on Art* (Oxford, 1961), pp. 133–34. My discussion is also influenced by Michael Fried's distinction of the "pastoral" and "dramatic" modes of absorption (which however does not discuss notions of temporality); see Fried (note 94), pp. 131–32.

175 For a negative view of this aspect of the plastic arts, see Emmanuel Levinas, "Reality and Its Shadow," in Sean Hand, ed., *The Levinas Reader* (Oxford, 1989), pp. 137–39.

176 I should add that I am using Keats's poem here because I believe it is one of the most important texts on the theoretical issue of the disjunction between represented time and time of viewership in a work of art. That the scenes Keats describes also include one of amorous dalliance, and that therefore the issue of the temporality of love is also brought into play, only reinforces the relevance of the Ode to my discussion. The question of the historic relationship between the Allegories and the Ode inasmuch as they both belong to the larger Romantic movement is much more complex and could not be addressed here without a wider comparison of French early Romanticism circa 1785 and the British version of the movement circa 1820, which obviously is beyond the scope of this work. It is unlikely that Keats ever saw Fragonard's Allegories, and I am not claiming any such factual connection between the two. I will let the fact that both the series of paintings and the poem deal with similar issues of the temporal predicament of love stand, if not as a proof, at least as a suggestion that this question continued to be addressed throughout the Romantic period.

177 John Keats, "Ode on a Grecian Urn," in Jack Stillinger, ed., *The Poems of John Keats* (Cambridge, Mass., 1978), pp. 372–73, ll. 1, 2, 7–8.

178 Keats (note 177), pp. 372–73, ll. 17–20.

179 Keats (note 177), pp. 372–73, ll. 21–22.

180 Keats (note 177), pp. 372–73, ll. 24–26.

181 Keats (note 177), pp. 372–73, ll. 27–28.

182 "M. Fragonard, né avec un somme de génie propre à former plusieurs artistes, ne nous paraît pas avoir rempli toute l'étendue de ses obligations envers la nature. Loin de suivre la carrière sublime de son Art, où les plus grands succès lui etaient assurés, il s'est detourné dans des petits sentiers inconnus, pour se faire un genre plus favorable au délire de l'imagination qu'à l'exacte vérité." Quoted in Rosenberg, "Ce qu'on disait de Fragonard," *Revue de L'Art* 78 (1987), p. 88.

183 "son ambition s'est bornée a faire briller quelques éclairs, dans une carrière ou son génie pouvait répandre une lumière plus grande et plus durable…on regrettera toujours que M. Fragonard n'ait pas pris un vol plus élevé." Rosenberg (note 182), p. 88.

184 On the Salon de la Correspondance and Fragonard's participation in it, see Molotiu (note 2), pp. 84–99.

185 On this cycle, see Molotiu (note 71), pp. 91–114.

186 On violence in the Var, see Hubert C. Johnson, *The Midi in Revolution: A Study of Regional Political Diversity, 1789–1793* (Princeton, 1986), pp. 201, 216–17.

187 The information about the guillotine comes from an official plaque set up at the entrance to the park.

188 "Ah! chevalier, que vous importent l'Etat, vos concitoyens, la société!… Vous n'ambitionniez que de faire le bien et aujourd'hui ce bien même vous est indifferent. Quel est donc ce sentiment dépravé qui a pris la place de votre amour pour la vertu? Vous ne désirez que de vivre ignoré à l'ombre de vos paupliers." Napoléon Bonaparte, *Oeuvres littéraires,* ed. Alain Coelho (Nantes, 1979), pp. 56–57.

189 "Il est vrai, chevalier, que nous sommes nés pour être heureux, que c'est la loi suprême que la nature a gravée au fond de nous-mêmes. Il est vrai que c'est la base qui nous a été donnée pour servir de règle à notre conduite. Chacun, né juge de ce qui peut lui convenir, a donc le droit de disposer de son corps comme de ses affections, mais cet état d'independance est vraiment opposé à l'état de servitude où la société nous a mis." Bonaparte (note 188), pp. 57–58.

190 "Il a donc fallu substituer au cri de notre sentiment, celui des préjuges. Voilà la base de toutes les institutiones socials." Bonaparte (note 188), p. 58.

191 "Je plains votre erreur. Quoi, chevalier, vous croyez que l'amour est le chemin de la vertu? Il vous immétrigue a chaque pas. Soyez sincère. Depuis que cette passion fatale a troublé votre repos, avez-vous envisagé d'autre jouissance que celle de l'amour? Vous ferez donc le bien ou le mal selon les symptomes de votre passion. Mais, que dis-je! Vous et la passion ne font qu'un meme être. Tant qu'elle durera vous n'agirez que pour elle…" Bonaparte (note 188), pp. 62–63.

192 "La Révolution a été faite par des voluptueux." Charles Baudelaire, *Oeuvres complètes* (Paris, 1961), p. 639.

193 See William Wordsworth, *The Prelude* (1805–6), bk. 10; (1850 version), bk. 11, and especially the lines quoted in note 195.

194 Karl Marx, "The Eighteenth Brumaire of Louis Bonaparte," in *Surveys from Exile: Political Writings* (London and New York, 1973), vol. 2, p. 150. Translation slightly modified.

195 Indeed, Wordsworth's language commingles the experience of revolution with that of Romantic love: "O pleasant exercise of hope and joy! / For great were the auxiliars which then stood / upon our side, we who were strong in love! / Bliss was it in that dawn to be alive, / But to be young was very Heaven!" William Wordsworth, *The Prelude* (1805–06 version: bk. 10, ll. 690–94; 1850 version: bk. 11, ll. 105–9). See also Thomas Carlyle's *The French Revolution* (1837), which is perhaps the most impassioned epic poem in prose created in the Romantic period.

INDEX

121

123

The dedication of this book records my indebtedness to Donald Posner (1931–2005), who supervised the dissertation on which it was based, and who passed away just as I finished revising the manuscript. He was one of my closest friends and a model of scholarly integrity; he will be missed greatly. I would also like to thank the other members of my dissertation committee, Robert Rosenblum and Robert Lubar of the Institute of Fine Arts, for their valuable advice. Ms. Eunice Williams generously shared with me her knowledge of Fragonard and her connoisseurship. I want to thank Anne L. Schroder for sharing with me, back in 1994 when I was in the beginning stages of my research, an early version of her article, "Reassessing Fragonard's Later Years: the Artist's Nineteenth-Century Biographers, the Rococo and the French Revolution" (published in Elise Goodman, ed., *Art and Culture in the Eighteenth Century: New Dimensions and Multiple Perspectives* [Newark, 2001], pp. 39–58). At the Louvre, I would like to thank Mrs. Pierre Rosenberg and Régis Michel. I also benefited greatly from my discussions on Fragonard with Mme Marianne Roland-Michel of the Galeries Cailleux, and from my discussions on a great variety of eighteenth-century topics with Jean-Claude Lebensztejn of the Sorbonne. Mme Joëlle Déjardin of the Musée d'Art et d'Histoire de Provence provided me with valuable information on the Fragonard, Maubert and Gérard families, as well as on the Maubert house. I wish I could still thank in person Reni Celeste (1963–2004), who, when she was my student in the Graduate Program in Visual and Cultural Studies at the University of Rochester, helped me iron out the line of argument in this book's Chapters III and IV.

My work on the dissertation on which this book is based was supported by a Theodore Rousseau Travel Fellowship and a Chester Dale Fellowship from the Metropolitan Museum of Art; by a Dissertation Fellowship from the Kress Foundation; as well as by financial awards from the Institute of Fine Arts. To all these institutions, I would like to express my gratitude for their generosity.

I particularly want to thank Scott Schaefer, Curator, and Jon Seydl, Associate Curator, of the J. Paul Getty Museum's Paintings Department, who supported this book and gave me the opportunity to co-curate with them the accompanying exhibition; in Getty Publications I thank my editor, Mollie Holtman, for her sorely tested patience, ReBecca Bogner and Stacy Miyagawa for managing the production aspects of the book, and Catherine Lorenz for its glowing design.

I have left the most important thanks for last: I owe so much to my wife, Julie Van Voorhis, for her support and encouragement, for her companionship and her love. Our son, Alexander Lucian Molotiu, was born as I was in the final stages of working on this manuscript, and I can't help but recognize the two, and then the three, of us in some of Fragonard's images reproduced here.

Andrei Molotiu

ACKNOWLEDGMENTS

126 This volume accompanies an exhibition at the Sterling and Francine Clark Art Institute and the J. Paul Getty Museum entitled *Consuming Passion: Fragonard's Allegories of Love.*

Above all, thanks must go to Andrei Molotiu, whose imaginative and novel research initiated this project. We all remain grateful for his intelligence and sensitivity as well as his unflagging passion for the material.

At the Getty, thanks begin with the museum's director, Michael Brand, for his steadfast support, as well as to William M. Griswold, former Acting Director, for backing the initial planning. The judicious counsel and thoughtfulness of Scott Schaefer, Curator of Paintings, has fueled this project from the start, and his signal acquisition of *The Fountain of Love*—the painting at the core of this project—and its subsequent conservation by Mark Leonard, Conservator of Paintings, has allowed this exhibition to happen at all. At the Clark, Chief Curator Richard Rand, himself a key voice in Fragonard studies, has been a wonderful colleague, committed to the project from the start, and the Clark's director, Michael Conforti, sustained the project from its early stages.

An array of colleagues at both institutions created this exhibition. At the Getty, Maite Alvarez, Catherine Comeau, Laurel Kishi, Amy Linker, Sally Hibbard, Amber Keller, Sarah McCarthy, Andrew Pribuss, Leon Rodriguez, Peter Tokofsky, and especially Quincy Houghton, were instrumental in developing this exhibition and its programs, while Katrina Mohn's contributions deserve special mention. At the Clark, we gratefully recognize Dan Cohen, Jim Ganz, Gwendolyn Smith, Mattie Kelley, Barbara Lampron, and Kathleen Morris. Thanks also go to Mark Gillette, Priscilla Dekermendjian, Jo Hedley, Anne Lacoste, Rose Linke, Mary Morton, Rosalind Saville, and Anne T. Woollett for their contributions. Scott Allan heroically stepped in to curate the Getty presentation at the last moment.

We are greatly indebted to the institutions and private collectors who were willing to part for a time with some of their most captivating works, with particular appreciation to Hervé Aaron, Susan Absolom, Shelley Bennett, Cynthia Burlingham, Patrick Cooney, Philippe Costamagna, Claudine Dixon, Jackie M. Dooley, Laura Giles, Robert Gordon, Margaret Morgan Grasselli, Rena Hoisington, Bernard Jazzar, Dennis Jon, Heather Lemonedes, Henri Loyrette, J. Patrice Marandel, John Murdoch, Lynn Orr, Sissi Paul, Carolyn Peter, Pierre Rosenberg, Jacob Rothschild, Marie-Catherine Sahut, Alan E. Salz, Gloria Williams Sander, Dorit Schäfer, Perrin Stein, Walter Timoshuk, Carol Togneri, Agnès Webster, Heinz Widauer, David S. Zeidberg, and a number of anonymous private collectors. Lynda and Stewart Resnick have lent three pictures by Fragonard to the exhibition from their collection, an especially generous contribution.

Finally I would like to single out Joseph Baillio, whose contributions to the research, photography, and loans were absolutely critical and executed with grace and lightning speed.

Jon L. Seydl
Associate Curator, Paintings Department
J. Paul Getty Museum